C000276335

CHAIRS

Editor and text
PATRICIA BUENO

Design and typesetting
CARLOS GAMBOA PERMANYER

Production
JUANJO RODRÍGUEZ NOVEL

Translation
MARK HOLLOWAY

First published by: Atrium Group de ediciones y publicaciones, S.L.
c/ Ganduxer, 112
08022 BARCELONA
Tel: +34 932 540 099
Fax: +34 932 118 139
email: atrium@atriumgroup.org
www.atriumbooks.com

ISBN 84-98692-95-3

Dep. Leg.: B-38702-03

Printed in Spain by
Anman Gràfiques del Vallès, S.L.

Page 3: Photograph by Jonathan De Villiers from the book *150 Articles, 150 Works,* published by Kartell■

CONTENTS

Significance of icons used:

⊟ Height of chair in cm

⊟ Width of chair in cm

⊟ Depth of chair in cm

⊟ Height of seat in cm

INTRODUCTION

Why a book about chairs? Because chairs are a perfect excuse for many things. A source of inspiration to express artistic restlessness. The throne that allows for the accumulation of power. The sophisticated office chair from which to exercise command. The beach chair that offers a rest by the sea. The comfortable reading chair that provides a link to the real world while the hours fly past immersed in imaginary worlds. The electric chair that, for some, legitimizes killing. The sprung chair, source of interminable conversations. The chair as a starting point from which to democratize the world as desired by those who sympathized with the ideas of the Bauhaus and, later, many others who have seen in this object a platform from which to express their social restlessness. A daring design becomes a paradigmatic example of a manifesto of aesthetics that expresses a break with the ideas that came before. The chair also serves to express our need to be close to nature and to others rather than being against them. Or as the perfect excuse to wait or to leave...

Many a stance has found the perfect excuse to manifest itself in the chair, which has determined the perspective from which to view the world. For all of these reasons, from the study of this piece of furniture, it is easy to understand the motivations that have driven carpenters, upholsters, architects, engineers and industrial designers to create different types of chairs that have responded to the varying motivations, necessities and cultural settings of different times. Between a chair manufactured in 1900 and one created in 2000, we can find the rise and fall of monarchs, conquests, wars, changes in frontiers, transformations in political power, times of crisis alternating with periods of economic growth, changes in social classes and, of course, an unstoppable technological progress that has given rise to numerous technical innovations that have permitted a change in habits and tastes.

At present, what distinguishes a good design from a mere copy is not limited to a component of originality, but to its capacity to hold significance; its adaptation to the real necessities of its users; its respect for the environment with, for example, the use of recyclable materials; its versatility, which allows for its use in diverse environments and situations; an approach in accordance with industrial requirements, so that its manufacturing costs permit production of the design for the general population, as has been desired by many designers for a long time; its innovative component as much as its form as its background; its ergonomics as a fundamental element to obtain a relationship between the chair and its user, and last, an aesthetic that responds to the lifestyle of those to whom it is directed as a way of also obtaining a form of spiritual liberty.

On the other hand, what seems to be clear is that the maxim of functionalism, "form follows function", has become obsolete and has given way to radically different approximations in the world of design that respond to the motivations of each individual creator.

In this book, the evolution of the decorative arts and society from the times of the Egyptian Empire to the present is traced through from the most iconic chair designs by the greatest innovators found behind each and every one of them. The last pages are dedicated to creative freedom, with a chapter dedicated to the chair as an excuse for art and which presents different ways of contemplating this object as something which serves as much more than to simply rest in. Therefore, we only need to find an excuse to take a seat and enjoy the variety and complexity of this object of such a simple appearance.

PATRICIA BUENO

A HISTORY OF THE CHAIR

FROM ITS ORIGINS TO THE 19th CENTURY

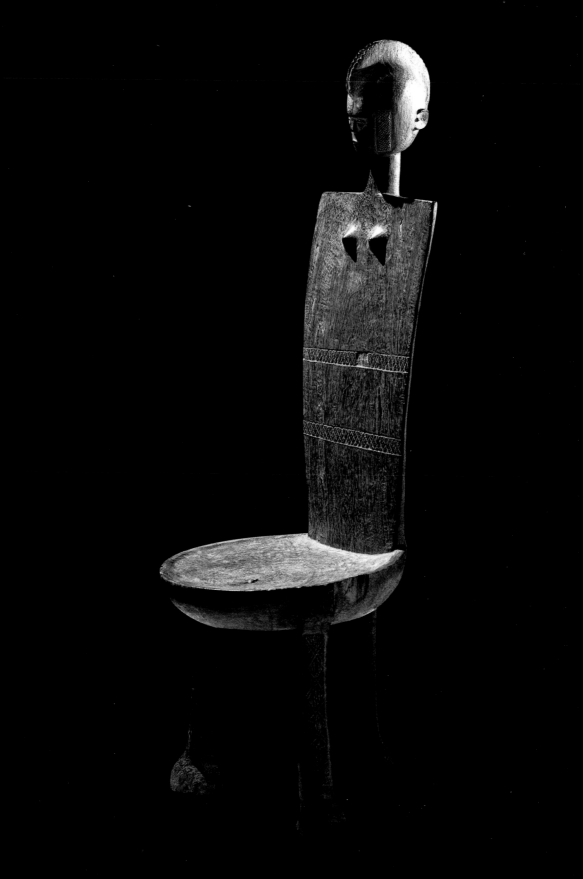

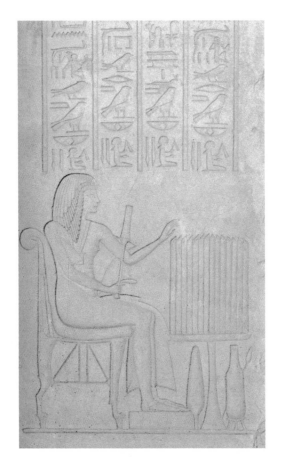

" ... every truly original idea – each innovation in design, every new application of materials, each technical invention in furniture manufacturing seems to find its utmost expression in the chair."

(George Nelson – designer and author of the book *Chairs*, 1953.)

The chair is the most elementary, common, and varied piece of furniture in our surroundings. For this reason it is also the most interesting, given its capacity to transmit cultural information from different times and places.

Although now it would seem that man has always sat in the same way, the position that people have adopted to sit in has varied throughout history from period to period, culture to culture, city to city. and from continent to continent.

Whereas in some places it is habitual to sit oneself in a squatting position, on one's knees or crossed-legged, the chair is the exclusive mode of comfort in the West. People are so accustomed to using chairs in every aspect of their lives that it is difficult to imagine that their use was not prevalent until well into the fourteenth century when they became extended to all social strata. This demonstrates that the modifications in the design of this piece of furniture have been determined by aspects far beyond its mere practical function, given that it is associated with numerous symbolic symbols. The chair has evolved along with political, economic and religious power, with art, knowledge, aesthetic sensitivity and, last but not least, industry.

It is fascinating to follow the trail of such a commonplace object as this given, as always, that a study of the past helps us understand the present. Investigating the evolution of the chair throughout history reveals the social, economic and cultural tensions that have affected the world from the times of the Egyptian Pharaohs. This is a journey that will change the way we contemplate a chair, from an everyday object to a living witness of the evolution, and at times the regression, of the human being.

The most common theory as to how the chair has become omnipresent in the West, in as much as being a more or less comfortable support for the body, is that its origins were the thrones used by royalty (evidently a symbol of earthly and celestial power) and the fact that society has always had the custom – or necessity – to imitate the more privileged classes. This theory takes us back to the year 3100 BC.

Page 10: chair from Tanzania, extracted form a block of wood and includes traditional symbolic motifs.
Opposite: Relief carved in the frame of the access door to the statue chamber of the tomb of Horemheb who is shown sitting at a table of offerings (approx. 1325 BC).

During the grandeur of ancient Egypt (approx. 3100 – 475 BC), to sit upon a support was reserved for royalty and the upper classes of society. In this early period, the stool appeared as one of the first pieces of furniture. Its construction was gradually perfected until a low curved backrest was incorporated which is believed to have supported the pelvis and sacrum in such a way as to enable a position of comfort and balance for the lumbar spine. Maybe the greatest, or most intriguing, curiosity of this innovation is that it has never been seen again in the history of the chair.

In the era of the IV Dynasty, the chair reached its highest level of perfection. From this era forward, it was found in two basic forms throughout the twelve dynasties (approximately until 1320 BC), as a refined chair used by royalty, nobility and officials; with the stool used by the other social classes who never completely abandoned the custom of resting in a squatting position for which no form of support is necessary. To increase comfort, a white cushion could be added to either model. The more luxurious chairs were frequently finished with encrustations of ivory, ebony or glasswork.

The position adopted in the higher chairs, with the sitter's legs hanging down to the floor, is the first example of a chair that corresponds to the present western model. Another innovations of interest is the incorporation of a footstool with this type of seat, which permitted a position with the thighs parallel to the floor to be adopted which is very similar to modern ergonomic postures used at present.

During the same period, the Mesopotamian Empire developed, in which we see many similarities in furniture design with Egyptian culture. Perhaps one of the most significant differences was the existence of stools with crossed legs and others in the form of a box that incorporated wickerwork panels on each side. Although what is really significant is that this last design has a clear similarity to pieces that are still being made in Iraq today, more than 4,000 years later.

As in Egypt, chairs with a high backrest were for the exclusive use of the royalty and the privileged classes. In Mesopotamian culture, curiously, the Egyptian

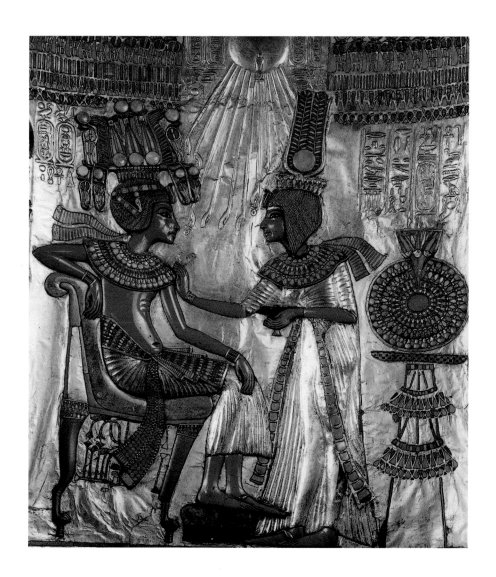

Detail of backrest from Tutankhamon's throne (approx. 1325 BC).

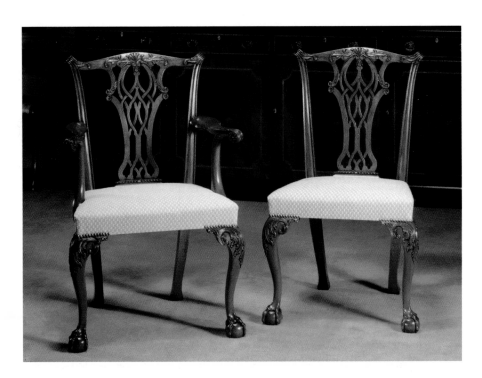

chair with the lightly inclined backrest, despite being known, was not adopted. The
chairs were made a with back that was straight and deliberately rigid, which may
reflect the severity of the owners.

At the beginning of the 5th century BC, during the period of ancient Greece
(where sophistication in design in various artistic disciplines developed) the arti-
sans of the time developed a new sort of chair known as the "classical" Greek de-
sign. This design incorporated a wide strip of wood set horizontally in the upper
part of the backrest that would wrap around the back of the person seated. On
occasions, the curvature of this backrest was exaggeratedly accentuated. The legs
were generally curved and the chair was lightweight, which facilitated movability
and flexibility of use. Thus, at this time, the form of the classical chair that would

Chair in the Chippendale style.

serve as the basis for designs of the eighteenth, nineteenth and twentieth centuries was established.

This design seems to have been based on the preoccupation of the Greeks to obtain a greater degree of comfort. This was achieved by adding a backrest formed in such a way as to adapt to the shape of the body. The use of the chair became more common, although it was still limited to the higher classes of society. On the other hand, the use of benches for seating expanded in schools and theaters as it did by philosophers and their audiences■

The models of stools, chairs and divans (used by the Greeks to eat in a reclined posture and which have become our present-day chaise lounges) from the age of Classical Greece (475 – 370 BC) have exerted their influence to the present■

Designs from Greek culture were held on to by the Roman Empire and the distinction between thrones and chairs as seats for the powerful was strengthened. With the fall of the Roman Empire, the custom of sitting on a chair disappeared for centuries after being eradicated by the invading force that saw it as an unnecessary eccentricity. However, chairs continued to be used in the church and in the entrances to houses of the most powerful. It wasn't until the seventeenth and eighteenth centuries that new designs started to appear, inspired by Greek and Roman styles. This is a surprising fact that indicates that western history has not always followed a continually ascending line■

Chair in Elizabethan style■ Chair style Louis XVI■ Easy chair style Louis XV■ Easy chair style Louis XVI■

In this way, throughout the Byzantine Era and the early Middle Ages, the tradition of the classical arts and the notion of a comfortable support was lost, and the chair became a severe form with large dimensions and exclusive to authority and ceremonial acts.

During the Gothic Period (twelfth to fifteenth centuries) in Europe the only people with an education and economic resources were those related to the church. As a consequence, furniture of the period was determined by the needs of the clergy. This gave an impulse to the development of utilitarian chairs such as those that would facilitate the study of manuscripts, writing and painting. From these necessities was born, in the fourteenth century, for example, the swivel chair that facilitates the work of scholars.

The asceticism typical of the period eliminated any concession to comfort or to the improvement of posture from the design of chairs. Chairs were characterized by their austerity and maintained right angles between seat and backrest which tended to be high and laboriously carved or decorated.

The most appreciated pieces of furniture of this period were large chests that, in addition to containing and allowing for the transportation of personal objects, were also used as seats. Once the population had abandoned its nomadic traditions, these large chests became benches that were placed up against the wall.

Chair Louis XIV. Easy chair Louis XV. Chair Louis XVI. Chair Louis XVI.

It was not until the sixteenth century that Europe established directions in the evolution of the Decorative Arts in general, and in particular in the chair, an object in which the main characteristics of each period were to be incorporated. France and England \exerted the greatest influence on the design of furniture. Their influence was joined by the United States in the nineteenth century.

The majority of the decorative styles that followed one another over these years are named in honor of the ruler of each period, given that these persons tended to promote the manufacture of furniture that responded to their tastes and fancies. ￭

Some of the most significant influences exerted by monarchs over the Decorative Arts are found in France under the reign of the "Louises" (Louis XIV, self-proclaimed Sun King, Louis XV and Louis XVI) and later, under Napoleon Bonaparte, with the style of the Empire. Each of these rulers desired to stamp their grandeur and stateliness on furniture reflecting to their obsessions and personal circumstances.

From the beginning of the seventeenth century, during the reign of Louis XIV, various fashions in the decoration of interiors followed one another which established France as the country with the greatest influence in questions of furniture design. It was during Louis XV's rule, at the start of the most genuine French Rococo style, when the notion of the chair as a support for the body that would allow a relaxing posture to be maintained was revived. The structural elements were

Biedermeier chair ￭ Empire chair (Coll. Antiquarian Giorgio Copetti)￭ Art Nouveau chair (Coll. Antiquarian Giorgio Copetti)￭ Director chair (Coll. Antiquarian Giorgio Copetti)￭

curved and gave way to undulating forms that suggested refinement and the joy of life. As far as the legs were concerned, they were usually carved in the cabriole style: curved in the form of an extended "S" and finished in the volute ornamentation of an animal's paw. The backrests followed the tendency already initiated during the previous reign: they were high with square or slightly curved crests with a severe drop. The use of wickerwork in the backrests and seats of the chair began to prevail. In armchairs, the backrest and armrests formed one complete curved unit that was upholstered in lively tones of damask, cotton and silk. One of the most notable aspects of this period was the introduction of asymmetry in the designs.

Altogether, the Rococo chair succeeded in transmitting a sensation of stately elegance, comfort, movement and delicacy. In this way, the chair lost the rigidity acquired during the preceding centuries and once again began to show softer lines along with the notion of comfort that had initially been developed by the Greeks.

The well-off of the time commissioned the manufacture of chairs from cabinetmakers who did their best to stamp the tastes of the privileged classes on their creations which acquired the distinction of artistic pieces due to the elaborate carpentry worked into them.

New technologies and materials came into being which incorporated the use of upholstery noticeably. Little by little, the carpenter began to lose ground to the upholsterer as the designer of chairs. The forms became softer and rounded, the backrest was made higher to wrap around the user, the depth of the seat was augmented, springs were incorporated into the base and the concept of "comfortable" came into being. However, the use of chairs was to continue being a privilege of the well-off until the development of the Industrial Rev-

olution, which made chairs available to the lower classes as of the nineteenth century.

All of the curves and comfort brought about by the Rococo style were lost during the reign of Louis XVI, whose aesthetic tastes were influenced by Neoclassicism in its

most rigorous form. Strict symmetry returned with a special emphasis on straight lines, a taste for right angles and vertical legs which imitated the ancient Greek-Latin columns with long narrow abruptly cut-off conical forms.

This influence from classical antiquity was accentuated with the Empire Style, typical of the nineteenth century, which, as its name indicates, was a faithful reflection of the Napoleonic Empire.

Bonaparte, who was responsible for the revival of the style and icons of the classical periods of Greece and Rome, imposed a tyrannical classical tradition. He established very strict rules that considerably reduced the margin of creative freedom previously enjoyed by cabinetmakers who could not move away from the imposed rules. Furniture adopted simpler and more geometric forms that were dominated by straight lines, exaggerated symmetry and solid structures. Legs tended to be in the form of columns with clawed feet. The characteristic backrest of the Empire style was quadrangular and concave with a slightly reminiscent form of a gondola. Some chairs were decorated with figures or symbols from ancient mythology and others with the letter "N" for Napoleon I.

In England the evolution was more or less the same with the succession, as of the sixteenth century, numerous decorative styles that reflected its particular idiosyncrasy. It was there that the first decorative style known by the name of the artist who created it, Thomas Chippendale (born in Yorkshire, 1718-died in London, 1779),

Double easy chair style Chippendale.

appeared. The Chippendale style, which brought together all of the ideas from preceding styles, represented the peak during the period of splendor for Anglo-Saxon furniture. Its most important contribution to the future was the introduction of the concept of considering the rooms within a house to be a whole, a complete unit in which all of the elements should relate to and complement one another (we will see this idea once again in the iconic styles of modernity such as the Bauhaus). Chairs, in which width predominated in comparison to depth, and which presented a great variety of backrests, stood out. Their beauty and severity led them to be acquired for every noble building in the country.

This great English cabinetmaker made a number of fine pieces of beauty and functionality with a revolutionary bourgeois and comfortable character that managed to bring together the pure art of furniture making with perfect industrialization. As a consequence, with Chippendale, bourgeois art began its pilgrimage to the continent and especially to France and the Netherlands.

The Windsor chair, of rural origin, was also developed during this period. It was constructed with spindles and a solid piece of wood which formed the seat. With time and respective national additions, this chair has become almost a patriotic symbol as much as in England as in the United States. The rocking chair, on the other hand, has also come to be a distinctive North American passion.

As of this moment, the design of the chair was influenced by ideologies of the bourgeoisie, holders of economic power, and by the Industrial Revolution, which democratized the use of the chair and put it within the reach of society at large.

It was in the twentieth century that technical developments and the introduction of new materials turned the chair into one of the areas of preferred experimentation for architects and designers. This gave rise to the introduction of new forms that had previously been unimaginable and brought together ergonomics, aesthetics and economy. One hundred years of continual creativity had begun.

Louis XV style easy chair ∎

THE 20th
CENTURY
100 YEARS OF INNOVATION

The Pioneers

Chair design of the twentieth century was by the influenced exerted during the early years by the great pioneers, those men who knew how to introduce formal and conceptual innovations to their creations. Not only did they change the aesthetics of the world that surrounds us, but they also brought to bear a new way of understanding the lifestyle of the times. Names such as Michael Thonet, Antonio Gaudí, Charles Rennie Mackintosh, William Morris or Frank Lloyd Wright marked a change in the history of design and stood as a point of reference and inspiration for the generations that were to follow.

The trends that opened the century were Art Nouveau and the Arts and Crafts movement. The first, which was popular from 1880 to the beginning of World War I, found beauty and inspiration in organic forms. The designs of this movement were based on sinuous lines inspired by plant or animal forms and show a strong influence of Japanese art. Art Nouveau came about as a necessary substitution for ancient historicist styles in an eagerness to adapt to an emerging "modern" culture. The intention was to reconcile art and industry although it was impossible to satisfy the demands of mass production due to the high level of craftsmanship required by the pieces manufactured. In Vienna, Josef Hoffmann, Adolf Loos and Kolomon Moser developed a more straight-lined version of the style that put special emphasis on functionality.

The Arts and Crafts movement came into being around 1880 in England. It had a strong ideological content stemming from a reaction against the consequences of the industrial revolution on the living conditions of the workers. William Morris was the main exponent and believed that a "good design" would influence the development of a "good society". The movement defended a return to the artisanal methods of the Middle Ages and the virtues of handmade objects, it favored design that was simple, functional and without superfluous decoration and believed that quality and beauty were achieved by the use of natural materials. In the United States, this style had two leading representatives in the Stickley brothers, who practically converted it into a national style with genuine North American characteristics. In the southwest of the United States, it was converted into the so-called Mission Style while Frank Lloyd Wright transformed it into his very own Prairie Style.

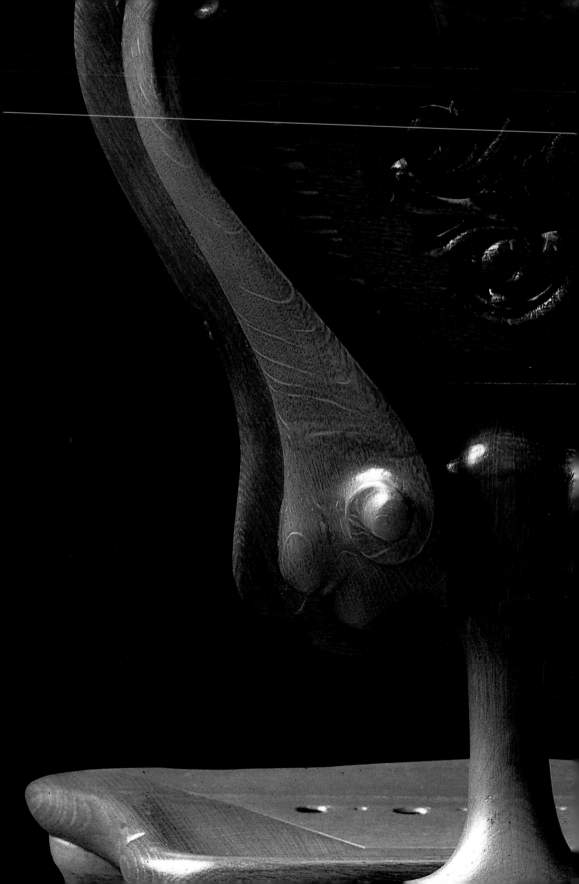

MICHAEL THONET

1. CHAIR "214 F", by Thonet.
Curved wooden structure and uphol-
stered seat. Made following the original
model manufactured by Michael Thonet
using a minimal number of elements.
⊟ 84 ⊟ 52 ⊟ 46 ⊟ 47 cm.
2. CHAIR "214", by Thonet.
Curved wooden structure and wick-
erwork seat. This is the direct heir of
the model "#14" manufactured in
1859 by Michael Thonet.
⊟ 84 ⊟ 43 ⊟ 52 ⊟ 46 cm.
3. Image of Philipp, Claus and Peter
Thonet, descendants of the founder
and present-day directors of the
firm.
4. CHAIR "214 K", by Thonet.
Reinterpretation of the historic
model as a symbol of his innovation
and of the beginning of a new era.

1796 Boppard am Rheim, Germany–1871 Vienna, Austria.

Although this important furniture manufacturer developed his activi-
ty during the second half of the nineteenth century, his presence is es-
sential in a book that sets out to trace the history of the chair.

Michael Thonet became internationally recognized as being a pio-
neer in the industrial production of furniture thanks to the patent he
obtained in 1856 for a revolutionary system for curving wood using
vapor under pressure. Through his experiments, he also encouraged
the use of laminated woods in the manufacture of chairs, another of
the most significant innovations of the twentieth century, making
the production of chairs with fewer pieces, greater unity and visual
fluidity possible. This also led to savings in costs. His influence is ev-

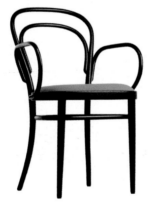
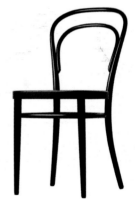

ident in the work of great designers of the twentieth century such as
Marcel Breuer, Alvar Aalto, and Charles and Ray Eames. In this way,
Thonet set a historic example of industrial production and was able
to establish a connection between design and technology that had
never existed before. As a result of this union, one of the most repre-
sentative icons of industrial design was born: the #14 chair, one of
the most copied in history, the curved lines of which continue to be
fashionable to this day, demonstrating that good designs are ageless.

When Thonet died on 3 March 1871, he was known throughout the
world as the most important furniture manufacturer of the century.

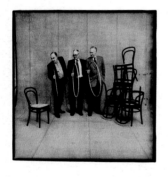

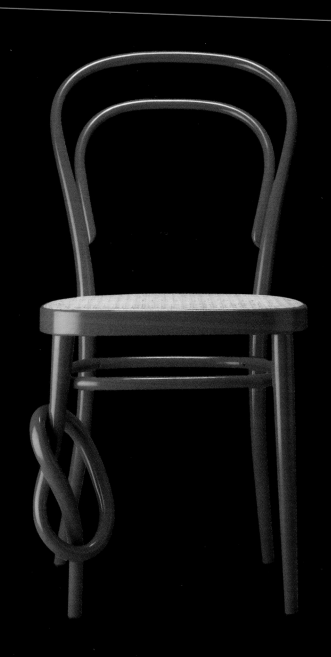

1. CHAIR "CALVET", 1902. Produced by Bd Ediciones de Diseño.
Carved in oak and varnished for the Casa Calvet in Barcelona.
⊟ 94 ⊟ 52 ⊟ 54 cm.
2. CHAIR "BATLLÓ", reproduction by Bd Ediciones de Diseño.
Carved in oak for the dinning room of the Casa Batlló.
⊟ 74 ⊟ 52 ⊟ 47 cm.
3. EASY CHAIR "CALVET", 1902. Produced by Bd Ediciones de Diseño.
Carved in oak and varnished for the offices of the Casa Calvet in Barcelona.
⊟ 65 ⊟ 65 ⊟ 52 cm.

1852 Reus, Spain-1926 Barcelona, Spain.

Antonio Gaudí has become, with the passing of the years, the most important figure in Catalan and Spanish architecture. He has been admired internationally for his originality and boldness for the way in which he has resolved formal and technical problems.

His furniture designs cannot be disassociated from his most emblematic building, given that his vision of architecture as forming a whole implies that his creative genius manifested itself as much as in the interiors of his buildings as in their facades. He actively integrated all of the elements of his buildings, from the doorknobs to, of course, the chairs, into the architectural space. Organic forms, inspired by nature, became essential structural elements and furniture that gave the

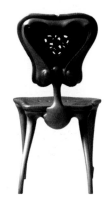 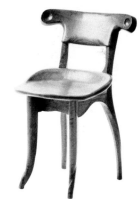

impression of having been made from an extremely pliable material. As in nature, no two pieces of his furniture are the same as asymmetry is one of its distinctive characteristics. Ergonomics was another of Gaudí's preoccupations. He designed chairs in such a way that they would adapt to the corporal structure of whoever had to use them.

Although his work is generally included within Modernism, his capacity to innovate, his ability to synthesize the historicist aesthetics that had predominated up until the time, along with the creation of an "avant-garde" form of decoration, unique and brilliant, makes it difficult to categorize his work as any particular style.

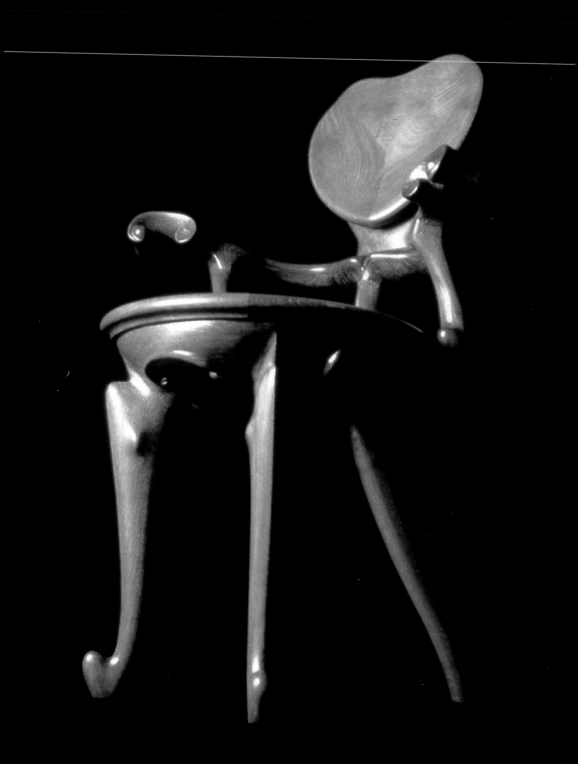

CHARLES RENNIE MACKINTOSH

1. CHAIR "WILLOW", 1904. Collection "Cassina I Maestri"■
Stained ash structure and curved wickerwork backrest. Seat with cushion■
⊟ 119 ⊟ 94 ⊟ 41 ⊟ 39.5 cm■ (Photo: M. Carreri)■
2. CHAIR "ARGYLE", 1897. Collection "Cassina I Maestri"■
Stained ash structure. Upholstered seat■
⊟ 136 ⊟ 48 ⊟ 47 ⊟ 46 cm■ (Photo: M. Carreri)■
3. CHAIR "INGRAM", 1900. Collection "Cassina I Maestri"■
Natural cherry structure. Upholstered seat■
⊟ 95 ⊟ 47 ⊟ 44.5 ⊟ 45 cm■
4. CHAIR "HILL HOUSE", 1902. Collection "Cassina I Maestri"■
Stained ash structure. seat upholstered in green or pink■
⊟ 141 ⊟ 41 ⊟ 35 ⊟ 45 cm■ (Photo: M. Carreri)■

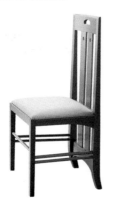

1868 Glasgow, Scotland-1928 London, England■

Charles Rennie Mackintosh can be credited with some of the most original and elegant chairs of Art Nouveau, although he cannot be strictly classified as belonging to this movement■

Architect, designer and painter, in his furniture he modified the forms of Art Nouveau from organic to geometric and in so doing became the predecessor of the styles to follow, such as the movement Viennese Secession or the Modern Movement spirited by the Bauhaus■

As did his North American counterpart Frank Lloyd Wright, Mackintosh gave special importance to interiors following his belief that a building should form an organic whole in which all of the de-

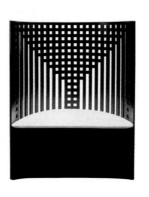 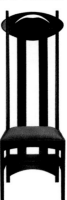

tails should be in harmony. His affection for simple forms and his passion for the decoration of surfaces are reflected in the design of these interiors in which all the parts are organized in relationship to a theme generally inspired in nature■

Simultaneously, his chairs incorporated references to nature models, and geometric order, the craftsmanship of Arts and Crafts as he brought apparently contradictory poles of Art Nouveau together. In his chairs, the exaggeratedly high backrests stand out and summarize his style: a combination of subtlety and affluence, of severe austerity and exuberant romanticism■

Although his original style rapidly won recognition in Austria and Germany, Charles Rennie Mackintosh did not become widely known in his own country until many years after his death■

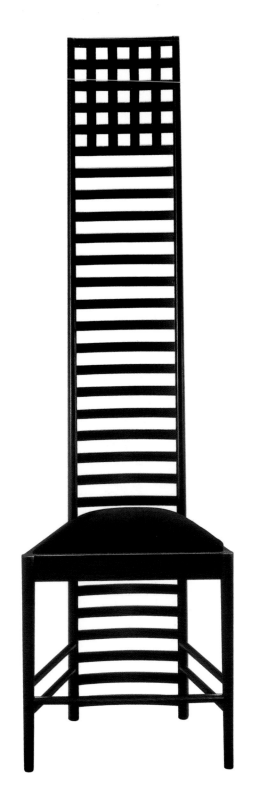

FRANK LLOYD WRIGHT

1867 Wisconsin, United States-1959 Arizona, United States∎

1. CHAIR "JOHNSON WAX 2", 1936. Collection "Cassina I Maestri"∎
Painted steel tube structure. Upholstered seat and backrest with leather trimmings. Wheels incorporated∎
⊟ 88 ⊟ 61 ⊟ 54 ⊟ 46 cm∎ (Photo: L. Torri)∎
2. CHAIR "ROBIE", 1908. Collection "Cassina I Maestri"∎
Stained or natural cherry structure. Upholstered seat∎
⊟ 133,5 ⊟ 40 ⊟ 45,5 ⊟ 46 cm∎ (Photo: Romano Fotografie)∎
3. CHAIR "COONLEY 1", 1907. Collection "Cassina I Maestri"∎
Stained or natural cherry structure. Upholstered seat∎
⊟ 46 ⊟ 43 ⊟ 47 ⊟ 46 cm∎ (Photo: Studio Marcone)∎
4. CHAIR "COONLEY 2", 1907. Collection "Cassina I Maestri"∎
Stained or natural cherry structure. Upholstered seat∎
⊟ 70 ⊟ 43 ⊟ 47 ⊟ 46 cm∎ (Photo: Studio Marcone)∎
5. CHAIR "BARREL", 1937. Collection "Cassina I Maestri"∎
Stained or natural cherry structure. Upholstered seat∎
⊟ 81 ⊟ 54,5 ⊟ 55,5 ⊟ 50 cm∎ (Photo: Romano Fotografie)∎

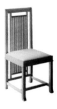

Considered by many as the most important North American architect of the twentieth century, Frank Lloyd Wright was the force behind the Prairie Style that revolutionized residential design at the beginning of the century with a philosophy destined to develop a modern form of architecture for a democratic North American society. In the houses in question, the different spaces are integrated into one coherent whole and the exterior and interior converge uniting the surroundings with the structure∎

Wright conceived of a building as a complete creation in which the interior furniture would be in harmony with the geometry and the materials of the structure, which in turn was integrated into its geographic set-

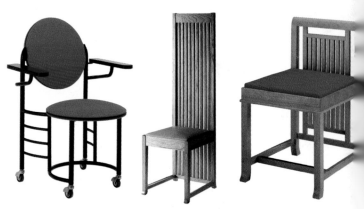

ting. Furthermore, he was convinced that the surroundings in which people live directly influenced their character. As a result of this, his furniture and chairs show quality in their construction, present simple straight lines and enhance the textures and natural grains of the woods, as opposed to the ornamental carving and embellishment were more typical in earlier styles. He designed each piece individually according to the client and to the piece's particular architectural surroundings∎

His architecture is classified as organic, in as much as it respects the qualities of the materials used and the harmonious relationship between the form and the function of the building. He transformed the saying "form follows function", as professed by his maestro Louis Sullivan (later adopted as an emblem by the Modern Movement), and adapted it to his own theory: "form and function are one." He used nature as the ultimate example of this integration∎

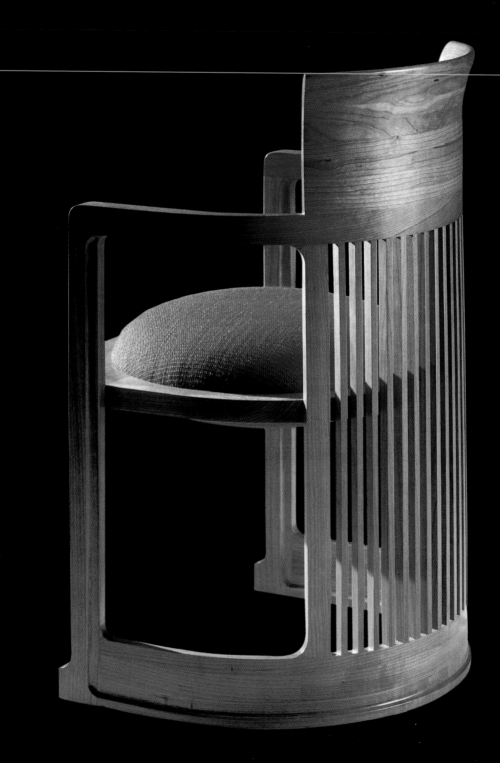

A Challenge to Convention

This decade was to see the birth, development and coexistence of numerous aesthetic movements that caused, commotion in the very foundation upon which art was based and appealed for new forms of expression and, as a consequence, a change in the mentality of society of the time. Cubism, Futurism, Postimpressionism, Abstract Art, Expressionism, Dadaism and Surrealism agitated Europe with continuous ruptures in the prevailing aesthetics and ideologies.

As far as design was concerned, two trends reached their point of eminence in these years: Viennese Succession and De Stijl, the Dutch movement.

"Art for its time and, for art, freedom," was the motto of the Viennese Succession movement that originated in Vienna around 1900 with the intention of doing away with the historicist tradition in design that dominated the creations of the end of the century. The style reached its highest degree of definition during this decade, with geometric lines and a stress placed on the importance of functionalism and the primacy of structure. Josef Hoffmann, Otto Wagner and Adolf Loos (with his radical criticism against ornamentation) are some of the designers who were associated with this movement. One of the creations that best illustrates this style is the Prague chair which was created in 1925 by Josef Hoffmann.

The De Stijl group, on the other hand, was founded in 1917 in Holland by the architect Theo van Doesburg. The artists who formed the group wished to create a universal style in painting, architecture and design which was to be based on pure abstraction and simplicity using squares and rectangles on flat surfaces of intense primary colors — combined with black, gray and white — and harmonized by the use of straight lines as a point of departure. Among the group's most important contributions to the iconography of twentieth century design are the geometric paintings of Piet Mondrian and Gerrit T. Rietveld's revolutionary furniture, such as the Red Blue Chair, which is essentially a three dimensional representation of one of Mondrian's paintings. The manifestations of this group were to have a great importance on the Bauhaus School which was founded in 1919 by Walter Gropius.

SEAT "F51", designed in 1920 by Walter Gropius. Produced by Tecta.

GERRIT THOMAS RIETVELD

1. CHAIR "ZIG-ZAG", 1934. Collection "Cassina I Maestri"■
Polished natural cherry structure■
⊟ 74 ⊟ 37 ⊟ 43 ⊟ 43 cm■
2. CHAIR "RED AND BLUE", 1918. Collection "Cassina I Maestri"■
Stained ash structure. Lacquered plywood seat and backrest■
⊟ 88 ⊟ 65,5 ⊟ 83 ⊟ 33 cm■
(Photo: M. Carrieri)■

1888 Utrecht, Holland-1964 Utrecht, Holland■

The year 1917 brought a change in architectural theories. This change came about because of a chair, Gerrit T. Rietveld's Red Blue Chair, which interpreted the theories of Neoplasticism and questioned the prevailing norms that dominated style and taste. Rietveld's incorporation of concepts from Neoplasticism into his furniture design inspired a reexamination of architectural and decorative thought that was to influence notably the aesthetic movements that were to follow■

In 1918, he joined the De Stijl group and made a decisive contribution to the evolution of the theory of Neoplasticism of which he became one of the most important representatives. The intention of the collective was to achieve a perfect equilibrium between humanity and society, and between society and nature, by means of the physical relationship that mankind has with its surroundings■

In each and every one of his pieces of furniture, Rietveld expresses a declaration of intentions and at the same time he clarifies the new concept of architectural space. Lines and surfaces meet each other at all angles without joints. The design elements create an abstract spatiality in which the use of color makes an essential contribution to the process of interpretation and perception of the tangible form in a conceptual extension that reveals a new evaluation of relationships. The result is the creation of a magical synthesis between the design of the article and the space itself■

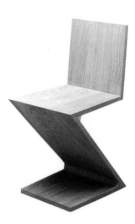

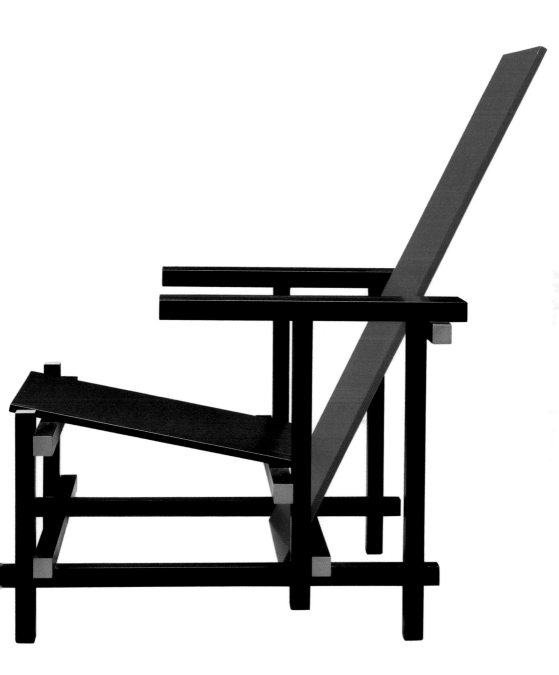

The Age of the Architects

The style initiated at the beginning of the century thrived during this decade: architects became the main innovators in furniture design and used the chair as a testing ground where they could experiment and develop their architectural ideas on a small scale. The development of new materials, especially steel tube and plywood, were to be fundamental in the evolution of the Decorative Arts■

The ideology established by the Bauhaus School stands out in these years. The influence of this school, the motor behind the Modern Movement, has lasted to this day. Founded in 1919 by Walter Gropius, and closed in 1933 by the Nazi Party, its members understood design to be a means to improve society and held a desire to manufacture furniture of a good quality and design which was to be available to the vast majority of the population■

As far as the aesthetic premises of the Bauhaus are concerned, the following stand out: the defense of function as being more important than form (from here comes the precept, "Form follows function"); geometry; simplicity; honesty; universality; standardization; economy and the application of new technologies. They intended to create a new domestic environment with the union of technology and craftsmanship by means of the conviction that a house and the utensils found inside should relate to each other in a sensitive way. Among the leaders of this group, as far as the design of chairs is concerned, Ludwing Mies van der Rohe and Marcel Breuer are notable. During the same period, Le Corbusier and Charlotte Perriand were experimenting in France with the possibilities that aluminum offered and opening the doors for some of the most outstanding furniture for seating of the twentieth century■

Another of the aesthetic movements that flourished in these years was Art Deco, named after the Exposition des Arts Décoratives et Industriels Modernes that took place in Paris in 1925 where the style was exhibited for the first time as a celebration of life in the modern world. The members of this movement proposed sensual and refined aesthetics that emphasized the use of exquisite craftsmanship and materials that were exotic and luxurious in nature. This style can be defined by the diversity of influences that produced it ranging from Art Nouveau, the aesthetics of the Bauhaus, cubism, the Russian Ballet, the culture of American Indians, Egyptian iconography, classical forms and nature■

Design by El Lissitzky, 1930. From Tecta. ⊢ 73 ⊟ 57 ⊢ 49 ⊟ 44 cm■

EILEEN GRAY

1. ARMCHAIR "BIBENDUM", 1929. By
Classicon▪
Chromed steel tube structure. Uphol-
stered in leather or fabric▪
⊟ 73 ⊟ 90 ⊟ 83 cm▪
2. STOOL "N°1", 1927. By Classicon▪
Chromed steel column, lacquered
aluminum base, seat upholstered in
leather▪
⊟ 70-85 ⊟ 38 cm▪
3. CHAIR "NON CONFORMIST", 1926.
By Classicon▪
Chromed steel tube structure. Seat
and backrest upholstered in leather▪
⊟ 78 ⊟ 57 ⊟ 63 ⊟ 45 cm▪
4. STOOL "#2". By Classicon▪
Steel structure and base. Seat uphol-
stered in leather▪
⊟ 73 ⊟ 30 ⊟ 39.5 cm▪
5. CHAIR "ROQUEBRUNE", 1932. By
Classicon▪
Chromed steel tube structure. Seat
and backrest in leather▪
⊟ 76,5 ⊟ 45 ⊟ 55 ⊟ 45 cm▪
6. CHAIR "AIXIA", 1926. By Classi-
con▪
Chromed steel tube structure, bub-
inga wood feet, and upholstered
seat▪
⊟ 83 ⊟ 40,2 ⊟ 52 ⊟ 48 cm▪

1878 Enniscorthy, Ireland-1976 Paris, France▪

Currently recognized as one of the most important figures of the Mod-
ern Movement in France, Eileen Gray entered the world of furniture
and interior design as a result of her study of the technique of lac-
quering. She came to dominate this technique to such an extent that
she became well known in the artistic circles of Paris at the beginning
of the century▪

 She developed an artistic vocabulary of her own that complemented
her nonconformist character and moved away from the curving lines of
Art Nouveau that dominated in France at the time and found a greater
sympathy with the rational geometric forms and simple lines as pro-
posed by the De Stijl group. Eileen Gray stood out for the original use

she made of materials and forms. She cultivated a sensitivity that al-
lowed her to express movability and flexibility in her designs. In these
years, she dedicated herself to the creation of furniture "adapted to
our existence, in proportion to our rooms and in harmony with our
aspirations and feelings," demonstrating her belief in the formation of
complete environments, in houses that she understood to be living
organisms▪

 Creations such as the Non Conformist chair, in which she established a
brilliant play of asymmetry, the Transat armchair, especially created for
the well-known villa E.1027, or the Bibendum armchair, with its revolu-
tionary, chromed, steel, tube structure have situated her among the names
of the "sacred" of the twentieth century. Between the '40s and '70s, her
work fell into complete obscurity and her contribution to the modern
way of life was not rediscovered until a few years before her death▪

MIES VAN DER ROHE

1. CHAIR "D 42", 1927. By Tecta■
Chromed steel tube structure. Seat
and backrest in wickerwork made by
Lilly Reich■
☐ 79 ☐ 48 ☐ 74 ☐ 44 cm■
2. Cantilevered chair of 1927. Distrib-
uted by Alivar (Collection "Museum")■
Curved steel tube structure. Seat and
backrest in leather■
☐ 79 ☐ 47 ☐ 69 cm■
3. CHAIR "BARCELONA", 1929. Distrib-
uted by Alivar (Collection "Museum")■
Steel tube structure in the form of an
X inspired by classical design. The
design of the leather upholstery is
attributed to Llily Reich. Designed
for the German Pavilion of the Uni-
versal Exhibition of Barcelona■
☐ 75 ☐ 75 ☐ 75 cm■
4. CHAIR "BRNO", 1930. Distributed
by Alivar (Collection "Museum")■
Polished flat steel structure. Seat
and backrest upholstered in leather■
☐ 76 ☐ 58 ☐ 57 cm■

1886 Aachen, Germany-1969 Chicago, Illinois, USA■

According to Mies van der Rohe, considered to be the most repre-
sentative of minimalist architects of the twentieth century, "The
chair is a very difficult object. All of those who have tried at some
time to make one know this. Countless possibilities exist along with
many problems. A chair must be lightweight, it must be solid and it
must be comfortable. It is almost easier to build a skyscraper than
it is to make a good chair■"

Mies van der Rohe, who directed the Bauhaus School from 1930
to 1933, thought that architecture and furniture design were inti-
mately related: the problems, the principles and even the materials in-
cluded in the construction of a skyscraper can also be found in the de-
sign of a chair. To him, we owe two of the best-known maxims of the
twentieth century: "less is more" and "God is in the details." These
principles are not only found in the commencements of his architec-
tural projects, but in his furniture design as well. One of his most em-
blematic works is the German Pavilion in Barcelona that was con-
structed for the Universal Exhibition of 1929 and which is considered
by many critics to be the quintessence of spatial abstraction in archi-
tecture. The pavilion gave rise to the birth of the Barcelona chair, one
of the most famous of the century. Mies van der Rohe also investi-
gated the possibilities offered by the structure of cantilevered chairs,
inspired by the designs of Mart Stam. The creation in 1930 of the
Brno chair confirms this as it is the first truly functional chair of this
type with a steel structure■

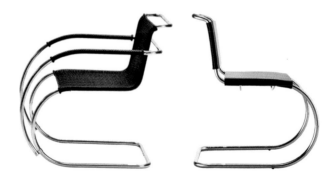

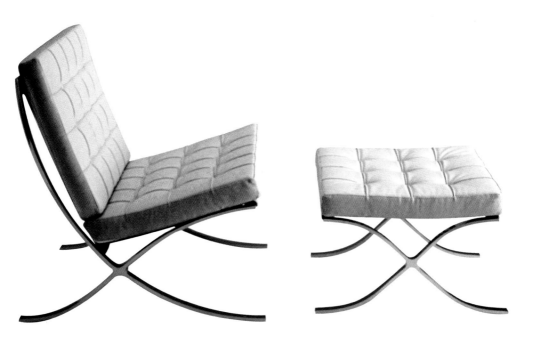

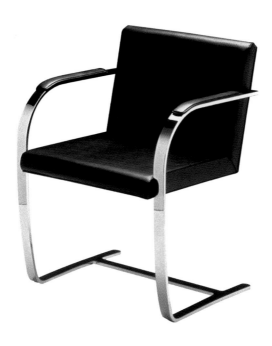

LE CORBUSIER

1 and 2. EASY CHAIR "LC1", 1928.
Collection "Cassina I Maestri"■
Designed by Le Corbusier in collabora-
tion with Pierre Jeanneret and Char-
lotte Perriand. Chromed steel struc-
ture with leather seat and backrest■
⊟ 64 ⊟ 69 ⊟ 65 ⊟ 40 cm■
3. EASY CHAIR "LC7", 1928. Collec-
tion "Cassina I Maestri"■
Designed by Le Corbusier in collab-
oration with Pierre Jeanneret and
Charlotte Perriand. Swivel armchair
with chromed or painted steel struc-
ture in various colors. Seat and
backrest in leather or fabric■
⊟ 73 ⊟ 60 ⊟ 58 ⊟ 50 cm■
4. EASY CHAIR "LC2", 1928. Collec-
tion "Cassina I Maestri"■
Designed by Le Corbusier in collabo-
ration with Pierre Jeanneret and
Charlotte Perriand. Easy chair with
chromed or painted steel structure
available in various colors. Seat and
backrest in leather or fabric■
⊟ 67 ⊟ 76 ⊟ 70 ⊟ 43 cm■

1887 La Chaux de Fonds, Switzerland-1965 Cap Martin, France■

Charles Edouard Jeanneret, who adopted the artistic name of Le Cor-
busier in 1920, is internationally recognized as one of the most influ-
ential architects of the twentieth century. He presented provocative
ideas, created revolutionary designs and demonstrated a strong, and
also utopian, sense of the function of architecture. He felt that archi-
tecture should adapt itself to the needs of a democratic society dom-
inated by machinery and proposed a vision of the city as an architec-
tural whole■

His idea of a house is that of "a machine for living", an industrial
product that should include functional furniture. In this spirit, Le Cor-
busier designed, in collaboration with Pierre Jeanneret and Charlotte

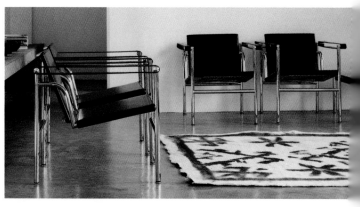

Perriand, a series of pieces of furniture based on tubular steel that pro-
jected new rational aesthetics. This furniture was created as instru-
ments that should function harmoniously with spaces designed by and
for the modern man■

His chairs responded to nothing more than the objective of being
the expression of their function. As a consequence, their basic compo-
nents were organized around a metallic tube structure of the sim-
plest form possible. Le Corbusier held the belief that any object of dai-
ly use should express the binomial form/function. In this way, the
liberated object would show its innate beauty and natural essence by
means of the simplicity and basic nature of its form. Maybe, it is for
this reason that his chairs continue to be surprisingly contemporary
more than seventy years after their creation■

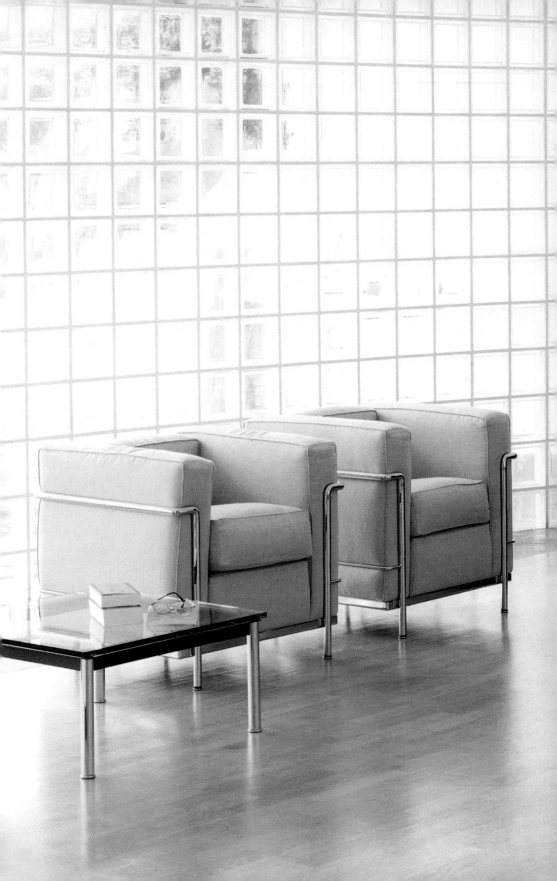

MARCEL BREUER

1902 Pecs, Hungry-1981 New York, USA■

1. CHAIR "LAJKO". By Ultramobile■
Cantilevered chair with chromed steel structure. Upholstered seat and backrest■
⊟ 91 ⊟ 59 ⊟ 61 ⊟ 47 cm■

2. EASY CHAIR "S35R" with stool, 1929. By Thonet■
Chromed steel tube structure. Wickerwork seat and backrest■
⊟ 84 ⊟ 65 ⊟ 83 cm■

3 and 5. CHAIR "D4", 1927. By Tecta■
Steel tube structure. Fabric seat and backrest■
⊟ 71 ⊟ 78 ⊟ 61 ⊟ 45 cm■

4 and 7. CHAIR "CESCA", 1929-30 (artistic copyright Mart Stam). Produced by Thonet; Knoll■
Cantilevered chromed steel tube base, seat and backrest wickerwork over wooden frames■
Upholstered version■
With arms: ⊟ 81 ⊟ 58 ⊟ 61 cm■
Without arms: ⊟ 81 ⊟ 46 ⊟ 58 cm■

6. Chaise-longues on wheels, 1928–30. By Tecta■
Chromed or painted steel structure. Wickerwork seat and backrest■
⊟ 63 ⊟ 61 ⊟ 186 ⊟ 30 cm■

8. CHAIR "D40", 1928. By Tecta■
Cantilevered chair with chromed steel tube structure. Wickerwork seat and backrest. Arms in ash■
⊟ 88 ⊟ 53 ⊟ 61 ⊟ 45 cm■

9. CHAIR "WASSILY", 1925. Reproduction by Galvano Técnica■
Breuer was inspired by the handlebars of bicycles in the creation of this chair, that represent a true innovation. Chromed steel tube structure. Leather seat and backrest■
⊟ 75 ⊟ 78 ⊟ 70 cm■

Although Marcel Breuer held considerable prestige as an architect, recognized as being one of the last truly functional architects, it was his work as a furniture designer that established him as one of the greatest influences of the twentieth century■

Stimulated by the ideology of the Bauhaus School, where he was a student and teacher between 1920 and 1928, Breuer experimented with the application of new production methods to the traditional problems of design. According to him, "A piece of furniture is not an arbitrary composition, it is a necessary component of our surroundings. In itself impersonal, it becomes meaningful only as a result of the way in which it is used or how it forms part of a complete scheme■"

His outstanding chair designs, based on a tubular steel structure (such as the innovative Wassily chair created in 1925 and inspired by the handlebars of a bicycle), and his overhanging chairs — with which Mart Stam (holder of the patent) and Mies van der Rohe had experimented – are have exerted a great influence in the development of the chair and marked a turning point in the history of design. At their time, these designs presented numerous inherent advantages to the ideology of the Modern Movement: obtainable by the masses, hygienic, lightweight, technologically new, non-traditional, flexibile and extremely simple in form. In 1935, forced by the Nazis, he emigrated to London where he started to work with the possibilities presented by plywood which enabled him to develop creations that have also come to form part of the history of design■

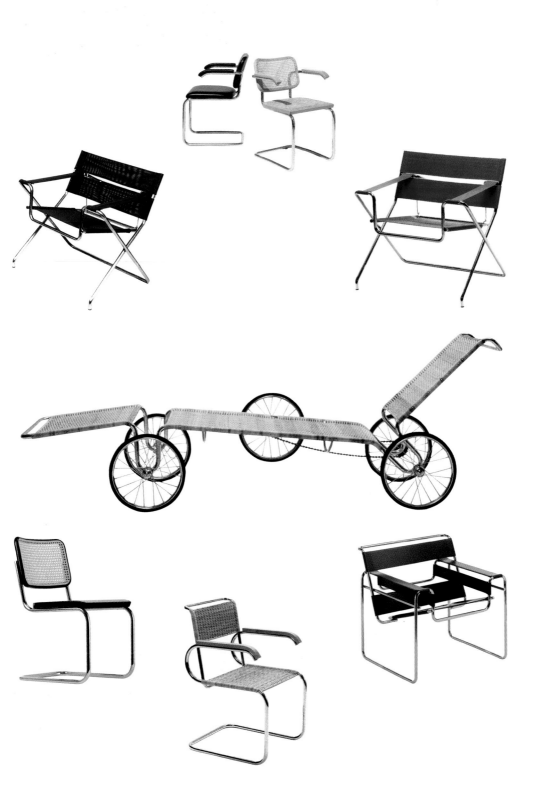

The Triumph of Organic Design

In the '30s, while Art Deco and Bauhaus Functionalism were still expanding their areas of influence in Europe and the United States, a new sensitivity — developed by a group of Scandinavian designers and architects who challenged the severe and impersonal forms of the Modern Movement and substituted them for others that were softer, drawing special attention to natural materials and organic forms — came into being.

The most influential name within this aesthetic trend, known as Organic Scandinavian Design, is that of the Finnish architect and designer Alvar Aalto. Not only was Alvar Aalto one of the most important promoters of the use of plywood in the manufacture of furniture, but he was also widely recognized for his designs based on the idea of adapting the chair to the human body.

The delicate union between functionalism and sensitivity is the main characteristic that identifies Scandinavian design. The tendency of placing man's necessities before questions of style, the use of natural materials (especially wood in light tones), simplicity, practicality and authenticity in their estimations and forms; in a sense, a more "agreeable" version of the Modern Movement which added a more human and warmer element to the design of furniture and everyday objects and played an important role in the evolution of modern design.

Following in the footsteps of Scandinavian design, and especially that of Alvar Aalto, Charles and Ray Eames worked in the United States with new techniques for molding plywood. They primarily used methods that had been developed for the North American Navy during World War II and which implied a before and after in the history of North American design. Along with Eero Saarinen, with whom Charles Eames collaborated on numerous projects, and George Nelson, they established the basis for a language that was to become genuinely North American. In this way, using the work of these great creators as a starting point, and once the war had ended, North American designers started to create a style of their own in which they distanced themselves from the enormous influence Europe had exerted up until that time. These years saw the beginning of the world supremacy of the "American way of life." On the other hand, the leading representatives of European Functionalism had emigrated to the United States and were participating in the birth of the International Style that was to degenerate into a form of design driven by economic and commercial motives.

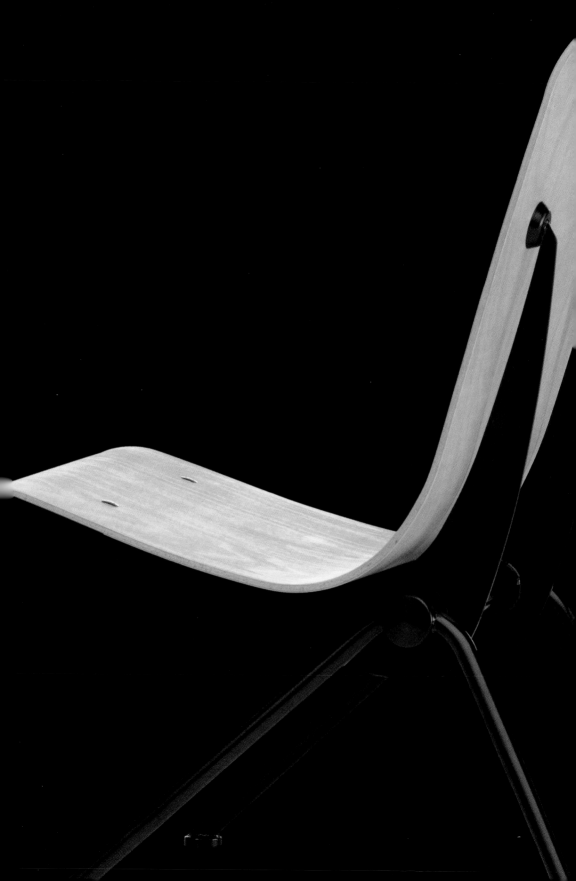

Previous page:
CHAIR "ANTONY" by Jean Prouvé, French architect and designer whose designs have had a great influence on furniture design. Steel tube base lacquered in black and seat body in plywood. Produced by Vitra. (Photo: H. Hansen)■

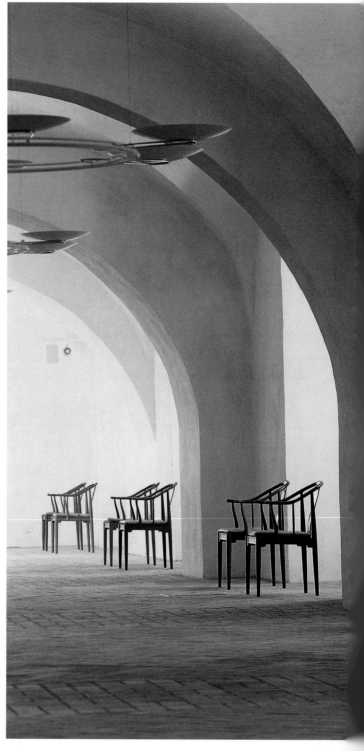

1. "THE CHINA CHAIR", 1944. Created by Hans J. Wegner, from Denmark, one of the leading figures in organic design of the twentieth century. Produced by Fritz Hansen■
Manufactured in cherry or mahogany■
⊟ 82 ⊟ 55 ⊟ 55 ⊟ 45 cm■
2. CHAIR "TORRES CLAVÉ", 1934. Created by the architect Josep Torres Clavé, who was inspired by popular models from the island of Ibiza. Produced by Mobles 114■
Structure in cedar and seat and backrest in woven anea■
⊟ 75 ⊟ 70 ⊟ 78 cm■
3. "THE CHURCH CHAIR", 1936. Created by Kaare Klint, forerunner of the distinguishing trait of Danish design which had been converted into a style of international reference by mid century. Produced by Fritz Hansen■
Manufactured in oak■
⊟ 84 ⊟ 52 ⊟ 50 ⊟ 43 cm■

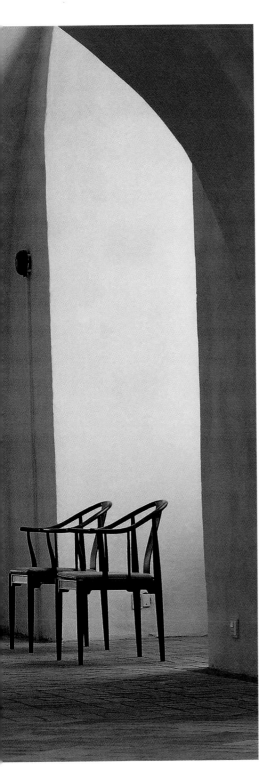

1. CHAIR "STANDARD", 1934–50. By Jean Prouvé. Produced by Vitra■
Steel plate and rounded steel tube base. Seat and backrest in natural or lacquered ash■

2. CHAIR "SE 68", 1950. Design by Egon Eiermann, for Wilde+Spieth■
This model is a classic of German design■

3. CHAIR "RISOM", 1941. Design by Jens Risom. Forms part of the first collection produced by Knoll. Characteristic of Scandinavian design■

4. THE AX CHAIR, 1950. Created by Hvidt & Mølgaard. Produced by Fritz Hansen■

5 and 7. CHAIR "SANT' ELIA" (1936) and "FOLLIA" (1934), by Giuseppe Terragni for Zanotta■

6. CHAIR "NAVY", 1944. By Emeco■
Icon of North American design, its manufacture was started for the U.S. Navy. Structure in one piece of aluminum■
⊟ 86 ⊟ 41 ⊟ 50 ⊟ 46 cm■

8. STOOL SATISH, 1931. Design by Eckart Muthesius, produced by Classicon■
Stainless steel structure and seat upholstered in leather■

9. CHAIR "565", 1943. Designed by Gerald Summers. Produced by Alivar (Collection "Museum")■
Manufactured in only one piece of molded plywood■

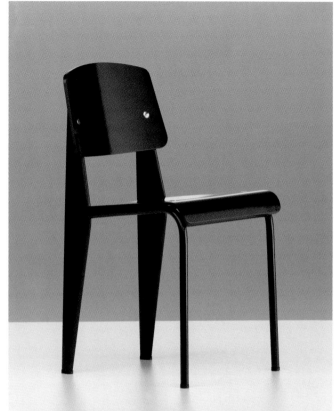

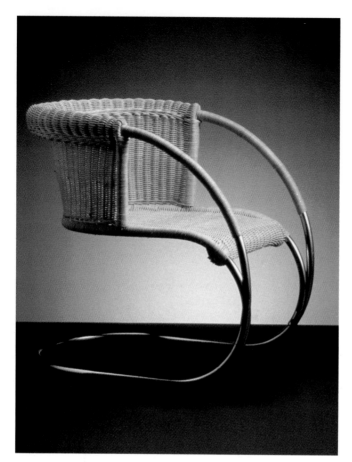

1. Chair designed by Mogens Lassen for Fritz Hansen∎
Steel tube cantilevered structure. Seat and backrest in wickerwork∎
2. "THE WISHBONE CHAIR", 1950. Design by Hans J. Wegner for Carl Hansen∎
Ash, beech or oak structure. Woven cord seat∎
⊟ 70 ⊟ 74 ⊟ 52 ⊟ 44 cm∎
3. CHAIR "SE 42", 1949. Designed by Egon Eiermann. Produced by Wilde+Spieth∎

1. CHAIR "SE 68", 1950. Design from Egon Eiermann, for Wilde+Spieth■
2 and 4. Chairs from the program "S 43", 1931. Created by Mart Stam. Produced by Thonet■
Cantilevered chair with steel structure. Seat and backrest in molded beech plywood■
⊟ 82 ⊟ 44 ⊟ 53 cm■
3. EASY CHAIR "GENNI", 1935. Design from Gabriele de Mucchi. Produced by Zanotta■
Chromed steel tube structure. Twin position backrest. Seat and backrest upholstered in leather■
⊟ 73/82 ⊟ 57 ⊟ 109 ⊟ 41 cm■
5. EASY CHAIR "MAGGIOLINA", 1947. Design from Marco Zanuso. Produced by Zanotta■
Steel tube structure and leather body. Cushioned seat and backrest■
⊟ 83 ⊟ 71 ⊟ 102 ⊟ 40 cm■
6. EASY CHAIR "CITÉ", 1930. Design from Jean Prouvé. Reissue by Vitra■
Lacquered steel plate structure. Seat and backrest upholstered in one piece. Armrests in leather bands. (Photo: H. Hansen)■
7. STOOL "BANU", 1931. Design from Eckart Muthesius. Produced by Classicon■
Steel structure. Seat upholstered in leather■

ALVAR AALTO

1. CHAIR "66", 1933–35. Produced by Artek■
Natural birch structure. Various options in seat (varnished birch, upholstered, linoleum or laminated)■
⊟ 78 ⊟ 39 ⊟ 42 ⊟ 44 cm■
2. CHAIR "611", 1929. Produced by Artek■
Natural or stain birch structure. Stackable■
⊟ 80 ⊟ 48,5 ⊟ 49 ⊟ 45 cm■
3. KITCHEN STOOLS "64" AND "K65", 1933-35. Produced by Artek■
Birch structure. The seat is presented in various options. Dimensions:
"64":⊟ 65 ⊟ 52 ⊟ 52 cm■
"K65":⊟ 70 ⊟ 38 ⊟ 40 ⊟ 60 cm■
4. EASY CHAIR "42", 1931-32. Produced by Artek■
Birch structure. Seat molded in birch plywood lacquered in black or white■
⊟ 72 ⊟ 60 ⊟ 75 ⊟ 36 cm■

1898 Kuortane, Finland-1976 Helsinki, Finland■

To this great Finnish architect and designer, contemporary design owes a great debt for the technical solutions that he devised for the molding of wood, in addition to his singular interpretation of the Modern Movement to which he added warmth and humanist ideals. He transformed strict geometry into organic forms and demonstrated a special sensitivity for the physical and psychological welfare of the users (his motive for only working with natural materials, essentially wood)■

He started experimenting with molding wood at the end of the '20s in collaboration with his wife, the designer Aino Marsio. Together they created what can be considered formally and technically revolutionary chairs which they conceived of as a natural extension of their architec-

tural projects. One of their greatest contributions was to solve the problem of connecting the vertical and horizontal elements. This was achieved by the creation of molded wooden legs that could be directly incorporated into the interior part of the seat without the necessity of additional frames or supports. These designs led to the acceptance of plywood as a material of the avant-garde and situated Alvar Aalto in the position of being one of the most outstanding designers of the century. The success of this furniture, which was intended to be modern, humane and specifically Finnish, led to the founding of the Artek company, which has continued to produce these pieces to the present day■

The exhibition of his work that was organized in 1998 by the Museum of Modern Art in New York eloquently showed the prestige that Alvar Aalto enjoyed among his peers■

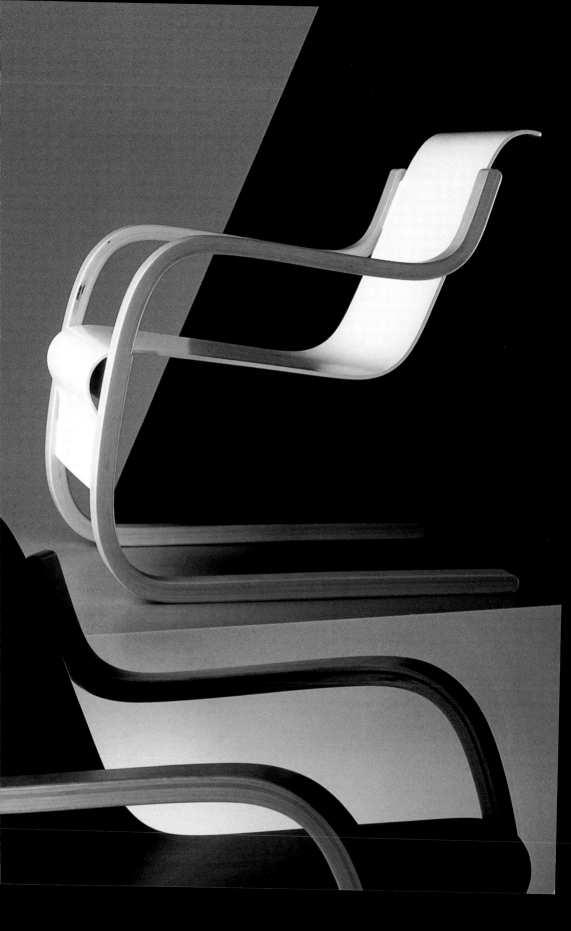

1. CHAIR "63", 1933–35. Produced by Artek∎
Birch structure. Seat and backrest upholstered in fabric or leather∎
⊟ 79 ⊟ 46 ⊟ 48 ⊟ 44 cm∎

2. EASY CHAIR "406", 1938–39. Produced by Artek∎
Birch structure. Seat in canvas or leather webbing∎
⊟ 87 ⊟ 60 ⊟ 72 ⊟ 41 cm∎

3. "THE PAIMIO CHAIR", 1931–32. Produced by Artek∎
This is one of Aalto's most emblematic designs, created for the Sanatorio Paimio. Birch structure. Seat of curved birch plywood lacquered in black or white∎
⊟ 64 ⊟ 60 ⊟ 80 ⊟ 33 cm∎

4. CHAIR "611", 1929. Produced by Artek∎
Natural or stained birch structure. Stackable∎
⊟ 80 ⊟ 48.5 ⊟ 49 ⊟ 45 cm∎

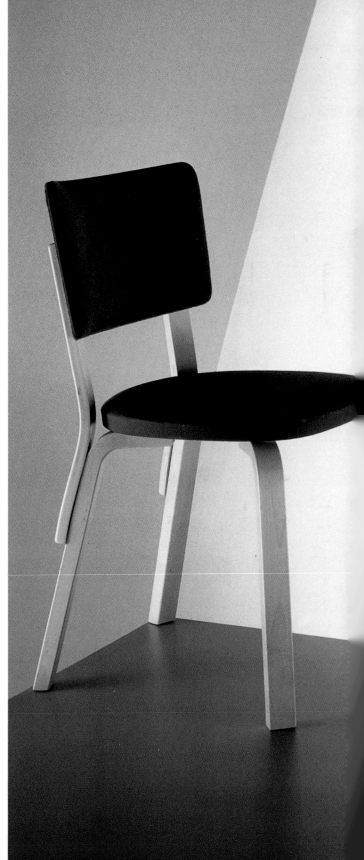

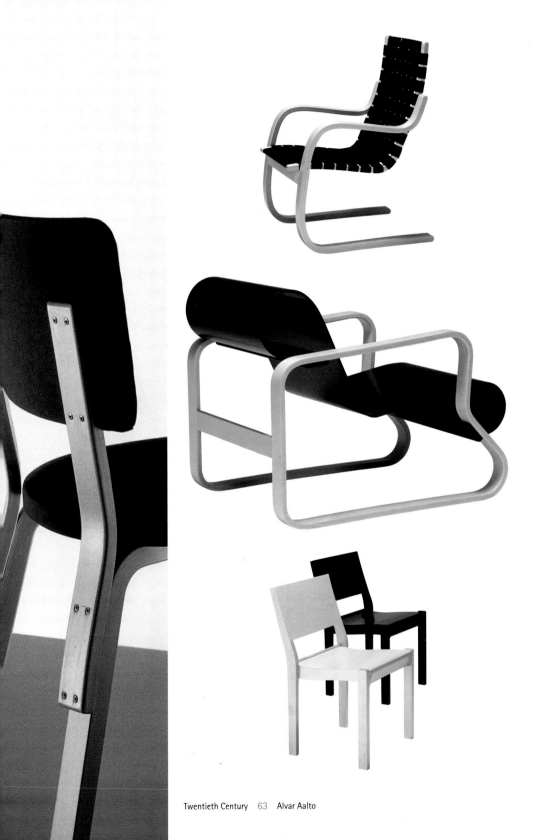

CHARLES & RAY EAMES

1. "ALUMINUM CHAIR", produced by Vitra■
Lateral profiles, footrest, armrests and lower framework in polished or chromed aluminum cast under pressure. Various options on seat and backrest available■
2. CHAIR "DCW" (Dining Chair Wood), 1946. Produced by Vitra■
Curved laminated structure in natural ash■
3. CHAIR "PLASTIC CHAIR" (1948). From Vitra■
Re-issue of the legendary chair with fiberglass body (now substituted by polypropylene). Base steel wire framework■
4. "WIRE CHAIR", 1953. Reedited by Vitra■
Welded steel wire body with cushions. Eiffel Tower lower framework in steel wire and four tubular steel legs■
5. CHAISE LONGUE "LA CHAISE", 1948. Re-edition by Vitra■
Chromed tubular steel base. Seat consisting of two fiberglass form glued together and painted white. Crossed oak legs■
6. "LOUNGE CHAIR", 1956. Produced by Vitra■
Structure consisting of three forms in cherry three-ply, with a natural or lacquered in black finish, and leather padding■

1907 Missouri, USA-1978 Missouri, USA (Charles Eames)■
1912 California, USA-1988 Missouri, USA (Ray Eames)■

Charles Eames is considered by man, as designer par excellence of the twentieth century. In 1941, his marriage to Ray Kaiser created a unique consonance which was not only to give rise to the creation of chairs that have become design symbols, but also to other contributions that would form an integral part of the modernization of the United States after World War II■

They used their experience with molding laminated wood, acquired during the wa,r to produce, by means of techniques invented by themselves, low-cost chairs with organic forms that were comfortable to sit on and that were suitable for mass production. Their revolutionary

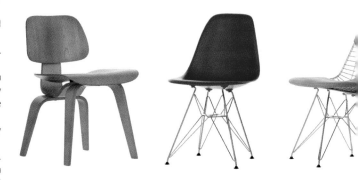

work with plywood led them to experiment with other materials: glass reinforced plastic chair bodies (in 1948, they created the first industrially produced plastic chair), chairs manufactured with a welded curved metallic mesh, as well as others in molded aluminum■

All of their creations were based on the desire to make a better world in which design would be at the service of life and in which objects would serve to satisfy the practical necessities of the greatest number of people possible. As relevant examples of modern designers, Charles and Ray Eames demonstrated how good design could improve the quality of life along with human comprehension and knowledge. As far as they were concerned, a design could only be considered successful if it identified the intertwined necessities of the client, society, and the designer■

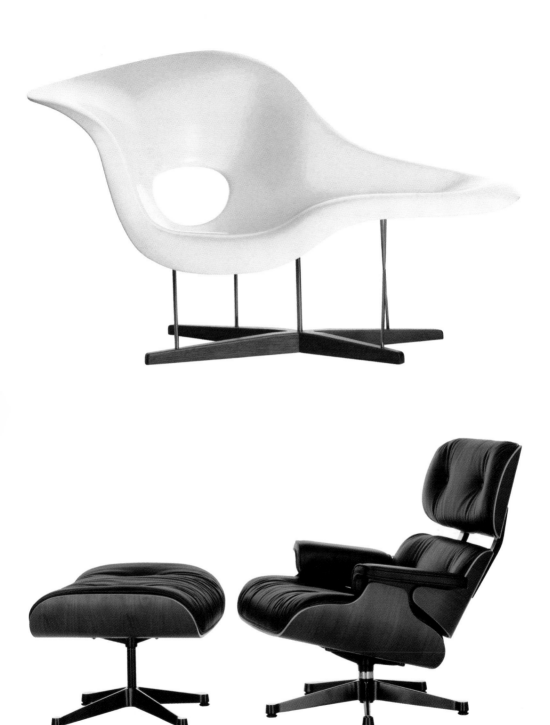

EERO SAARINEN

1, 5, 6 and 7. "EXECUTIVE SIDE CHAIR", 1957. Produced by Knoll▪ This chair became a classic upon its introduction and established new standards in modern chair design. It is also considered to be one of the most important creations of this Finnish Designer▪

2 and 4. CHAIR "TULIP", 1956. Produced by Knoll▪ Aluminum base and molded glass reinforce plastic body. Available with or without upholstered seat. Winner of the Museum of Modern Art, New York prize in 1969▪

3. "WOMB CHAIR", 1948. Produced by Knoll▪ Steel bar base finished in chrome or black paint. Upholstery over glass reinforced plastic body with occasional cushions▪

1910 Kirkkonummi, Finland-1961 Michigan, USA▪

Son of Eliel Saarinen, a well-known Finnish architect, Eero Saarinen's passion for sculpture marked his career as an architect and furniture designer. In fact, he referred to himself as a "maker of forms" and all his designs possess a strong sculptural quality▪

In 1923, the entire family moved to the United States where Eero Saarinen became one of the most creative and successful architects of the postwar period. His furniture designing side was closely connected to Charles Eames, with whom he collaborated on the development of various projects for chairs and whose partnership culminated in their being awarded first prize in the exhibition "Organic Design for the Decoration of Interiors" that was or-

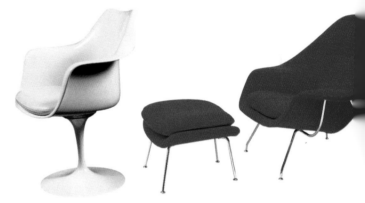

ganized by the Museum of Modern Art in New York in 1940. They shared a passion for ergonomics and an inclination toward the use of new materials such as plywood and plastics▪

At the beginning of the '50s, while the majority of designers continued designing legs as a structure separate from the form of the seat, Saarinen worked on the idea of completely rethinking the concept of a chair and distanced himself from the "chaos of legs that dominated modern interiors." He found the solution in a chair that resembled a high-stemmed wineglass: the famous Tulip Chair which, in addition to giving a sensation of lightness, displays an ingenious structure formed by three integrated elements, the body, the stem or pedestal, and the unifying shaft. the chair is a "sculpture" that reflects his desire to distance himself from preconceived ideas▪

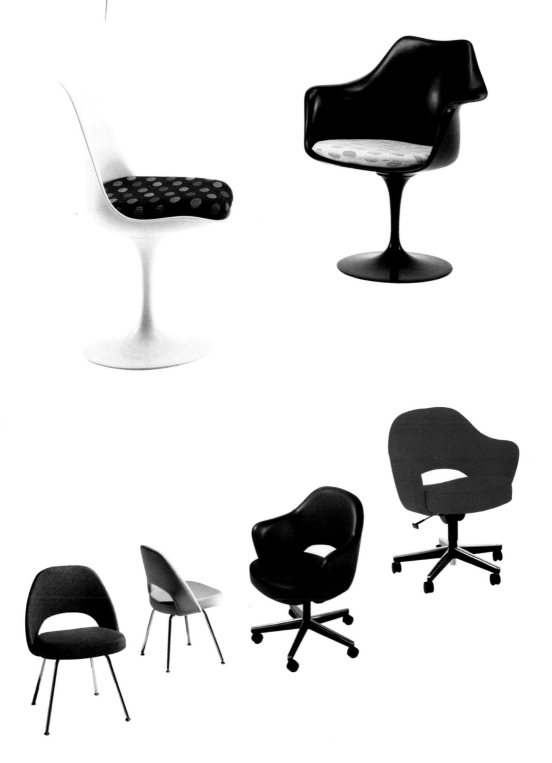

The Amusement Begins

These years were characterized by frenetic activity in all fields, stimulated by economic growth and the expeditious evolution of technology that revolutionized the field of furniture design. The new materials, especially plastics and polypropylene, permitted form to be given to any idea.

The '50s started with no great novelties. This was due to the prevalence of the established aesthetics of the Modern Movement, with its clean and functional lines, despite the fact that the majority of designs had lost their original ideological base in favor of economic considerations stimulated by the flourishing consumerism of the middle class. As a reaction to this kind of cold, soulless furniture, other types of aesthetic manifestations that proposed an authentic renovation came into being: from the warm and craft-based forms of Scandinavian design, with designers such as Arne Jacobsen and Poul Kjaerholm, to the explosion of Pop Art, an artistic movement that injected vigor into the panorama of the Decorative Arts.

In furniture design, Pop aesthetics intended to reflect the freshness and irony of popular culture by means of a palette of intense colors and the use of new materials, especially versatile plastics, converted itself into a symbol of the economic growth of the '60s. The notions of tradition and longevity were challenged and playful throwaway furniture was produced with designs that came from the very aesthetic of comic books. For the first time in history, frivolity, banality, vulgarity, imagination and the most scandalous obsolescence came to form part of interiors with forms, materials and colors that would have been unimaginable until then. At the same time, the arrival of man on the moon inspired a futuristic style of iconography (even today, much of the furniture designed at that time appears to be more avant-garde than that which followed).

Italy started to place itself in a leading position in the field of furniture design during these years. Names such as Gio Ponti, founder of the magazine *Domus*, the Castiglioni brothers, or Joe Colombo, with his zeal to create the domestic environment of the future, are found among the most influential designers.

On the other hand, ergonomics began to acquire legitimacy with the beginning of investigations into the design of a form of office furniture that would improve working conditions.

Previous page:
CHAIR "3107", 1955. Designed by
Arne Jacobsen for Fritz Hansen∎
Steel tube base and body in lami-
nated wood. Stackable∎
⊟ 78 ⊟ 50 ⊟ 52 ⊟ 44 cm∎

1. "THE TULIP CHAIR", 1960, by
Poul Kjaerholm for Fritz Hansen∎
Stainless-steel base and seat uphol-
stered in leather∎
2. SOFA "MARSHMALLOW", 1956. De-
signed by George Nelson. Reissued
by Vitra∎
Composed of eighteen round vinyl
cushions fixed to black rectangular
cross-sectioned crossbeams. Ex-
tendible according to user needs∎
3. EASY CHAIR "PK 20", 1967. De-
sign from Poul Kjaerholm for Fritz
Hansen∎
Cantilevered steel base. Seat uphol-
stered in leather and backrest avail-
able in two different heights∎
⊟ 73/89 ⊟ 76 ⊟ 80 cm∎
4. EASY CHAIR "PK22", 1956. Design
from Poul Kjaerholm for Fritz Hansen∎
Steel base and seat in wickerwork or
upholstered in leather∎
⊟ 71 ⊟ 63 ⊟ 63 ⊟ 38 cm∎
5. CHAIR "699" or "SUPERLEGGERA",
1957. Designed by Gio Ponti for
Cassina∎
Ash structure and seat in Indian
wickerwork. Its principal character-
istic is its robustness and lightness
(it can be lifted by a child using just
one figure)∎
(Photo: Andrea Zani)∎
6. "EASY CHAIR", 1951. Design from
Hans J. Wegner for Carl Hansen∎
Solid oak structure. Seat and back-
rest in woven leather∎
⊟ 73 ⊟ 73 ⊟ 35 cm∎

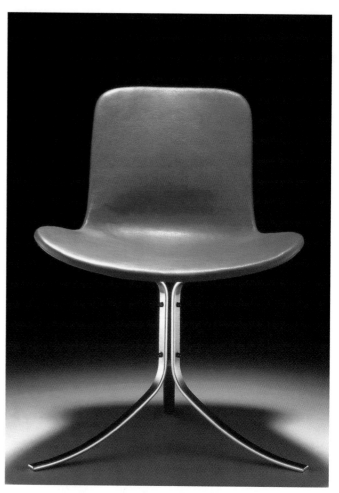

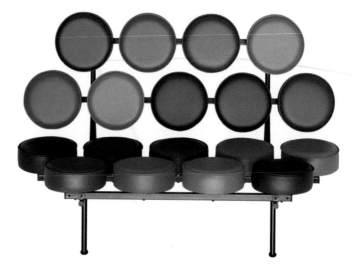

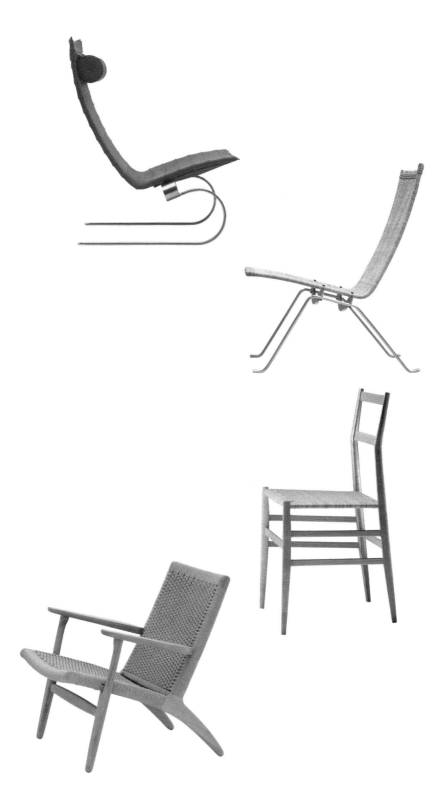

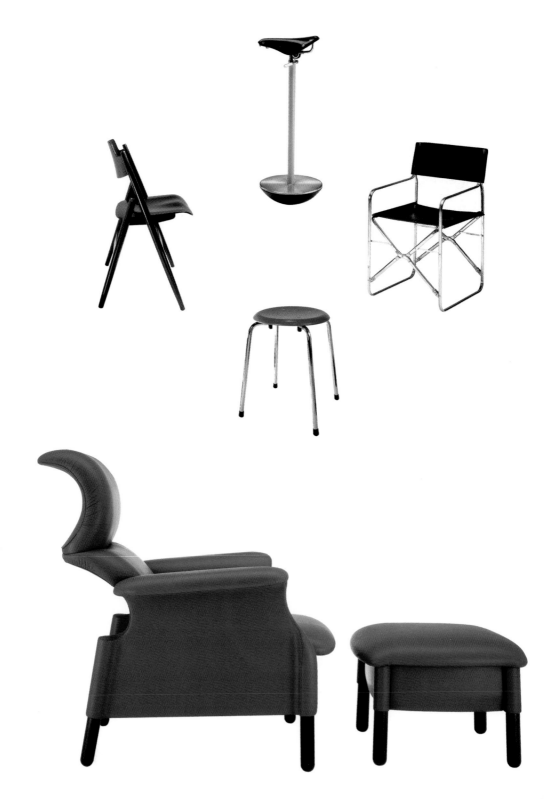

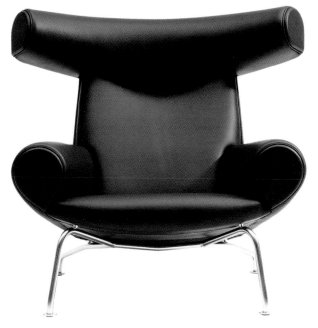

1. "Sella", 1957. Design from A. and P. G. Castiglioni for Zanotta∎ Iron base, steel column painted pink and bicycle saddle∎
⊢ 71 ⊢ 33 cm∎

2. Chair "SE 18", 1952. Design from Egon Eiermann for Wilde+Spieth∎ A classic in folding chairs. It received the "Good Design" prize in 1953∎

3. Stool "S 38", conceived in 1950 by Egon Eiermann. Produced by Wilde+Spieth∎

4. Chair "April", 1964. Design from Gae Aulenti for Zanotta∎ Folding chair for interiors and boats, with stainless-steel structure. Removable seat and backrest in fabric or leather∎
⊢ 86 ⊢ 51 ⊢ 55 ⊣ 46 cm∎

5. Easy chair "San Luca", 1961/1990. Design from A. and P. G. Castiglioni. Produced by Bernini∎ Wooden base and upholstered in leather∎
⊢ 100 ⊢ 87 ⊢ 96 cm∎

6. Easy chair "Barceloneta", 1953. Design from F. Correa and A. Milà. Issued by Santa & Cole∎ Beech structure and seat in canvas or leather. Created as an ironic homage to Mies van der Rohe's Barcelona chair∎
⊢ 89 ⊢ 56 ⊢ 72 cm∎

7. Easy chair "Ox Chair", 1960. Design from Hans J. Wegner for Erik Jørgensen∎ Chromed steel base and seat upholstered in ox hide. The chair evokes the strength of a bull∎
⊢ 90 ⊢ 99 ⊢ 99 ⊣ 36 cm∎

1. "THE SHELL CHAIR", 1963. Design from Hans J. Wegner. Produced by Carl Hansen▪
Structure available in painted beech or in natural sycamore▪
⊟ 74 ⊟ 92 ⊟ 81 ⊟ 38 cm▪

2. CHAIR "CUBIST", 1967. Designed by Vladimir Kagan. Collection "Kagan New York"▪
Structure available in sycamore or walnut. Upholstered seat and backrest▪

3. STOOL "ALLUNAGGIO", 1965. Design from A. and P. G. Castiglioni for Zanotta▪
Steel legs, aluminum alloy seat and natural polyethylene feet. Suitable for outside▪
⊟ 42.5 ⊟ 152 cm▪

4. EASY CHAIR "BLOW", 1967. Designed by De Pas, D'Urbino and Lomazzi, for Zanotta▪
Inflatable PVC easy chair that has become a symbol of '60s design▪

5. EASY CHAIR "SACCO", 1968. Design from Gatti, Paolini and Teodoro for Zanotta▪
Anatomical easy chair which adapts to body posture. Fabric or leather cover and interior composed of highly resistant expanded polystyrene balls▪
⊟ 68 ⊟ 80 ⊟ 80 cm▪

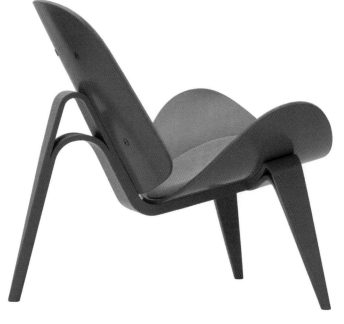

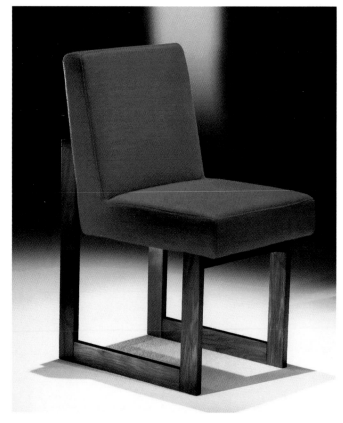

1. CHAIR "4875", Designed by Carlo Bartoli. Produced by Kartell (Collection "Classical Seats").
Polypropylene structure.
⊢ 71 ⊢ 44 ⊢ 48 ⊣ 43 cm.

2. CHAIR "UNIVERSALE", 1965. Designed by Joe Colombo. Produced by Kartell.
Polypropylene structure. The first chair molded from one material. Stackable.
⊢ 71 ⊢ 42 ⊢ 50 ⊣ 43 cm.

3. CHAIR "PK 25", 1951. Design from Poul Kjaerholm. Produced by Fritz Hansen.
Steel structure. Produced for the final exam of the Copenhagen School of Arts & Crafts.
⊢ 75 ⊢ 69 ⊢ 73 cm.

4. CHAIR FROM THE "LOUNGE COLLECTION", 1966. Design from Warren Platner for Knoll.
Produced with hundreds of curved wires.

5 and 9. "THE SPANISH CHAIR", 1958. Design from Børge Mogensen for Fredericia Furniture.
Oak structure and seat and backrest in natural leather. Inspired by the chairs used by Spanish naval commanders.

6. CHAIR "SBG 197", 1950. Design from Egon Eiermann for Wilde+Spieth.
Incorporates the "Brussels" feet designed for the Universal Exhibition of Brussels in 1958.

7. STOOL "BIRILLO", 1970. Design from Joe Colombo. Produced by Zanotta.
Stainless steel column, fiberglass base and upholstered swivel seat and backrest.
⊢ 107 ⊢ 47 ⊢ 52 ⊣ 77 cm.

8. CHAIR "3238", 1964. Design from Børge Mogensen for Fredericia Furniture.
Oak structure and seat and backrest in natural leather. Inspired by North American Shakers.

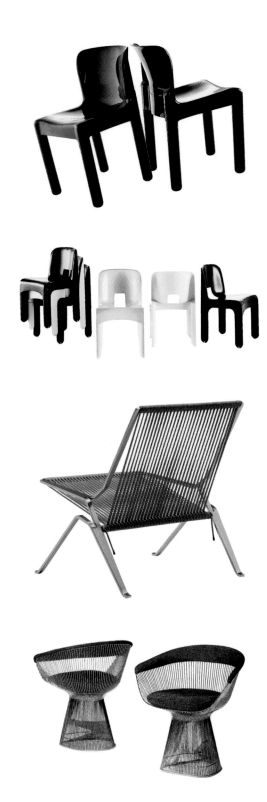

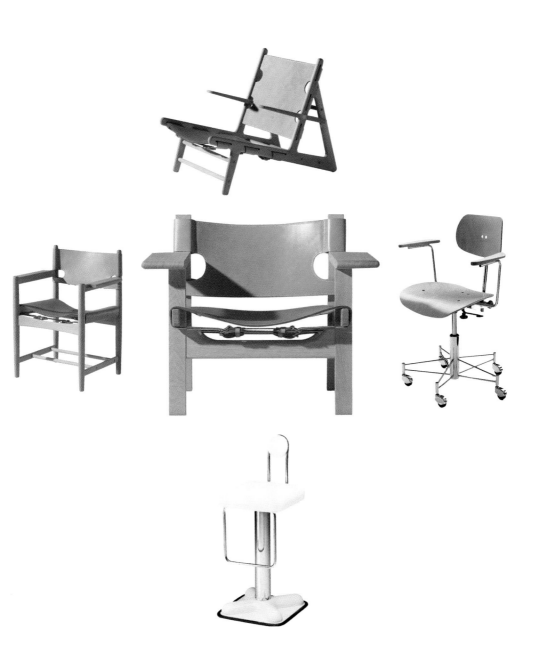

ARNE JACOBSEN

1 and 5. EASY CHAIR "SWAN", 1958. Produced by Fritz Hansen.
Aluminum base, seat upholstered in fabric or leather. Developed for the Royal Hotel of Copenhagen.
🗄 75 🗄 74 🗄 68 🗄 38 cm.
2. EASY CHAIR "THE EGG", 1958. Produced by Fritz Hansen.
Aluminum base, seat upholstered in leather. Developed for the Royal Hotel of Copenhagen.
🗄 107 🗄 86 🗄 79 cm.
3. CHAIR "THE TONGUE", 1955. Produced by Fritz Hansen.
Steel tube legs and seat in plywood.
🗄 79 🗄 43 🗄 49 🗄 44 cm.
4. CHAIR "THE ANT", 1952. Produced by Fritz Hansen.
Steel tube legs and seat in plywood. Stackable.
🗄 77 🗄 48 🗄 48 🗄 44 cm.
6. EASY CHAIR "3300", 1956. Produced by Fritz Hansen.
Steel tube structure. Seat and backrest upholstered in leather.
🗄 72 🗄 73 🗄 79 🗄 36 cm.
7. CHAIR "OXFORD", 1965. Produced by Fritz Hansen.
A great variety of options including finishes and different heights for the backrests are available. Originally designed for St. Catherine's College, Oxford.

1902 Copenhagen, Denmark-1971 Copenhagen, Denmark.

Aarne Jacobson was one of the most influential Danish architects and designers. He was also responsible for the introduction of the functionalist style in his country. He became famous for controlling all of the elements of his projects, from the height of the trees to the ashtrays, with the objective of achieving complete harmony.

Outside of Denmark he is particularly well known for his designs of furniture and objects, as he was the creator of numerous classics of modern design. A large part of his interest in the design of products came about as a result of the influence of Charles and Ray Eames, whose work became his source of inspiration for the creation, in 1951, of his first success: the stackable chair he called Ant, made

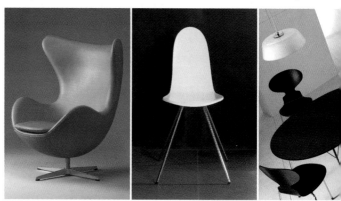

from only one piece of molded plywood supported by three thin steel legs. This was followed by model 3107, which has become one of the most popular and imitated chairs of the century.

Towards the end of 1950, he received a commission to build the Royal Hotel of Copenhagen. He designed all of the elements of the hotel, from the structure to the stainless steel covers with their abstract forms, which were later used by Stanley Kubrick for the film *2001: A Space Odyssey*. For the hotel, he also designed the iconic Swan and Egg chairs, in organic sculptural forms, which form part of his creative legacy.

In all of his projects, Jacobsen combined a profound attention to detail, the use of materials that were most convenient in each case, and the fusion of traditional and functionalist techniques from which the concepts and forms of his work originated.

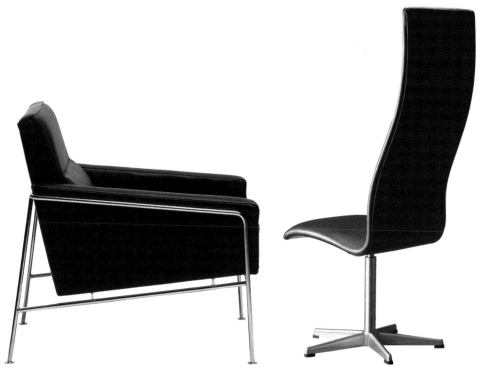

HARRY BERTOIA

1. Detail of the steel mesh body, characteristic of the collection of chairs created in 1952■
2. Group of chairs created by Harry Bertoia in 1952 for Knoll■
Their structure is Characterized by welded steel bars in the form of panels. This structure is resistant to scratches, stains and chipping. Upholstery available in a large number of options■
3. CHAIR "DIAMOND", 1952. Produced by Knoll■
Available completely upholstered in fabric or leather or with the steel structure visible and a cushion on the seat. Two sizes■
4. CHAIR "BIRD", with high backrest, 1952. Produced by Knoll■
Only available completely upholstered. Structure available in black, white or chrome■

1915 Udine, Italy-1978 Pennsylvania, USA■

Harry Bertoia's case is unusual. He has been recognized internationally for his work as a furniture designer when, in reality, he dedicated a very short period of time to this activity. He was encouraged by Florence Knoll, who placed a great deal of confidence in him and offered him an environment of complete liberty in which he could design whatever he wanted■

The result of this relationship were the steel wire mesh chairs produced by Knoll in 1952 that have become symbols of modern design. Before achieving this success, at the beginning of the '40s, Bertoia had collaborated with Charles and Ray Eames in their experiments with molded plywood. Being overshadowed by the Eames, his contribution in this field has never been fully acknowledged■

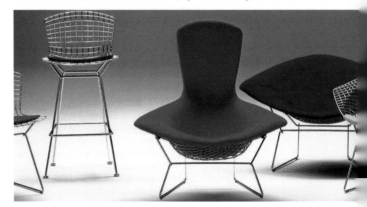

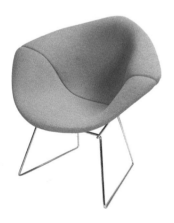

In reality, Harry Bertoia's true vocation was painting and sculpture. In fact, he conceived his steel chairs as if they were sculptures. In his own words, "If you look at these chairs, you will notice that they are essentially made of air, as in sculpture, space just passes through them, . . .once you have realized this, these chairs are studies of space, form and metal." In the mid '50s, Bertoia finally abandoned furniture design to completely immerse himself in the world of sculpture■

His chairs are still his best-known work and are perceived as functional sculptures that were created to support the human body comfortably above the floor■

In this way, through his metal chairs, Bertoia expressed the physical dimension of man while with his "tonal" sculptures he expressed his spiritual side■

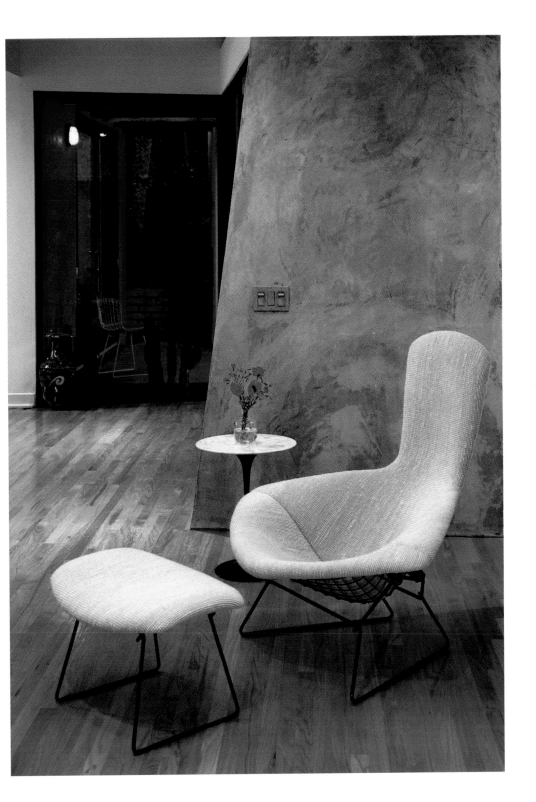

VERNER PANTON

1. "THE CONE CHAIR", 1958. Produced by Vitra.
Stainless steel base in the form of a cross and upholstered cone-shaped body. (Photo: H. Hansen).

2 and 6. "PANTON CHAIR", designed in 1960 and produced in 1967–69. From Vitra.
Structure in colored polypropylene reinforced with fiberglass. Produced under the procedure of injection molding. First plastic chair to be manufactured in only one piece. (Photo: H. Hansen).

3. "PANTO POP", 1990. From Innovation.
Made of plastic and available in various colors. Stackable.
⊟ 57 ⊟ 80 cm.

4. "PHANTOM", 1998. From Innovation.
Multifunctional piece in plastic and available in seven colors.
⊟ 93.5 ⊟ 35 ⊟ 81 cm.

5. CHAIR "HEART CONE", 1959. Produced by Vitra.
Stainless steel base in the form of a cross and upholstered heart-shaped body.

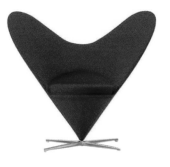

When Scandinavian design was at the peak of fashion, this Danish creator decided to distance himself from the forms and materials of the naturalists to create chairs that were completely new and that would situate him in the position of being one of the "fathers" of Pop culture and as a visionary designer who was able to anticipate trends.

Panton was a forerunner of the fluid, colorist and futurist style of the '60s, fueled by his passion for plastics and other synthetic materials. Taking as a base his belief that, "Sitting should also be fun, like playing, an exciting experience", he worked on new theories about what appearance a chair should have, how it should serve as a support and how vibrant colors could find their place in domestic and corporate surround-

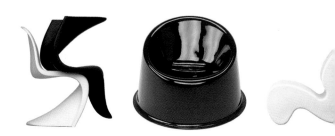

ings.

In 1959, he managed to make a name for himself in the world of design with the introduction of the Cone Chair, which drew great admiration for its extravagant geometric forms. This recognition allowed him to continue with his experiments and led to the creation of two landmarks in the world of design: the first inflatable piece of furniture and the omnipresent Panton Chair (produced in 1967, although its design dates from before), which was the first cantilevered chair made from one piece of molded plastic.

His chairs continue to be symbols of modernity, maybe because, and as he desired, "Experimenting with illumination, colors, textiles, and the furniture, using the latest technologies, I try to open new roads to encourage

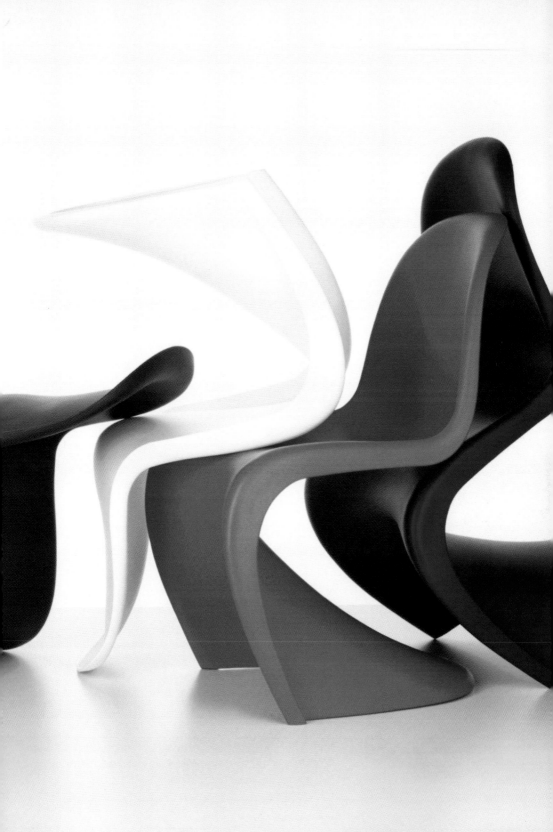

EERO AARNIO

1. "PASTIL CHAIR", 1967. Produced by Adelta∎
Fiberglass body. Suitable for exterior use. Floats in water. American Industrial Design Prize winner 1968∎
2. "BUBBLE CHAIR", 1968. Produced by Adelta∎
Transparent acrylic body with chromed steel frame∎
3. "TIPI", 2002. Produced by Adelta∎
Original forms for a chair which is presented upholstered in fabric Tonus 2000, in many colors∎
4. "FORMULA CHAIR", 1998. Produced by Adelta∎
Fiberglass structure with ergonomic forms∎
5. "BALL CHAIR", 1966. Produced by Adelta∎
Eero Aarnio sitting in his emblematic "Ball Chair". Fiberglass body and interior upholstered which many possible combinations of colors∎
6. CHAIR "FOCUS", 2002. Produced by Adelta∎
Metallic structure completely covered by fabric Tonus 2000. Large variety of colors∎

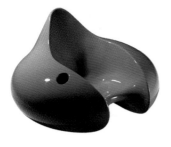

1932 Helsinki, Finland∎

Eero Aarnio's designs cannot be dissociated from the images related to the fervent conquest of space that was taking place at the end of the '60s. It was a time of optimism for the future in which furniture was designed with the intention of reflecting how the interiors of following generations might look∎

Eero Aarnio, one of the pioneers in the use of plastics, was at the forefront of this style of design. He wished to create ergonomic designs using materials of the avant-garde which would allow for lowcost mass production. The resulting forms represented his belief that products should be beautiful and extremely durable (which, paradoxically, went against the "throwaway" philosophy of Pop that had contributed so much to Aarnio's designs)∎

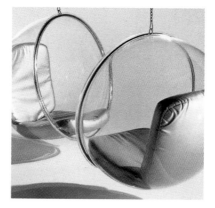 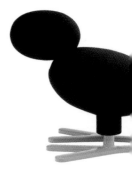

One of his first chairs, the Ball Chair, first presented to the public in 1966, brought him immediate fame and became one of the most representative images of the Space Age. Made from a fiberglass shell that echoes the geometry of a sphere, the chair engulfs the user in an intimate atmosphere that is protected from the outside as if it were "a room within a room." This chair was followed by other equally successful designs such as the Pastil Chair, winner of the 1968 American Industrial Design Prize, or the Bubble Chair, made of transparent plastic, which offers surprising acoustic isolation∎

In the '70s, he started to explore the possibilities offered by expanded polyurethane although he continued to defend plastic as being the ideal material for contemporary environments∎

The Age of "Everything Goes"

The '70s saw a renewed of individualism and irrational expression that reflected a general weariness of the homogeneity of functionalism. This movement was called Postmodernism, and it supposes the end of the challenge initiated by Pop to the austerity and tyranny of the so-called "good design" imposed for decades by the Modern Movement.

Postmodernism, with its epicenter in Italy, came about as part of a general change in design that ceased to be centered on finding solutions to problems and improving products to become based on the world of imagination, on ideas, on humor and visual stimulus. One of the groups that contributed most to the international manifestation of this style was the Memphis group, which was founded in 1981 by the architect and designer Ettore Sottsass.

The proposals from Memphis were a continuation of the radical ideas of the anti-design movement lead by groups such as Archizoom or the Alchymia Studio (formed by designers such as Alessandro Mendini, Andrea Branzi, Michele De Lucchi or Sottsass himself). They played with the experimentation and juxtaposition of unconventional materials, the combination of historic styles with contemporary materials and ideas, the use of kitsch and popular motifs and the contrast of clashing colors. In Memphis, there were no rules. Their objective was to create stimulating and imaginative interiors with an ironic and playful point of view. They were joined by creators with established international reputations such as Matteo Thun, Michael Graves, Javier Mariscal and Shiro Kuramata.

In the catalogue of their first exhibition they declared that, "We are all sure that the furniture created by Memphis will soon be out of fashion," and so it was. Although the group exerted a strong influence over the definition of a new language of design, its stylistic anarchy coexisted with styles and tendencies of a different nature that have outlived it, such as the industrial coldness of Hi-Tech, the geometry and austerity of Minimalism, a growing preoccupation with ergonomics and ecology, and the rediscovery of the aesthetics of the Modern Movement.

The chairs designed toward the end of the twentieth century reflect a great variety of styles that reflect the search for individualism and plurality. It is the age of "everything goes": from the experimentation by creators influenced by Postmodernism, such as Philippe Starck, Jasper Morrison, Ron Arad or Marc Newson, to the re-issue of "design classics," the values of which are still valid.

1 and 2. "S-Chair", 1990. Design from Tom Dixon for Cappellini▪ Metallic structure developed over the vertical allowing for the smallest base possible▪
⊢ 100 ⊣ 52 ⊢ 42 cm▪

3. Office chair "Kevi 2003", 1973. Design from Jørgin Rasmussen for Fritz Hansen▪

4. Armchair "Break", 1976. Design from Mario Bellini for Cassina▪ Structure in steel panels, completely upholstered in leather. Plastic feet▪
⊢ 85 ⊣ 56 ⊢ 51 ⊣ 45 cm▪

5. Chair "Ramón", 1975. Design from Ramón Bigas. Produced by Santa & Cole▪ Steel structure and seat and backrest in wickerwork▪
⊢ 75 ⊣ 45 ⊢ 45 cm▪

6. Chair "Sevilla", original design 1974. Created by Pep Bonet, Cristian Cirici and Mireia Nieto. Reproduced by Bd Ediciones de Diseño▪ Version in natural wickerwork, created in 1984. Steel structure covered in black plastic. Stackable▪
⊢ 81 ⊣ 50 ⊢ 52 cm▪

7. Swivel chair "Cassia", 1974. Design from De Pas, D'Urbino and Lomazzi for Zanotta▪ Stainless steel structure, base in aluminum. Seat with adjustable height upholstered in leather▪
⊢ 81/91 ⊣ 59 ⊢ 55 ⊣ 45/55 cm▪

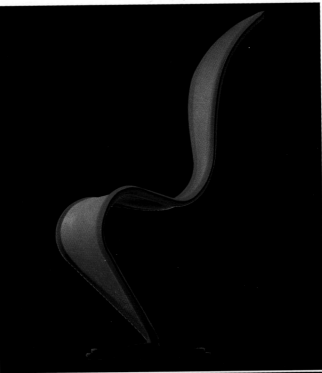

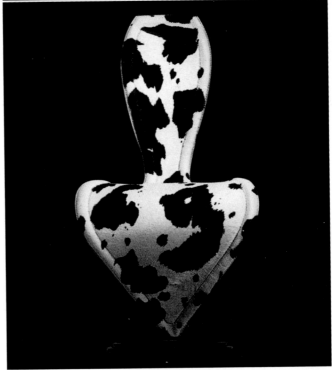

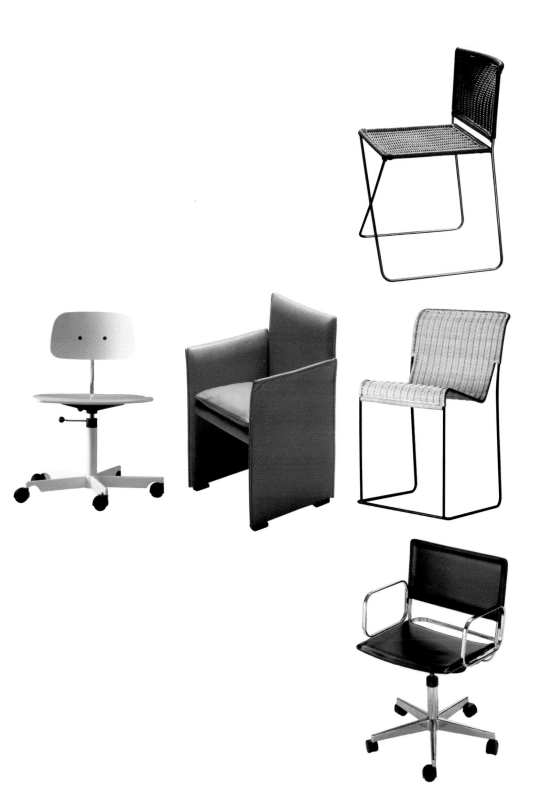

1. CHAIR "FERNANDO", 1984. Design from Carles Riart. Reproduced by Santa & Cole▪
Structure in sycamore. Upholstered seat and backrest▪
⊟ 85 ⊟ 45 ⊟ 50 cm▪

2. STOOL "GIOTTO", 1975. Design from De Pas, D'Urbino and Lomazzi for Zanotta▪
Structure in beech. Swivel seat with adjustable height▪
⊟ 45/55 ⊟ 45 cm▪

3. CHAIR "PAVONE", 1986. Designed by Riccardo Dalisi for Zanotta▪
Steel structure▪
⊟ 94 ⊟ 54 ⊟ 54 ⊟ 42 cm▪

4. TABLE CHAIR "ZABRO", 1984. Design from Alessandro Mendini for Zanotta▪
Chair converts into a table. Lacquered wooden structure with colorful hand-painted backrest▪
⊟ 137 ⊟ 93 ⊟ 50 cm▪

5. CHAIR "SNOOKER", 1985. Design from Carlos Riart. Reproduced by Santa & Cole▪
Structure in sycamore. Upholstered seat and backrest▪
⊟ 86.5 ⊟ 63 ⊟ 60 cm▪

6. STOOL "DUPLEX", 1983. Design from Javier Mariscal. Reproduced by Bd Ediciones de Diseño▪
Chromed steel structure combined with one colored leg. Seat upholstered in black leather▪
⊟ 77 ⊟ 42 ⊟ 46 cm▪

7. CHAIR "CAB", 1977. Design from Mario Bellini for Cassina▪
Steel structure completely upholstered in leather▪
⊟ 82 ⊟ 52 ⊟ 47 ⊟ 45 cm▪

8. EASY CHAIR "771", 1977. Design from Carlo Scarpa for Bernini▪

9. BENCH "MARIPOSA", 1989. Design from Riccardo Dalisi for Zanotta▪
Steel structure. Colorfully painted by designer. Nine signed originals exist▪
⊟ 88 ⊟ 102 ⊟ 55 ⊟ 40 cm▪

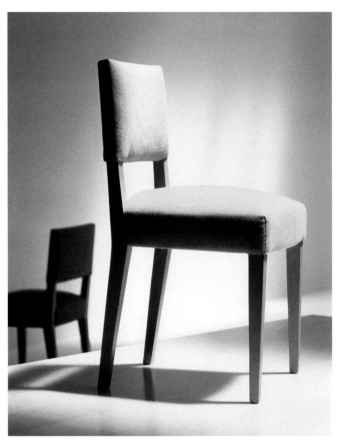

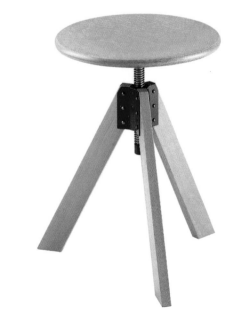

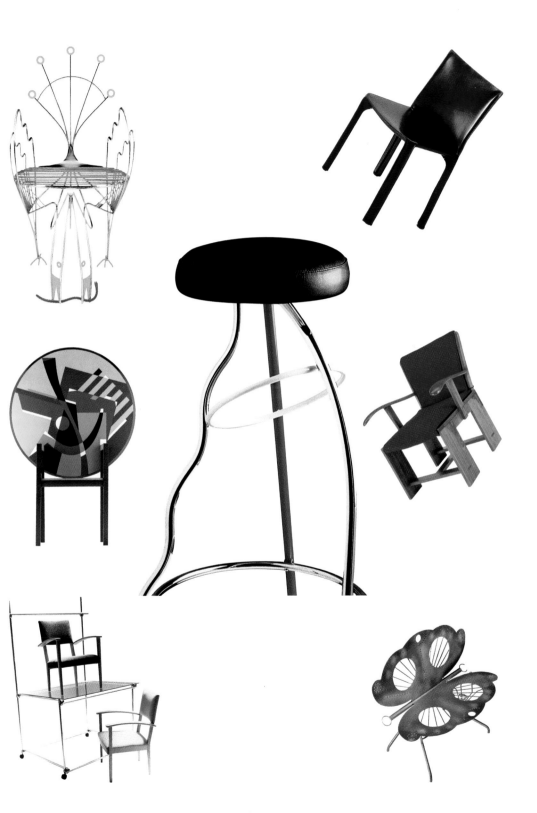

ETTORE SOTTSASS

1 and 2. CHAIR "MANDARIN", 1986.
Produced by Knoll■
Tubular steel structure with seat and
backrest upholstered in various colors
and finishes. The undulating arms are
characteristic■
3. EASY CHAIR "EASTSIDE LOUNGE
COLLECTION", 1983. Produced by
Knoll■
Reinterpretation of an easy chair
from a classical club. The seat and
headrest are upholstered in different
fabrics■

1917 Innsbruck, Austria■

"As far as I am concerned, design is a debate about life, social rela-
tionships, politics, food and even design itself." Although Austrian
born, Ettore Sottsass has been one of the leading Italian designers of
the last few decades. He has always worked to make design some-
thing more, something exciting and sensual, to change the way that
people see this activity. Thanks to this desire, he has managed to in-
troduce a new intellectual point of view that has permitted a freer,
unexpected, fluid and conceptual approach from young creators in
the world of design■

In 1956, Sottsass established himself as design consultant for
companies such as Olivetti. This was when large companies started to

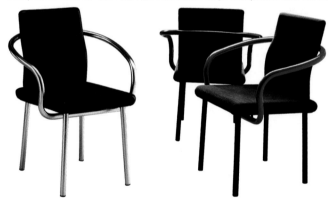

realize the necessity of including the figure of industrial designer in
the conception of their products■

As of the '70s, he became a key figure in the Italian Anti-Design
movement that came into being as a reaction against the functionalist
norms of "good taste." In 1981, this aesthetic renewal, fundamental to
the development of Postmodernism, reached international acclaim
with the first exhibition of the Memphis group founded by Sottsass. In
1985, when this movement was at the peak of its activity, Sottsass de-
cided to abandon the circle, driven by an urge to continue advancing
and experimenting rather than living off past successes■

Since then, he has worked in his architecture and design studio,
Sottsass Associati, where he continues confronting the established or-
der with the help of former members of Memphis along with young
collaborators■

VICO MAGISTRETTI

1. CHAIR "MAUI", 1997. Produced by Kartell.
Chromed steel base and polypropylene body. Stackable.
⊟ 77 ⊟ 55 ⊟ 52 ⊟ 45 cm.
2. CHAIR "SELENE", 1969. Produced by Heller.
Structure in glass reinforced polyester. This model is a reproduction of a classic from the '70s.
3. CHAIR "MAUNA-KEA". Produced by Kartell.
Aluminum structure. Seat and backrest in polypropylene.
⊟ 77 ⊟ 49 ⊟ 54 ⊟ 46 cm.
4. CHAIR "KENIA", 1995. Produced by Campeggi.
Folding chair.
⊟ 73 ⊟ 75 ⊟ 58 cm.
5. CHAIR "AFRICA", 2000. Produced by Campeggi.
Folding chair.
⊟ 104 ⊟ 78 ⊟ 80 ⊟ 45 cm.

1920 Milan, Italy.

Magistretti's designs could be situated on the other side of the coin to those of Ettore Sottsass. In fact, Magistretti was of the opinion that the furniture created by the Memphis group, "Offers no form of development. It is no more than a variation of fashion".

Ever since his initial involvement with furniture design at the beginning of the '60s, Magistretti has shown himself to be a master of elegant, simple, contained, and durable forms and has displayed a philosophy that protects him against rapid obsolescence. His furniture is a reflection of his passion for making what he calls, "Anonymous traditional objects" that respond to neither styles nor trends.

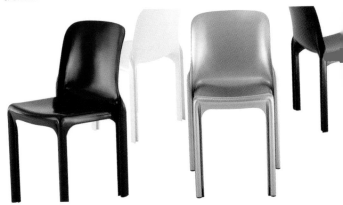

Along with Joe Colombo and Marco Zanuso, he was one of the first designers to start working with plastics and managed to change consumers' perception of this material: from cheap and flimsy to sophisticated and elegant. Some of the novelties that he brought to its use in industrial manufacturing were: legs in the shape of an "S", which reinforced the structure of the chair without altering its integrity and techniques for increasing the thickness of the plastics in areas that receive greater wear and tear. The result of his work are models that are comfortable, resistant, informal, lightweight, colorful and practical and which incorporate solutions that reflect technological, economic and functional considerations from the outset. As a result, during his fifty years of activity, Magistretti has become an ambassador of the rational aspects of postwar design and has achieved, for Italian design, international acclaim.

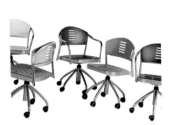

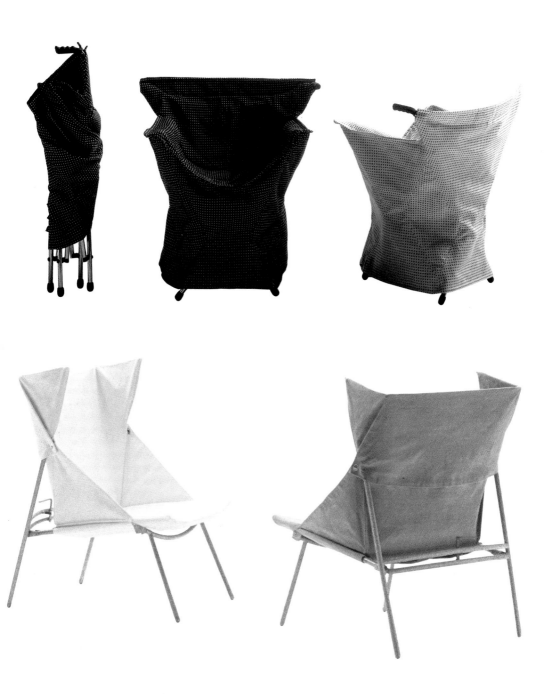

1. "VICO LOUNGE", 2000. Produced by Fritz Hansen■
Comfortable lounge chair inspired in the forms of the chair "Vico". Completely upholstered■

2. CHAIR "VICO SOLO", 1999. Produced by Fritz Hansen■
Steel tube structure. Seat in plywood and synthetic backrest. Stackable■
⊢ 73.5 ⊣ 52.5 ⊢ 46.7 ⊣ 45.5 cm■

3. CHAIR "MOOREA". Produced by Kartell■
Steel tube structure. Upholstered polyurethane seat■
⊢ 79 ⊣ 60 ⊢ 58 ⊣ 44/52 cm■

4. and 5. CHAIR "SILVER". Produced by Knoll■
Aluminum structure. Seat and backrest in polypropylene. Stackable■

6. CHAIR "VICO", 1994. Produced by Fritz Hansen■
Steel tube structure. Seat and backrest in plywood. Stackable■
⊢ 78 ⊣ 64 ⊢ 56 ⊣ 45 cm■

ÓSCAR TUSQUETS

Like the majority of outstanding individuals of twentieth century design, Óscar Tusquets is a multidisciplined creator. He defines himself as "architect by formation, paint by inclination and designer by vocation."

He formed part of a group of open-minded intellectuals resident in Barcelona (among whom architects such as Ricardo Bofill and Oriol Bohigas were to be found) that, at the end of the 60's, due to their opposition to Franco's regime, ended up being an important movement as far as aesthetic revival was concerned. This group labeled themselves with the name "gauche divine." In 1972, tired of finding no one bold enough to produce his ideas in the mediocre cultural environment of pro-Franco Spain, he decided to create his own company along with other

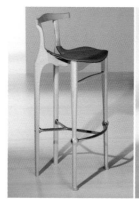
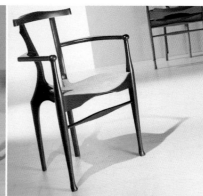

"renowned" designers such as Pep Bonet, Cristian Cirici and Lluís Clotet. Since then, Bocaccio Design, now known as Bd Ediciones de Diseño, has brought into being the objects and furniture conceived by its founders in addition to introducing internationally acclaimed avant-garde designers into Spain.

One of his best-known works, the "Banco Catalano" designed with Lluís Clotet, shows his admiration for Gaudí and the Modernist Movement. "The profile of the bench designed by Gaudí for the Güell Park seemed to be insuperable to us and we decided to adapt it for the 'Banco Catalano. There is no reason why plagiarism well undertaken should kill the original. Quality in plagiarism, as in everything, depends on the talent of the executor."

In his last book, *God Sees It,* he proposes that we always aim for perfection in a piece of work as if we were being judged by an intelligent god.

1. CHAIR FROM THE "SERIE JARDÍN", 1979/1981. Designed by Óscar Tusquets and Lluís Clotet. From Bd Ediciones de Diseño.
Steel tube legs. Seat and backrest in extended steel. Stackable. Version for the garden of the emblematic "Banco Catalano".
⊢ 90 ⊟ 60 ⊢ 80 cm.

2 and 3. STOOL (1989) AND CHAIR "GAULINO" (1987). Produced by CJC Concepta.
Structure in oak. Seat upholstered in cowhide. Stackable chair. Dimensions: chair
⊢ 85.5 ⊟ 45 ⊢ 50.5 ⊟ 46.5 cm.

4. CHAIR "PLUS", 2000. Produced by CJC Concepta.
Steel tube structure. Seat and backrest in beech ply. Stackable.
⊢ 83 ⊟ 58 ⊢ 58 ⊟ 45.5 cm.

5 and 8. CHAIR "PALIO", 1998. Produced by Driade.
Tubular steel structure covered with natural wickerwork.
⊢ 89.5 ⊟ 51 ⊢ 62 ⊟ 45 cm.

6. CHAIR "METALÁSTICA", 1987/1996. From Bd Ediciones de Diseño.
Steel structure. New version with seat and backrest in perforated steel. Stackable.
⊢ 82 ⊟ 53.5 ⊢ 55 cm.

7 and 9. CHAIR "SINUOSA", 2000. Produced by Driade.
Stainless steel structure. Polypropylene body. Weather resistant. Stackable.
⊢ 79 ⊟ 57 ⊢ 52 ⊟ 45 cm.

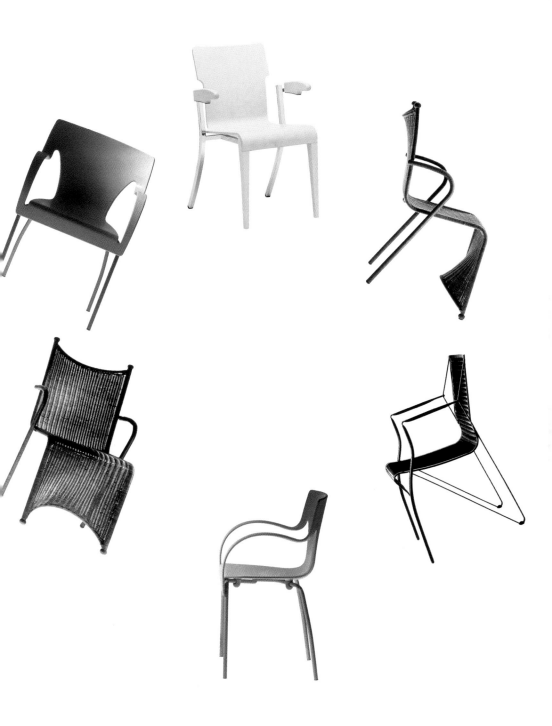

THE **21**st

CENTURY

A VISION OF THE FUTURE

RON ARAD

1951 Tel Aviv, Israel.

Since 1981, when he established the studio One Off in London (where he started creating structures with found and recycled objects which he combined with high-tech materials), Ron Arad has become a highly regarded creator within the international panorama for his unique pieces that, more often than not, fall into the category of art. In fact, the majority of his best-known designs originate from collections of handmade experimental pieces in limited editions which have later been adapted for industrial production by large companies in the sector.

Forms that are notably sculptural define Arad's furniture. This is perhaps because, as he himself explains, they are the result of the

1 and 4. CHAIR "TOM VAC" and ROCKING CHAIR "TOM ROCK." Produced by Vitra. Tubular steel structure. Seat body in polypropylene with undulating structure in color or transparent. Stackable with the exception of the rocking chair version that incorporates two beech rockers.

2. "BAD-TEMPERED CHAIR", 2001. Produced by Vitra.
This model is a reproduction of the 1985 original that was produced in sheet steel. It is now manufactured in plastics reinforced with glass fibers, carbon and Kevlar impregnated with synthetic resins.

3. CHAIR "FPE" (Fantastic Plastic Chair), 1997. Produced by Kartell. Aluminum structure and seat in polypropylene, suitable for outside use.
⊢ 78 ⊣ 43 ⊢ 59 ⊟ 46 cm.

5 and 6. "RON-ALDO DOWN" and "RON-ALDO UP", 2002. Produced by Bonaldo.
Dinning room chairs and easy chairs with cantilevered base and upholstered seat and backrest.

exploration of the "material, the morphology or technology." From the start, he has displayed a unique style based on a rather unconventional combination of materials and concepts and has always sought new techniques and materials with which to put his ideas into practice.

His experimentation with tempered steel sheet gave rise to the chair "Well Tempered" in 1986 and later to the series "Big Easy." These chairs have left their stamp on the history of design for the singularity of their forms, novel use of materials, and for introducing a new perspective to the aesthetics of the chair and to design in general.

His particular interpretation of the laws of equilibrium leads to structures that seem to be in continual movement and that tend to surprise both the spectator and user of his furniture.

7. Chair "Anonimus", 1995. Pro-
duced by Zeus Noto▪
Steel structure and aluminum legs.
Seat and backrest in curved beech
ply▪
⊟ 82 ⊟ 49 ⊟ 53 ⊟ 45 cm▪

8. Chair "Little Albert", 2001.
Produced by Moroso▪
Molded polyethylene structure. Suit-
able for outside use▪
⊟ 75 ⊟ 74 ⊟ 75 cm▪

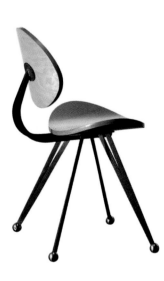

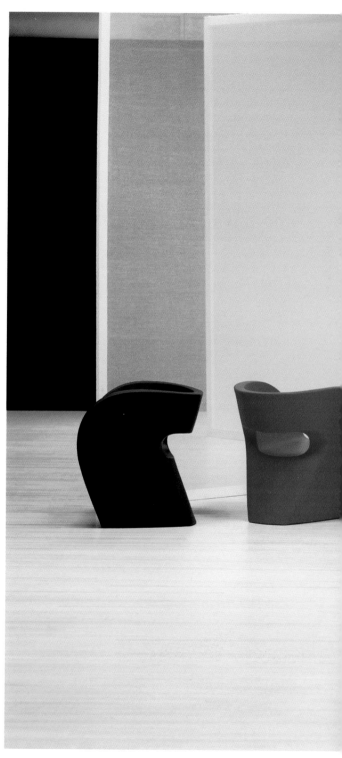

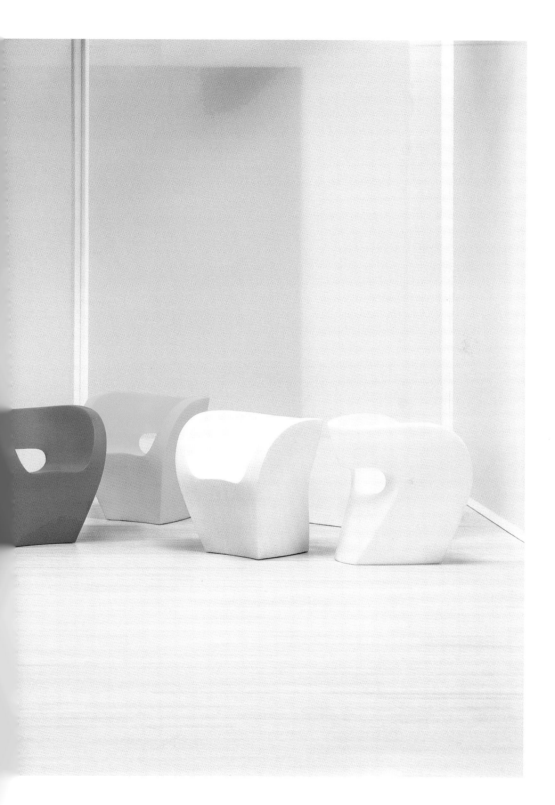

1. "ANEMONE", 2001. From Edra∎
Steel structure with plastic tubes manually laced in arbitrary form∎
⊟ 66 ⊟ 120 ⊟ 90 cm∎
2. CHAIR "CONE", 1993/98. From Edra∎
Metallic structure. Body in transparent polycarbonate leaves cut by laser∎
⊟ 74 ⊟ 107 ⊟ 85 cm∎
3, 4 and 5. CHAIRS "AZUL", "VERDE" and "VERMELHA", 1993–98. From Edra∎
Steel structure with aluminum legs. The seat and backrest have been made with cotton cord. (approx. 400 m). Dimensions: Azul,
⊟ 98 ⊟ 80 ⊟ 45 cm∎
Verde
⊟ 88 ⊟ 45 ⊟ 54 ⊟ 45 cm∎
Vermelha
⊟ 77 ⊟ 86 ⊟ 58 ⊟ 38 cm∎

Hunberto Campana–1953 Sao Paulo, Brazil∎
Fernando Campana–1961 Sao Paulo, Brazil∎

The Campana brothers' work is an elegant demonstration that design today goes far beyond form and function, far beyond the simple sum of its components. Their creations are able to reflect archetypes of Brazilian culture along with a contemporary language that breaks all frontiers simultaneously∎

The objects that come out of their workshop combine humor with an audacity in the use of materials. They use salvaged materials, or the "poor" materials, that flow in an urban chaos and then are worked with the application of artisan techniques. Their furniture is situated at a point in between products that are essentially industrial and those

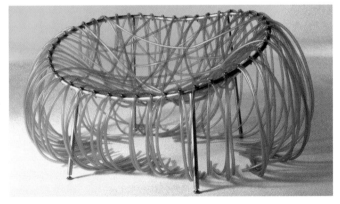

that are more artistic in nature and which bring about concepts that question the social context of the design process as such∎

One of the starting points in their creative process is the investigation into the relationship between the object and user. As Fernando Campana says, "I observe how people relate to each other and with the sun, sound and clouds" the ideas come from this interaction∎

The Campana brothers' chairs are intuitive and spontaneous. They are born from a union of Brazilian artisan traditions, the efficient use of industrial materials and techniques, and the creativity that comes from the ability to continue seeing the world with the eyes of a child∎

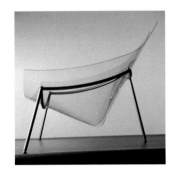

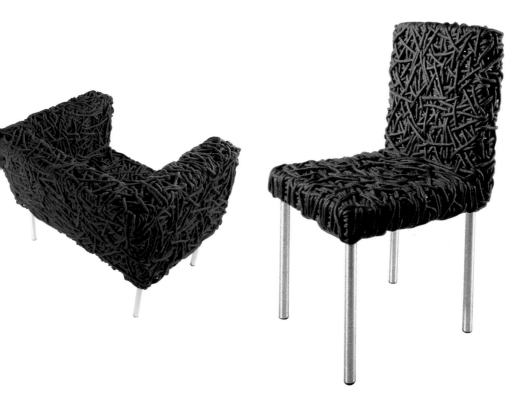

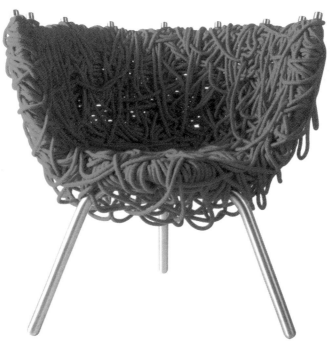

ANTONIO CITTERIO

1. CHAIR "MINI". Produced by Halifax■
Aluminum legs and armrests. Seat
and backrest in polypropylene■
⊟ 80 ⊟ 52,5 ⊟ 50,5 ⊟ 45,5 cm■
2. STOOL "SPOON", 2002. Produced
by Kartell■
Plastic structure that gives flexibility
and elasticity. Base in aluminum■
3 and 4. OFFICE CHAIRS "OSON-STU-
DIO" and "OSON-CORPORATE", 2002.
Produced by Vitra■
Numerous possibilities in adjust-
ments are offered. Seat and backrest
connected by means of a three-piece-
chain mechanism■
5. OFFICE CHAIR "AXESS", Antonio Cit-
terio and Glen Oliver Löw for Vitra■
Automatic adaptation to user.
Awarded the certificate of ergonom-
ics by the Institute LGA, Nurem-
berg. (Photo: H. Hansen)■
6. CHAIR "TONIX", 2002. By Antonio
Citterio and Toan Nguyin for Vitra■
7. OFFICE CHAIR "T-CHAIR", Antonio
Citterio and Glen Oliver Löw for Vitra■
The patented synchronized mecha-
nism moves to support the body in
any position. Flexible backrest in
polypropylene. (Photo: H. Hansen)■

1950 Meda, Italy■

Antonio Citterio's admiration for minimalist art is clearly reflected in his
furniture. The basic motifs of his creations, as much in his furniture as
in his architecture and interior design, are essential forms that are able
to transmit a lot with very little and in which the quality of the materi-
als used is vital to the realization of this expressive simplicity■

Citterio is one of the most prolific designers of his generation and
fully representative of Italian "good design", and he has worked for
large companies in the contemporary furniture design sector for many
years. His working philosophy, which is to develop only that furniture
he himself would like to be surround by, leads to extremely functional
pieces. Citterio manages to transmit visual interest along with har-

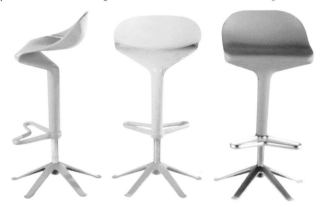

mony by means of a balanced and original combination of materials
and form removed from proposals that may be hazardous or too
radical■

This minimalist attitude and the integrity with which he has
marked his line of work from the beginning are probably the reasons
that the chairs and sofas he designed in the mid '70s for firms such
as B&B Italia have stood up to the passage of time. This furniture is
still as relevant as it was then which proves that functionalism is a
way of life that goes beyond fashions■

He obtained one of his major achievements in the '90s with the de-
sign of a new system of office chairs for Vitra. These chairs combined
steel and leather upholstery simply and elegantly in a way that en-
riched their functionality■

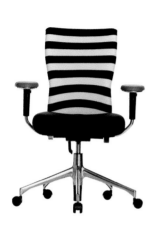
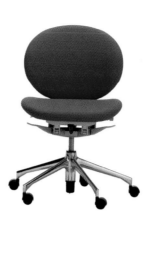
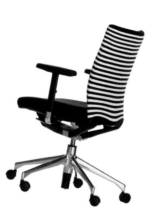

8. CHAIR "VISACOM", 2002. Produced by Vitra■
Oscillation-free base in chromed tubular steel. Seat and backrest upholstered in fabric or leather■
9. CHAIR "SOLO", from B&B Italia■
Aluminum structure. Seat with steel frame upholstered in fabric or leather■
⊨ 88 ⊨ 42 ⊨ 57 ⊨ 47 cm■

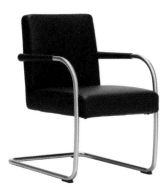

The Twenty-first Century 111 Antonio Citterio

PIERO LISSONI

1. CHAIR "FORM", 2002. Produced by Kartell∎
Chromed steel structure. Seat body in polyurethane∎
⊟ 63,1 ⊟ 84,9 ⊟ 81 ⊟ 31 cm∎
2. EASY CHAIR "CAFÉ", 1998. Produced by Living Divani∎
3. EASY CHAIR "FROG", 1993. Produced by Living Divani∎
Chromed tubular steel structure. Seat and backrest in wickerwork∎

1956 Seregno, Italy∎

Piero Lissoni is another of the outstanding figures in Italian design who has been inspired by minimalism. However, he would prefer the use of the term simplicity to minimalism because of the risk this could have on limiting his work to a concept that is currently applied to a great range of products without its true meaning being taken into account∎

As far as Lissoni is concerned, the purity and honesty of his forms is something that goes beyond any form of labeling. His work is defined from its own poetry which transcends any exigency imposed by the industry. His furniture comes into being as the result of exhaustive investigation and satisfactory combination of materials that are molded to create sober and functional forms∎

In 1986, he established the Studio Lissoni in Milan where he undertakes work which encompasses architecture, interior design, graphic design, industrial design and art and corporate image direction for leading companies in the industry. This vast variety of activity probably evolves from the concept that Lissoni has of design: "Generally, when someone says industrial design he or she is only thinking about objects, but it is a lot more than this: it means thinking and designing everything around us∎"

Lissoni believes that the conceptual crisis of form subordinated to function brings a leading role to the search for aesthetics completely free from ties. A search that should find inspiration in the world of art and dramatically express the variety of man∎

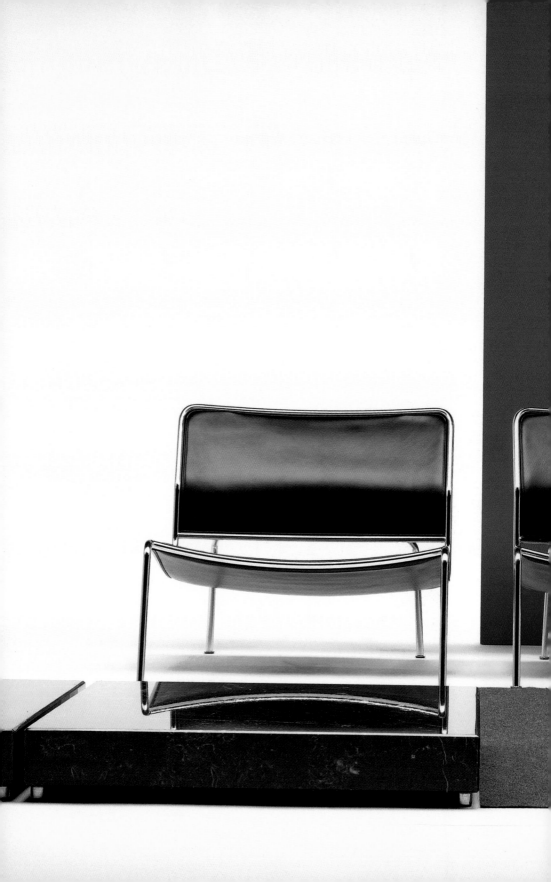

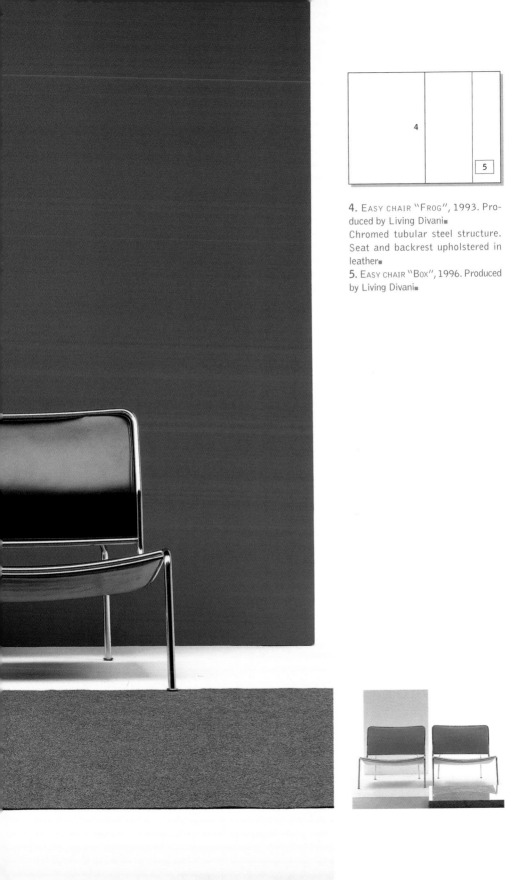

4. EASY CHAIR "FROG", 1993. Produced by Living Divani▪
Chromed tubular steel structure. Seat and backrest upholstered in leather▪
5. EASY CHAIR "BOX", 1996. Produced by Living Divani▪

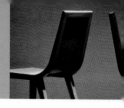

LIÉVORE, ALTHERR, MOLINA

1. CHAIR "RADICAL", 1992. Produced by Andreu World■
Structure in beech. Seat and backrest in one piece of beech ply. First Prize Design FIM 92■
⊟ 86.5 ⊟ 41 ⊟ 51 ⊟ 45 cm■
2 and 4. CHAIR "MANILA". Produced by Andreu World■
This model offers numerous possible combinations: structure in beech or walnut, seat and backrest upholstered in leather or wickerwork or combined. In various dimensions■
3. EASY CHAIR "JKR". Produced by Perobell■
Chromed metal legs. Seat and backrest with wooden structure covered with polyurethane and upholstered. Reproduction of one of the firm's classic models■
5. EASY CHAIR "RDL". Produced by Andreu World■
Easy chair version of the chair "Radical". Structure in beech■

Alberto Liévore–1948 Buenos Aires, Argentina■
Jeannette Altherr–1965 Heidelberg, Germany■
Manel Molina–1963 Barcelona, Spain■

Alberto Liévore, architect, has worked as a furniture designer since he founded the showroom-shop Hipótesis in Buenos Aires in 1972. Furniture that has led to his national recognition has been produced in this workshop. In 1977, once installed in Barcelona, he formed, along with Norberto Chaves, the Grupo Berenguer, which was later to be joined by well-known designers such as Jorge Pensi and Oriol Pibernat. In collaboration with the magazine *On Diseño* they formed SIDI (International Selection of Design of Services for the Habitat), a platform from which to launch Spanish design■

In 1991, he founded the studio Alberto Liévore & Asociados with Jeannette Altherr and Manel Molina who had previously collaborated with another giant of Spanish design, Miguel Milà. In addition to working in furniture design, they undertake projects involving interior design, packaging, products, consulting and art direction, and they also teach■

Liévore, Altherr and Molina have a particularly personal view of design: "We try to avoid reducing the object to a mere cultural manifestation. On each project, once we have accepted the complete complexity of the phenomenon, we try not to sacrifice anything, form or function, reason or sensibility, art or technique, innovation or continuity, etc. We intend to achieve a compact form that is full of meaning as the result of a complex system of equilibrated forces■"

6. CHAIR "RADICAL", 1992. Produced by Andreu World∎
Structure in solid beech. Seat and backrest in one piece of beech ply. First Prize Design FIM 92∎
7. CHAIR "SEDUS". Produced by Muebles Do+Ce∎
Structure in wood with upholstered seat and backrest∎
⊢ 74 ⊢ 51 ⊢ 53 cm∎
8. EASY CHAIR "FABRA". Produced by Perobell∎
Steel structure. Upholstered seat and backrest∎
9. CHAIR "890", 2002. Produced by Thonet∎
Manufactured in three types of tubular steel base: cantilevered, with frames or with legs. Seat totally upholstered∎
⊢ 76 ⊢ 62 ⊢ 64 cm∎

JOSEP LLUSCÀ

1948 Barcelona, Spain

Josep Lluscà is one of Spain's-best known industrial designers. He forms part of the group of designers that, since the '60s, has situated Spain, and above all Barcelona, in the international arena as far as design is concerned.

He has been vice-president of the Agrupación de Diseñadores Industriales del Fomento de las Artes Decorativas (ADI-FAD), member of the Consejo de Diseño of the Generalitat of Cataluña, and of the Consejo Asesor de la Fundación BCD, Barcelona, as well as being a teacher and member of the Consejo Rector del Departamento de Diseño de Producto de la Escuela Eina, Barcelona.

1 and 7. CHAIR "GLOBAL". Produced by Enea.
Steel tube structure. Seat and backrest in polypropylene and arms in polyamide. Stackable. Prize: Delta de Plata, 1999.

2. OFFICE CHAIR "NEKO". Produced by Oken.
Aluminum base. Seat in recycled polypropylene. The seat can be in polypropylene or in wood. Diverse combinations available.

3. OFFICE CHAIR "LOLA". Produced by Oken.
Legs and arms in injected aluminum alloy. Seat structure in laminated wood covered in flexible polyurethane foam.
⊟ 98/106 ⊟ 65 ⊟ 63 cm.

4 and 9. CHAIR "ALOE". Produced by Oken.
Steel tube structure. Seat and backrest in curved wood. Also available in an upholstered version.

5. CHAIR "EINA". Produced by Enea.
Steel structure and injected aluminum arms. Seat and backrest in laminated beech, upholstered in polypropylene. Stackable.

6 and 8. CHAIR "LÓGICA". Produced by Enea.
Steel structure. Seat and backrest in varnished beech or upholstered in leather. Stackable and connectable laterally.

In 1972, he established the studio Lluscà and Associates in which he collaborated in the creation of new products for industries as diverse as furniture and accessories, public services, household appliances and goods, illumination, packaging, etc. On numerous occasions these projects have been awarded prestigious international prizes.

One of their best-known designs is the chair "Andrea" which was inspired by the chair of the Casa Calvet created by Gaudí. Lluscà's model is a result of the study of the center of gravity in which he takes Gaudí's chair as a reference point to resolve the joint between seat and backrest along with the structure and thus highlights the anatomical organic aspect of the form. With the exception of the difference in time, the Andrea chair seems to reproduce the dialogue between artisan heritage and new typological solutions that are constructive and industrial in nature.

11. CHAIR "ANDREA", 1988. Pro-
duced by Andreu World∎
Three-legged base in chromed conical
steel tube. Arms in injected aluminum.
Seat and backrest in stained beech.
Selection: Premios Delta ADIFAD
1988∎
12. STOOL "COMA". Produced by Enea∎
Lacquered steel base, footrest in pol-
ished aluminum and seat in polypropy-
lene with mineral fibers. Three heights:
75, 65 and 45 cm∎
13. CHAIR "COS", 1994. Produced by
Cassina∎
Structure in cherry or beech or
stained in black. Upholstered in
leather. Available with or without
arms∎
⊢ 82 ⊢ 63 ⊢ 57 ⊣ 45 cm∎
(Photo: A. Ferrari)∎

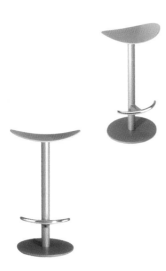

ALBERTO MEDA

1 and 4. CHAIR "HIGHFRAME". Produced by Alias■
Aluminum structure and seat and backrest in polyester with PVC mesh. Stackable■
⊟ 82 ⊟ 53 ⊟ 56 ⊟ 49 cm■
2 and 3. EASY CHAIR "ARMFRAME". Produced by Alias■
Aluminum structure and seat body upholstered in black leather or in polyester with PVC mesh■
5. OFFICE CHAIR "MEDA 2XL", 2002. Produced by Vitra■
Adjustable synchronic mechanism incorporated which adapts to the individual. (Photo: H. Hansen)■
6 and 7. OFFICE CHAIR "ROLLING FRAME". Produced by Alias■
Structure in polished or matte Aluminum. Seat and backrest upholstered in leather or in polyester with PVC mesh■
8. OFFICE CHAIR "MEETING FRAME", 2002. Produced by Alias■
Polished or matte aluminum structure. Seat and backrest upholstered in leather or in polyester with PVC mesh■

1945 Como, Italy■

Perhaps the major difference between Alberto Meda and other Italian designers of his generation — those responsible for bringing Italian design to the forefront — is his background as an industrial machine engineer. He shares with them the fusion of art and technology, reason and imagination and the constant search for technical and formal innovation■

His first incursion into the design world was in 1973 in his position as Technical Director of Kartell. In 1979, he established himself as an independent industrial designer and started collaborating with prestigious companies in the creation of all sorts of products ranging from cars to objects of illumination and chairs produced using the most advanced technologies■

Meda is internationally renowned for his use of the latest generation of materials in his designs. He uses carbon fiber, cast and extruded aluminum, Kevlar® and Nomex® with which he creates innovative and elegant objects that reflect his engineering background. As a result, his work establishes unifying links between new materials, new technologies and everyday articles and he reinvents traditional furniture by the use of industrial materials in another context■

Meda believes that simplicity should be the guiding light to all design work. " ... I am sure that by attempting to create simple things, one identifies with what we could call a 'biological' necessity. As we are complicated beings, why not at least allow ourselves to be surrounded by simple objects, otherwise, what a difficult life!■"

JASPER MORRISON

1. EASY CHAIR "PH". Produced by SCP▪
Structure in oak. Seat and backrest upholstered in fabric or leather▪
⊢ 83 ⊟ 52 ⊢ 54 cm▪

2 and 9. STOOL "ATLAS". Produced by Alias▪
Series of stools in different sizes and finishes. Structure in steel and swivel seat upholstered in a wide range of colors▪

3 and 5. CHAIR "HI PAD", 1999. Produced by Cappellini▪
Structure in brushed stainless steel. Seat and backrest upholstered in fabric or leather▪
⊢ 75 ⊟ 40 ⊢ 45 ⊟ 45 cm▪

4. STOOL "SLATTED STOOL". Produced by SCP▪
Structure in stainless steel▪
⊢ 70 ⊟ 48 ⊢ 27 cm▪

6. CHAIR "TATE", 2000. Produced by Cappellini▪
Structure in stainless steel. Seat in beech ply, natural or stained in various colors. Stackable▪
⊢ 81 ⊟ 53 ⊢ 47.5 ⊟ 45 cm▪

7 and 8. "AIR CHAIR", 2000. Produced by Magis▪
Structure in glass reinforced polypropylene. Molded by air injection. Suitable for outdoor use▪
⊢ 77.5 ⊟ 49 ⊢ 51 ⊟ 47 cm▪

1959 London, United Kingdom▪

"For various reasons, designing a chair cannot be compared to designing any other object. . . The chair is a puzzle. I do not think that the perfect chair has ever been invented, not even by Eames▪"

Jasper Morrison is another of the outstanding defenders of the indispensability of minimalism in modern design. He has managed to place himself among the most influential designers thanks to his personal approach to the activity that unifies an elegant rigorousness with a dose of humor▪

Morrison explains that one of his first influences was the 1981 Memphis Group exhibition in Milan: "Here was the proof that none of the old rules regarding design would continue to hold any importance." Here, he

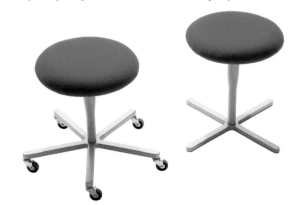

also realized that what he wanted was the complete opposite: objects free of all ornamentation that were to be an antidote against excess. His creations were received as a breath of fresh air in comparison with the pompous Postmodernist furniture of the time. His simplicity and apparent essentialness is so predominant that, on occasion, it seems that the objects he produces have not been designed by anybody. Only the closest study of the piece will reveal the creative processes behind it which give rise to the technical and formal solutions that have led to its perfection▪

His objectives are best defined in the way they are described by the critic Charles Arthur Boyer: "To produce everyday objects to be used by everybody, to make things lighter rather than heavier, softer rather than harder, inclusive rather than exclusive, to generate energy, light and space." The creative purity of his work is the fruit of observation and free thought▪

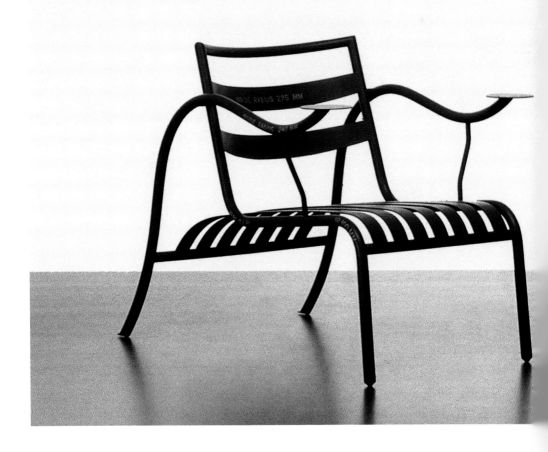

10. Easy chair "Thinking Man's Chair", 1988. Produced by Cappellini▪
Structure in tubular steel. Suitable for outdoor use▪
⊢ 70 ⊨ 57 ⊢ 90 ⊟ 35 cm▪
11. Easy chair "Low Pad", 1999. Produced by Cappellini▪
Structure in stainless steel. Seat upholstered in fabric or leather▪
⊢ 75 ⊨ 60 ⊢ 73.5 ⊟ 34 cm▪

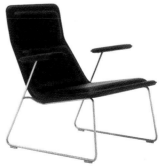

JORGE PENSI

1 and 4. CHAIR "DUNA", 1998. Produced by Cassina■
Structure in varnished aluminum. Structure of seat and arms in plastic, upholstered in polyurethane foam covered with fabric or leather■
⊟ 84 ⊟ 57 ⊟ 57 ⊟ 45 cm■
2. STOOL "GIMLET". Produced by Mobles 114■
Metallic structure with chromed footrest. Swivel seat in integral polyurethane. Three heights: 83, 65 and 50 cm■
3. CHAIR "POL", from Akaba■
Polished steel tube structure, arms in glass reinforced polyamide. Seat and backrest in polypropylene. Stackable■
⊟ 82 ⊟ 56 ⊟ 55 ⊟ 45 cm■

1946 Buenos Aires, Argentina■

In 1975 after having trained as an architect and industrial designer, and having worked for a number of years in his city of birth, Jorge Pensi established himself in Spain. Here, he became one of the outstanding figures in the surge in Spanish design that took place once Franco's dictatorship had come to an end and that was principally launched internationally from Barcelona■

In 1977, he formed a firm of design consultants, Grupo Berenguer, along with Norberto Chaves, Oriol Pibernat and Alberto Liévore and in 1985, he founded his own studio specializing in the creation of furniture, illumination and scenery design. He soon became internationally renowned especially for his elegant and fluid chairs such as the alu-

minum model Toledo, for which he has won numerous prizes. His work is defined as a wager for intuition. Pensi recognizes that aspects are found in his products that are not strictly derived from a cause and effect relationship and that at the same time his work often rejects a direct correspondence between intention and result given that in the process, to a larger or lesser degree, intuitive thought plays an active role■

Another of his objectives is to make his designs ageless, so that they resist the evolution imposed by the passing of time: "... Objects have a close link with time. I am specifically interested in the idea of permanence: it saddens me to see an object die because it has fallen out of fashion. For this reason, I try to avoid this happening. My ideal is to make objects that have a longer life than I do; I therefore try to give my work a beauty that transcends time■"

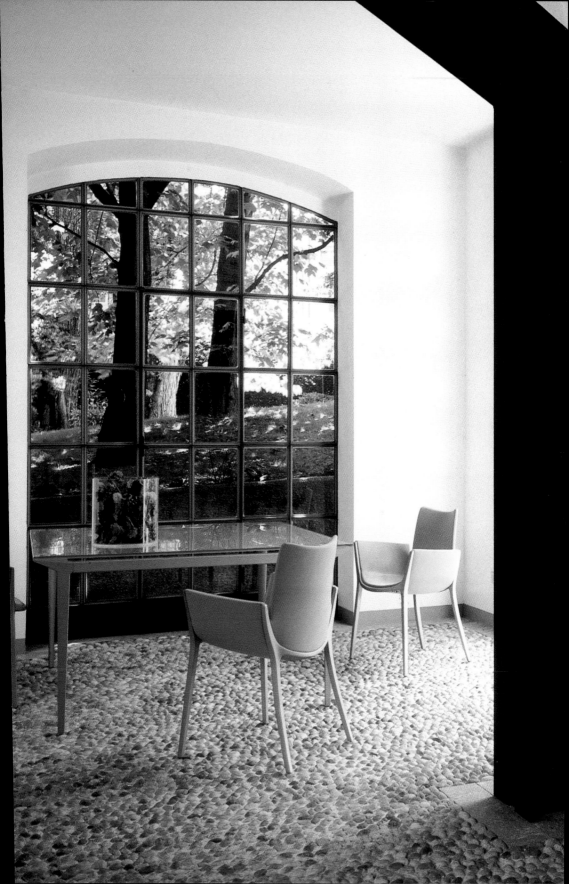

5. CHAIR "MOMO", from Andreu World.
Wooden structure. Metallic frame.
Upholstered seat and backrest.
6. CHAIR "POL", from Akaba.
Polished steel tube structure, arms in
glass reinforced polyamide. Seat and
backrest in polypropylene. Stackable.
With arms:
⊢ 82 ⊟ 56 ⊢ 55 ⊟ 45 cm.
Without arms:
⊢ 82 ⊟ 46 ⊢ 55 ⊟ 45 cm.
7. OFFICE CHAIR "MUGA", from Akaba.
Synchronized adjusting mechanism
incorporated. Available in various
versions, heights and finishes.
8. CHAIR "GORKA", from Akaba.
Structure of high pressure injected
aluminum. One-piece anatomic body
in glass reinforced polyamide. Can be
upholstered. Stackable.
⊢ 82.5 ⊟ 57.5 ⊢ 52 ⊟ 44.5 cm.
9. CHAIR "TOLEDO", de Amat-3
(photo courtesy of Knoll).
Anodized and polished aluminum
tube structure. Seat and backrest in
cast, polished and anodized alu-
minum.
⊢ 76 ⊟ 55 ⊢ 54 ⊟ 45 cm.

GAETANO PESCE

1 and 4. EASY CHAIR "SERIES UP",
1969/ 2000. Produced by B&B Italia▪
Inflatable easy chair molded in
polyurethane and covered with spe-
cial elastic fabric▪
⊟ 103 ⊟ 120 ⊟ 130 cm▪
2. EASY CHAIR "FELTRI", 1987. Pro-
duced by Cassina▪
Made entirely from thick felt. The
base has been impregnated in resin
to achieve resistance. Upholstered in
sown fabric▪
⊟ 130/98 ⊟ 73 ⊟ 66 ⊟ 45 cm▪
3. CHAIR "BROADWAY", 1993–2001.
Produced by Bernini▪
Stainless steel structure. Seat and
backrest in resin▪

1939 La Spezia, Italy▪

The architect, artist, and designer Gaetano Pesce was one of the most
important designers of the twentieth century and he continues to be so
in the twenty-first. From the beginning, he has surprised the design
arena by maintaining an absolutely personal code, by defending his
creative independence from any aesthetic cannon, universal or absolute,
and by expressing his freedom with respect to any limitations imposed
by technology and tradition▪

He started to stand out in the '60s when he first presented his ex-
uberant forms, abundant with symbolic implications, in contrast to the
cold and empty geometry imposed by functionalism. His series of in-
flatable seats, called Up, in anthropomorphic and sensual forms
sculpted in polyurethane led him to international fame and introduced
a new way of understanding design. Since then, he has maintained
his position against the separation of function and meaning, of art and
design and has based his work on the continual exploration of mate-
rials: "Every artist expresses himself with the materials of his time. I
use resin." Pesce unifies the logic of production on a large scale and
reduced costs with the creation of unique and unrepeatable objects
and manages to make his art accessible to all▪

Throughout his career, Pesce has contributed to the redefinition of
the principles that govern the practice of design and architecture in
his conviction that they are very powerful tools and can be used to in-
vent a new world. Pesce also defends fortuity, the happy accidents, in
the processes of creation and production and endorses the idea of di-
versified industrial series as opposed to a dominant standardization▪

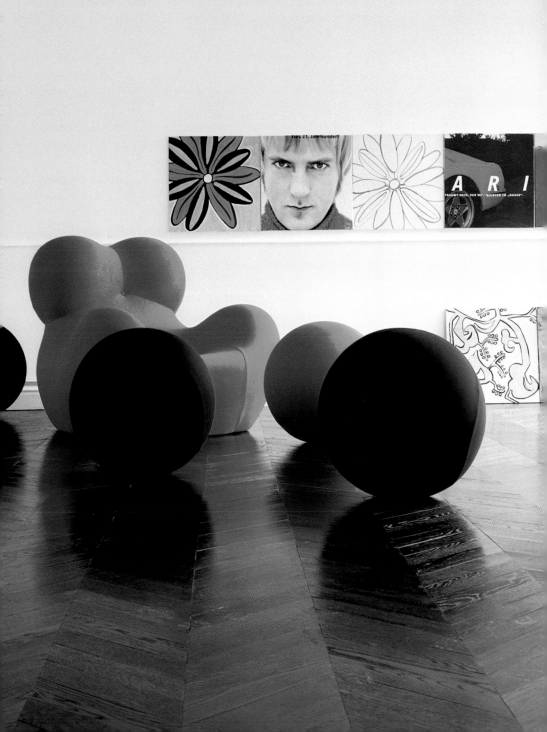

KARIM RASHID

1, 3 and 4. CHAIR "ALO", 2002. Produced by Magis∎
Structure in aluminum tube, with or without arms. Seat in aluminum. Reverse side of seat in polypropylene. Stackable. Suitable for outdoor use∎
⊢ 82 ⊟ 53 ⊢ 55 cm∎
2. CHAIR "BUTTERFLY", 2002. Produced by Magis∎
Structure in chromed steel tube. Seat and backrest in ABS molded by injection∎
⊢ 82.5 ⊟ 54.5 ⊢ 55.5 ⊟ 46 cm∎
5. STOOL "ARP". Produced by Pure Design∎
Base in steel. Seat in laminated wood. Two heights: 88.9 and 73.7∎
6. "OH CHAIR". Produced by Umbra∎
Steel structure. Seat in polypropylene. Stackable∎

1960 Cairo, Egypt∎

Karim Rashid is considered to be a "super star" in the panorama of contemporary design. From his New York studio, which he established in 1993, he designs all sorts of articles for companies ranging from fashion collections to wastepaper bins∎

Rashid defines his style as "sensual minimalism" or "sensualism" given that its fluid, soft, organic forms results in the attention being focused on the content of the object and not on its form, which is practically without ornamentation, and therefore it becomes minimalist. "Objects should unite experience with form in such a way that they become inseparable. This means redrawing objects that we live with so that they adjust to the way in which we really live. That

is to say that if we laze in chairs we should produce chairs that allow us to do so∎"

Rashid thinks that the future of design is in the fabrication of "made to measure" objects that will be personalized according to the demands of each customer. He considers that this will be feasible due to the new possibilities that will be offered by the technologies of the future. In fact, even now he designs his objects completely bY computer∎

His objective is to break with the norms of the past, to center himself on nothing more than necessities and real options of the present and future with the aspiration of creating surroundings in which technology, automation and systems based on experience make life easier. However, above all, Rashid's desire is to improve his environment as is suggested by the title of his book, *I Want To Change the World*∎

PHILIPPE STARCK

1949 Paris, France∎

Many consider Philippe Starck to be the guru par excellence of contemporary design. A modern reincarnation of King Midas who converts everything he touches into gold, from the interiors of hotels and bars, to yachts, motorbikes, sunglasses, kitchen utensils or chairs. Nothing seems to escape his creative influence. This prolific activity has transformed him into an omnipresent designer∎

In the '80s, he started to design furniture and accessories for the most representative firms in the industry. He went about this by developing objects with suggestive forms that distilled sensuality and personality. Some of his creations imply a reinterpretation of ancient decorative styles in the way that they combine contemporary materials with aesthetics that belong

1. EASY CHAIR "ZBORK", 2002. From Kartell∎
Made in colored polyethylene in the form of a sack. Suitable for outdoor use∎
2. CHAIR "LOUIS GHOST". From Kartell∎
Made in colored or transparent polycarbonate and imitates the Louis XV style. Suitable for outdoor use∎
⊟ 94 ⊟ 54 ⊟ 55 ⊟ 47 cm∎
3, 7 and 8. CHAIR AND STOOL "HUDSON". Produced by Emeco∎
Series of seats made in aluminum, polished or unpolished. Dimensions: chair without arms,
⊟ 85 ⊟ 43 ⊟ 50 ⊟ 46 cm∎
chair with arms,
⊟ 85 ⊟ 53 ⊟ 50 ⊟ 46 cm∎
stool,
⊟ 109 ⊟ 46 ⊟ 55 ⊟ 75 cm∎
4. CHAIR "BO", 2002. Produced by Driade∎
Made in polypropylene. Stackable. Suitable for outdoor use. (Photo: T. Vack)∎
⊟ 81 ⊟ 50 ⊟ 53 ⊟ 45 cm∎
5. CHAIR "HERITAGE". From Emeco∎
Structure in aluminum. Backrest available in fiberglass or in wood∎
⊟ 84 ⊟ 44 ⊟ 51 ⊟ 46 cm∎
6. CHAIR "TOY", 1999. From Driade∎
Made in polypropylene. Stackable. Suitable for outdoor use∎
⊟ 78 ⊟ 61.5 ⊟ 57.5 ⊟ 43 cm∎
9. CHAIR "SOFT EGG", 2002. Produced by Driade∎
Made in polypropylene. Stackable. Suitable for outdoor use∎
⊟ 74 ⊟ 60.5 ⊟ 57.5 ⊟ 43.5 cm∎
(Photo: T. Vack)∎

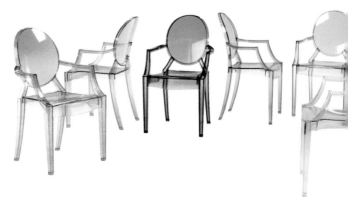

to the past. Starck is controversial personage full of contradictions who has known how to apply the rules of marketing to his very own person and who has awarded himself a halo of romanticism and geniality. In the last few years, he has initiated a campaign against design for design's sake, against compulsive consumerism and in the defense of the necessity to include in the process aspects of morality, honesty and objectivity∎

He has published the catalogue "Good Goods" in which he lists more than 200 "honest" objects that intend to open the way to replacing "the beautiful petrol culture for the humanist coupon of gas." The intention is to create lasting ecological objects that have a legitimate reason to exist and that respect the person. In this way, Starck is one more on the list of those who think that design can change the world and who strive towards "the creation of greater happiness with fewer things∎"

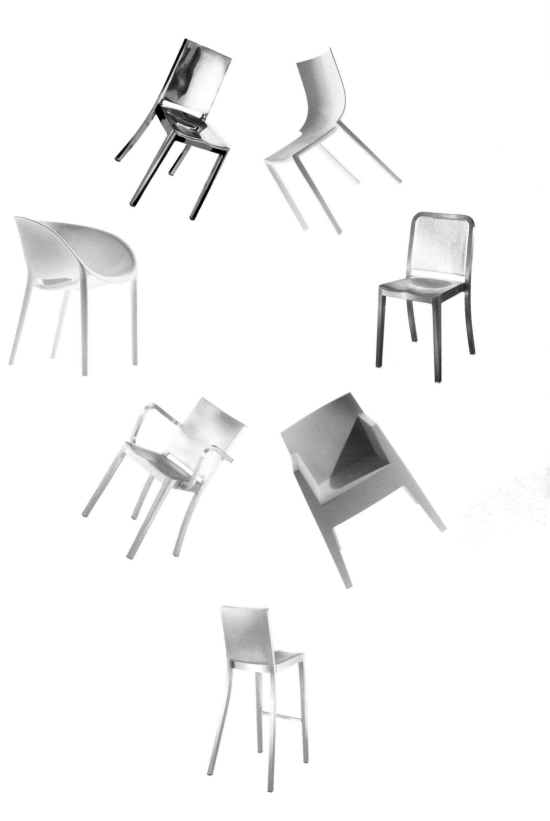

13. Chair "Lord Yo", 1994. Produced by Driade■
Structure in aluminum. Body in polypropylene. Stackable. Suitable for outdoor use■
⊟ 94.5 ⊟ 64 ⊟ 66 ⊟ 45 cm■

14. Office chair "Hudson". Produced by Emeco■
Made in aluminum. Adjustable height■
⊟ 79/86 ⊟ 61 ⊟ 61 ⊟ 41/48 cm■

15. Chair "Ero/s/". Produced by Kartell■
Aluminum rotatable base. Transparent or colored polycarbonate body. Organic egg shape■
⊟ 79 ⊟ 62 ⊟ 70 ⊟ 46 cm■

16. Easy chair and sofa "Ploof", 2002. Produced by Kartell■
Legs in polished aluminum. Seat and backrest in one piece of colored polyurethane■

17. Work chair "Hula Hoop". Produced by Vitra■
Body in dyed polypropylene, with armrests and integrated padding. (Photo: M. Eggimann)■

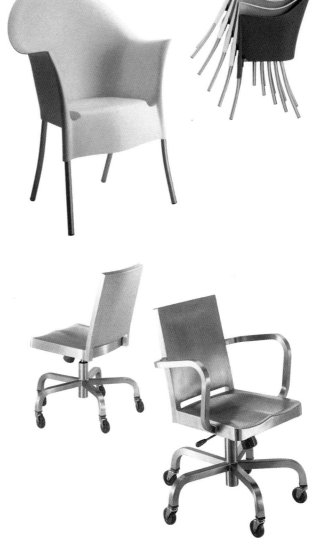

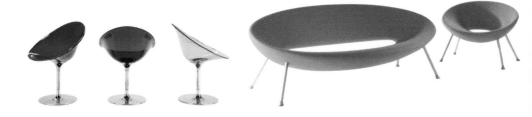

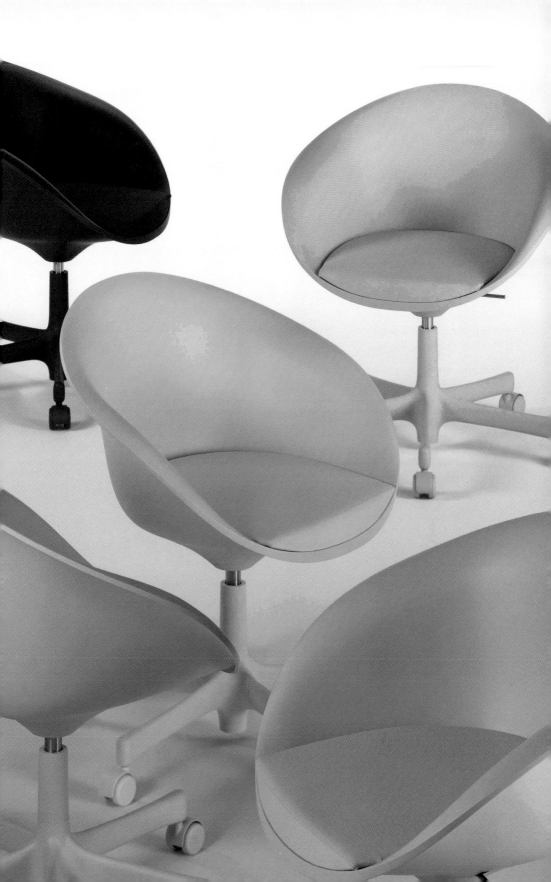

MARCEL WANDERS

1 and 3. CHAIR "GWAPA LOUNGE" and "GWAPA DINNER", 2001. Produced by Moooi. (Photo: M. van Houten)∎
Structure in stainless steel covered in rattan. Manufactured in version suitable for outdoor use. Dimensions: lounge,
⊟ 61 ⊟ 78 ⊟ 82 cm∎
dinner,
⊟ 75 ⊟ 55 ⊟ 57 cm∎
2. CHAIR "V.I.P.", 2000. Produced by Moooi. (Photo: M. van Houten)∎
Upholstered in a fabric similar to felt∎
⊟ 78 ⊟ 62 ⊟ 53 cm∎
4. "FLOWER CHAIR", 2001. Produced by Moooi. (Photo: M. van Houten)∎
Structure in chromed steel∎
⊟ 65 ⊟ 78 ⊟ 74 cm∎
5. "KNOTTED CHAIR", 1996. Produced by Cappellini∎
Made of string tied by hand and glued over a carbon nucleus. The result looks like a work of macramé. Prize Rotterdam Design∎
⊟ 70 ⊟ 50 ⊟ 65 cm∎

1963 Boxtel, Holland∎

"I am here to create a climate of love, to live with passion and to make my most emotional dreams come true∎"

Over the last few years, Marcel Wanders' contribution to the design industry has been one of the main reasons that has led Dutch design to position itself at the head of the avant-garde and to convert Amsterdam into one of the new centers of the international circuit∎

His work is along the same lines as others who wish to fuse utility and art, and he stresses his preoccupation with ecological conservation: "Durability in the field of ideas, relations, objects, etc., not only to create a less wasteful world, but to create deeper and more meaningful relationships with our environment∎"

In 1995, after realizing how difficult it was to find producers for objects based on new and different concepts that go beyond mere beauty, he founded his own studio in Amsterdam. One of the bases of his creative philosophy is the continuous exploration of the way in which modern technology interacts with nature. Wanders tends to adopt the brisk technological changes in his designs to show how nature has a greater capacity to assimilate innovation than to gather up strength to fight against change∎

For a number of years, he has been the art director of the Dutch company Moooi, which has become a launching pad for young designers with unusual and ambitious ideas, and initiates a constant challenge to the conventional meaning of beauty. The object is that which the forms fill with meaning∎

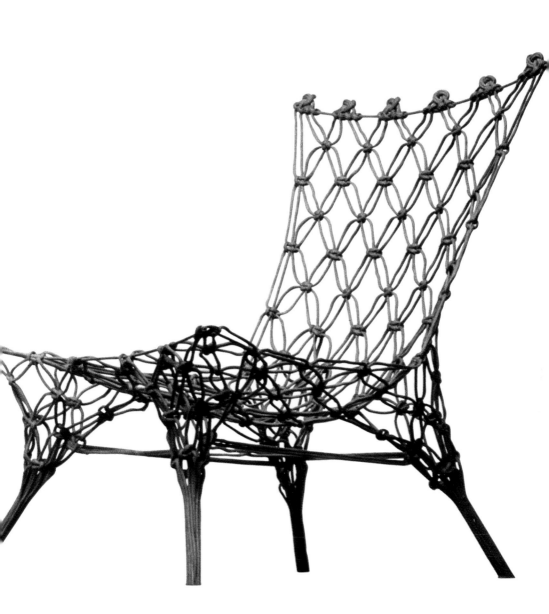

ANDREA BRANZI

1 and 3. CHAIR "REVERS", 1993.
Produced by Cassina■
Structure in aluminum. Seat in
beech ply. Backrest and armrests
formed by a strip of solid beech■
⊟ 76 ⊟ 64 ⊢ 51 ⊟ 45 cm■
(Photo: A. Zani)■
2. CHAIR "LORI", 1995. Produced by
Zanotta■
Totally upholstered in leather■
⊟ 82 ⊟ 41 ⊢ 52 ⊟ 46 cm■

1938 Florence, Italy■

In 1964, Andrea Branzi became a founding member of the radical de-
sign, or anti-design group, Archizoom, which was to be the first avant-
garde design group to become known internationally and which also
collaborated with the Alchimia studio and the Memphis group. Branzi
has always maintained a critical and experimental attitude toward so-
called "New Design" as much to the objects he has created and his
theoretic contributions. An eloquent example of this was the collection
of objects/creatures that he created in 1985 and 1986 called Domes-
tic Animals composed of fetish and contemplative designs produced in
natural materials and which evoked tribal rituals■

"Design is an activity that implicates a highly complex thought process
and that has an original logic of its own in which the aesthetic explo-
ration is tied to industrial strategies in which technology is only one part
of the symbolic context. The relationships between art and design are not
easy to theorize because they are always spontaneous and discontinuous■"

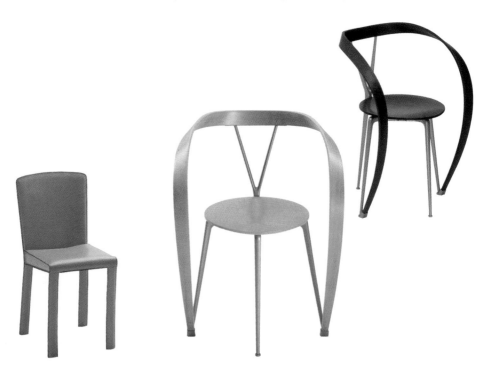

MATALI CRASSET

1965 Châlons-en-Champagne, France∎

This young designer has become known in the panorama of European design for her brilliance. After working with designers of the stature of Denis Santachiara and Philippe Starck, with whom she collaborated for five years developing articles for Thomson, she has established her own studio in Paris. Her activity ranges from furniture and accessories for interiors to theatre design, architecture, cosmetics, jewelry and clothes∎

Her vision of design is lucid, imaginative and poetic. In the furniture that she creates, she centers her interest in the temporary aspects of everyday objects and tries to escape from immobile or static interiors. To achieve this, Crasset stamps flexibility and mobility on her pieces of furniture so that the user can decide how and where to use them for him or herself. She calls this type of flexible situation, "polyvalent life"∎

1 and 3. Chair "Capriccio di Ugo". Produced by Domodinamica∎
Reclinable arms that convert into supports and act as auxiliary tables∎
⊢ 75 ⊟ 60/105 ⊢ 55 cm∎
2. Work chair "Capriccio di Ugo". From Domodinamica∎
Office version that incorporates wheels. Adjustable height∎
⊢ 80/88 ⊟ 62 ⊢ 55 cm∎

1 and 3. EASY CHAIR "ICON", 2002.
Produced by Fredericia Furniture.
Structure in stainless steel. Seat and
backrest upholstered. Flexible back-
rest.
2. CHAIR "SONAR", 2000. Produced
by Fredericia Furniture.
Metallic structure. Seat and backrest
in wood, upholstered version available.
Stackable.

1923 Copenhagen, Denmark.

Recently honored with the title of "First Lady of Danish Furniture
Design" at the Scandinavian Furniture Fair, Nanna Ditzel has been
creating innovative and functional furniture for more than five
decades.

She began her career after World War II at a time when very few
women worked in furniture design. She has always felt a need to ex-
periment with new techniques and new materials, with which she cre-
ates forms that are not only practical, but also original. Her furniture
ranges from the multifunctional pieces that she devised in the early
years of her career, intended to adapt to reduced spaces, to furniture
in wood for children and to a line of exotic chairs inspired by flowers
and seashells.

An icon in her country, Nanna Ditzel has been, along with Verner
Panton, one of the most influential and distinguished figures in Danish
design of the last few decades. Her ageless talent and ever youthful
spirit drives her to continue creating furniture.

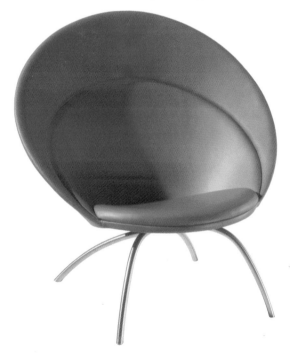

FRANK GEHRY

1929 Toronto, Canada▪

"Designing a new chair is like being asked to come up with the meaning of life while walking with a limp▪"

Frank Gehry is one of the most innovative architects of our time. He works in a vocabulary all his own, which has been strongly influenced by contemporary art and which leads him to approach his projects as if they were large sculptures with their own movements developed from a reinvention of materials▪

His designs for furniture are a rendering of his architectural philosophy and reflect his interest for the manipulation of basic materials to produce objects that are both functional and visually exciting. His first furniture collection, produced at the end of the '60s, was fabricated in cardboard with the intention of creating furniture that was both economical and expressive at the same time. Over the last few years, he has designed chairs in interlaced curved wood that, as in his previous collections, display a reaction against the expectations of the furniture market▪

1 and 4. CHAIR "FOG", 1999. Produced by Knoll▪
Aluminum body and steel legs. Flexible backrest. Stackable. Suitable for outdoor use▪
2. "HIGH STICKING CHAIR". Produced by Knoll▪
Inspired by the apple boxes with which he played in his youth, Gehry has created this series of chairs with thin strips of interlaced sycamore▪
3. CHAIR "HAT TRICK". Produced by Knoll▪
Structure in sycamore. The chair has been molded as if it were made of tape▪

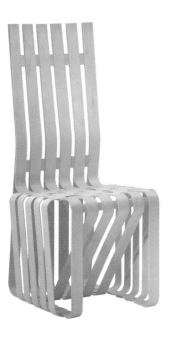

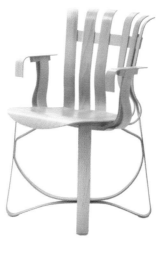

STEFANO GIOVANNONI

1. Chair "Bombo", 1999. Produced by Magis■
Base in chromed steel. Body in injection molded ABS. Swivel seat. Fixed or adjustable height■
⊢ 85/96 ⊟ 40 ⊢ 40 ⊟ 46/56 cm■
2. Easy chair "Kalla". Produced by Domodinamica■
Rotating aluminum base. Seat upholstered in elastic fabric. The arms can be opened or closed permitting numerous positions■
⊢ 88/99 ⊟ 58 ⊢ 58 ⊟ 48/59 cm■
3. Task chair "Bombo", 2000. Produced by Magis■
Base in stainless steel. ABS body. Castors in polyamide. Regulable in height thanks to gas piston■
⊢ 105.5 ⊟ 110/170 ⊢ 83 ⊟ 39 cm■

1954 La Spezia, Italy■

Stefano Giovannoni is one of the most well known expounders of commercial design focused on mass production. His objects, being colorful, amusing, functional and attainable by all, led him to being classified as what could be called "democratic design." In fact, Giovannoni was one of the central figures of the revolution of the '80s which led to a change from the idea of design being something elitist and intellectual to it becoming understood as a means of mass communication■

His designs are a reflection of his passion for rounded forms and his interest in comics, science fiction, film, mythology and the spheres of artificial and imaginative fiction. His objective is to design articles for mass production: "I am interested in design as a factor of large-scale consumption; to design objects to be used by everyone has always been one of my objectives." To help fulfill this aspiration he uses innovative communicative codes and materials—especially plastics—which stimulate market development■

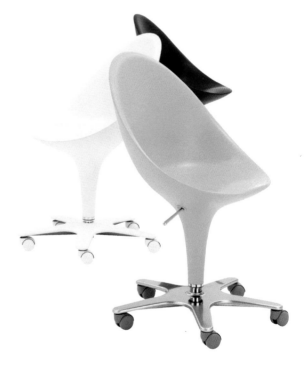

KONSTANTIN GRCIC

1965 Munich, Germany∎

When Konstantin Grcic, considered to be one of the most important transformers of contemporary design, is asked about the future of this discipline, he responds loyally to the philosophy behind his work: "We will make fewer products, but we will make them better. We will make things that are simple, but we will not make them simpler. We will love beautiful things, but these may be unrefined. We will use technology, but in a natural way. We will consider a mass market, but as a mass of individuals. We will work a lot, but we will enjoy it a lot∎"

After studying in London and working with Jasper Morrison for a year, Grcic established his own studio in Munich in 1991. His works are a reflection of his love for simple things, his pragmatism, of a minuscule observation of the world of objects and a strong affection for the history of design. The clarity of his creations is often accompanied by unexpected solutions that unite efficiency with a certain amount of irony∎

1 and 2. Easy chair "Chaos". Produced by Classicon∎
Base in steel and upholstered in fabric or leather∎
⊢ 74 ⊟ 90 ⊢ 66 ⌐ 42 cm∎
3. Chair "Tabac", 2001. Produced by Montina∎
Structure in laminated ash. Seat upholstered in fabric or leather∎
⊢ 78 ⊟ 51 ⊢ 57 ⌐ 46 cm∎

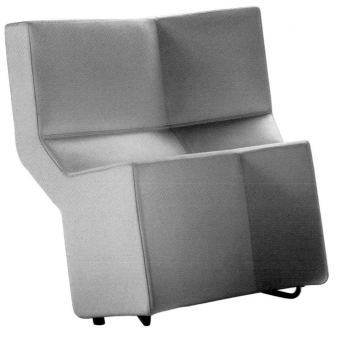

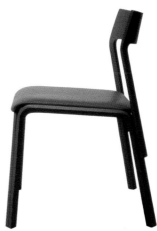

MASSIMO IOSA GHINI

1 and 2. CHAIR "OPEN". Produced by Domodinamica▪
Structure in steel. Wooden seat covered in Cordura®. Backrest can be folded to convert piece into stool▪
⊟ 58/90 ⊟ 45 ⊟ 51 cm▪
3. STOOL "OPEN BAR". Produced by Domodinamica▪
Structure in steel. Wooden seat covered in Cordura®. Folding backrest▪
⊟ 80/124 ⊟ 45 ⊟ 51 cm▪

1959 Bologna, Italy▪

Architect and designer, Massimo Iosa Ghini is well known for his participation in the trends of the Italian avant-garde and for having been a founding member of Bolidism—an architectural movement based on the idea of velocity as a dominant theme in the contemporary world—and for having designed objects and interiors for the Memphis group▪

Iosa Ghini started his career as an extremely sophisticated comic strip draftsman for trendy magazines and later translated this freedom of expression to three-dimensional objects. Since 1986, he has had his own studio in which he develops projects that range from defining the aesthetic appearance of a product, its technical development and the construction of its prototype, to the development of interior design for large companies such as Ferrari or Superga. His works are characterized by their dynamics and fluidity which evoke a sensation of speed that goes back to the style created by Bolidism▪

1958 Cardiff, Wales.

"A good chair is like a face, you know thousands, but only remember a few."

Ross Lovegrove is profiled as being one of the major designers destined to define the culture of our times and to stimulate a new vision of the future. His motto is, "Form follows emotion" and he uses a humanist focus as an axle in his creations in which he combines in equal doses his enthusiasm for industrial processes, his inspiration in forms from nature, and his ability to evoke an emotional response in his users. The results are forms that are organic, ergonomic and lasting.

From his studio in London, founded in 1990, he creates objects for the leading companies of the industry. He makes use of the most up-to-date materials such as polypropylene, carbon fiber or magnesium, as well as emerging technologies to develop his products, which are to be easily used and produced and to show, at the same time, a clear sensitivity as far as ecology is concerned.

1. SEAT "LOVENET SILVER", 2002. Produced by Moooi.
Structure in steel with PE fabric. The width of the armrests allows it to function as an auxiliary table.
⊟ 90 ⊟ 150 ⊟ 80 cm.
2. OFFICE CHAIR "SPIN", 1997. Produced by Driade.
Structure in steel. Body in polypropylene. Adjustable height.
⊟ 77/88 ⊟ 69 ⊟ 55 ⊟ 40/51 cm.
3. EASY CHAIR "AIR ONE", 2000. Produced by Edra.
Stackable easy chair made of polypropylene foam. Extremely lightweight.
⊟ 53 ⊟ 115 ⊟ 115 cm.

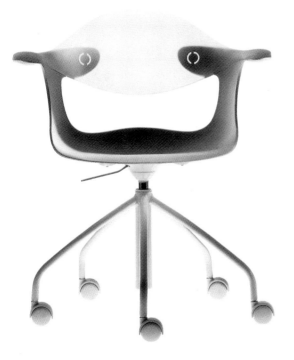

ENZO MARI

1 and 4. CHAIR "DELFINA", 1979. Produced by Robots■
Steel chromed structure. Backrest and seat in Kvadrat cotton. Compasso d'Oro Prize, 1979■
⊢ 79 ⊣ 48 ⊢ 57 ⊟ 47 cm■
2. CHAIR "TONIETTA", 1985. Produced by Zanotta■
Structure in aluminum polished or painted black. Seat and backrest upholstered in leather or in painted nylon■
⊢ 82 ⊣ 39 ⊢ 48 ⊟ 46.5 cm■
3. CHAIR "MARINA", 1991. Produced by Zanotta■
Structure in wood. Seat and backrest upholstered in leather■
⊢ 83,5 ⊣ 39 ⊢ 48 ⊟ 46.5 cm■

1932 Novara, Italy■

As revealed by Alberto Alessi in his book *The Dream Factory*, Enzo Mari holds a leading role in the 'hard and pure' vision of design applied to industrial production: maintain your fantasies under control, no uncalled-for ornamentation, but a constant search for that archetypal simplicity which is the only justification for bringing a new product into our already overpopulated consumer society■"

Enzo Mari has become one of the greatest authorities within Italian design due to his constant search for and experimentation with new forms and meanings which often fall into conflict with the overriding trends in industrial design. In his theories, he is critical of the consumer society and of the control exerted by marketing over present production. For all of this, he is considered to be "the critical conscience of design■"

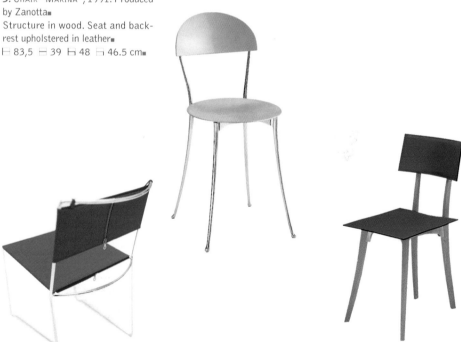

MARC NEWSON

1963 Sydney, Australia■

Marc Newson is one of the cult designers of the twentieth century. His futuristic approach, which is original and technically rigorous within the design world, has allowed him to take on projects ranging from chairs to a private jet and a car■

On occasion, the development of his projects have led him to act as if he were an engineer. He has constructed his own bicycles, watches or, and his first piece of furniture, the Lockheed Lounge, which he made in 1987 with a fiberglass base covered with sheets of aluminum and which led to his recognition■

Based in London since 1997, having previously worked in Sydney, Tokyo and Paris for some years, Marc Newson sums up his work in a highly creative and nonconformist way that leads him to depart from established schemes and to observe things from a side view as he imagines what a perfect version would be: "What has always motivated me as a designer is being bothered by the rubbish that surrounds me and the desire to improve it■"

1 and 3. "COAST CHAIR", 2002. Produced by Magis■
Structure in glass reinforced polypropylene. Seat and backrest upholstered in wool or leather■
⊟ 79.5 ⊟ 48.5 ⊟ 48.5 ⊟ 45.5 cm■
2. "FELT CHAIR", 1989. Produced by Cappellini■
Structure in molded fiberglass with ergonomic forms. Aluminum legs. Also made with structure upholstered in fabric or leather
⊟ 86 ⊟ 67 ⊟ 106 cm■

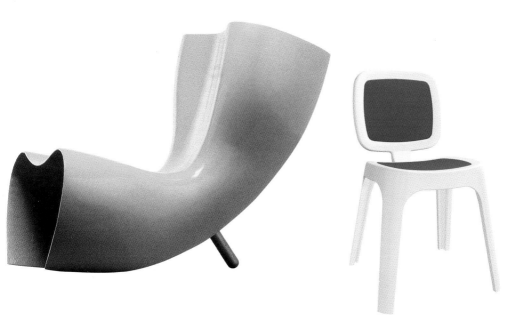

METALLIC REFLECTIONS
ALUMINUM, STEEL...

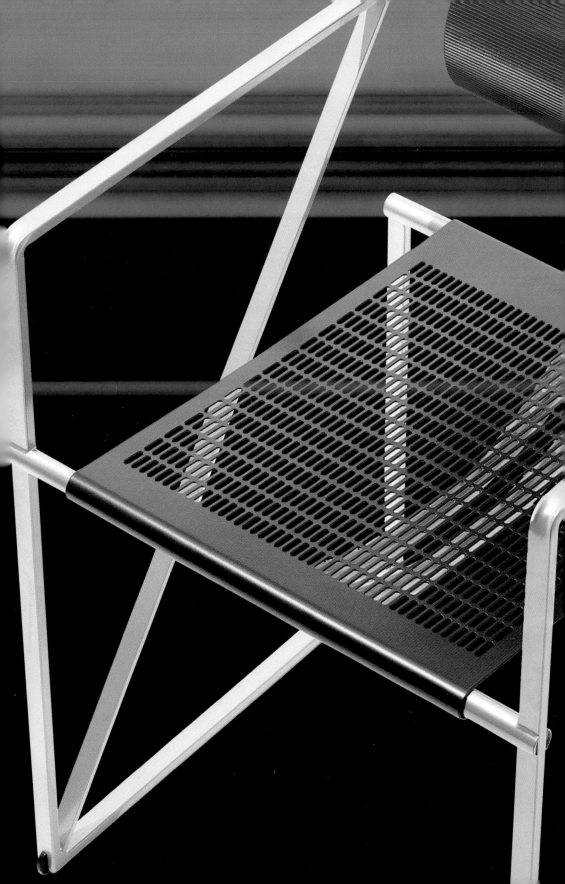

1. EASY CHAIR "BLOOM", 2000.
From Giorgio Cazzaniga for Living
Divani■
Combination of base in steel with
seat in wood, interior upholstered■
2. CHAIR "GAZELLA", from Jonathan
Crinion for Sintesi■
Structure in steel tube. Seat and
backrest in steel sheet■
⊟ 82 ⊟ 51 ⊟ 58 cm■
3. CHAIR "PAKI" from Bruno Rainaldi
for Alivar (Collection Brilliant Furni-
ture)■
Structure in steel. Seat and backrest
upholstered in fabric or leather.
Stackable■
⊟ 81 ⊟ 45 ⊟ 55 cm■
4. CHAIR "MEGAN". Produced by
Galvano Tecnica■
Structure in steel tube. Seat and
backrest in polypropylene■
⊟ 81 ⊟ 50 ⊟ 62 ⊟ 44 cm■
5. CHAIR "MIRANDOLINA", 1992.
From P. Arosio for Zanotta■
Structure in aluminum. Stackable.
Suitable for outdoor use■
⊟ 84 ⊟ 48 ⊟ 53 ⊟ 46 cm■

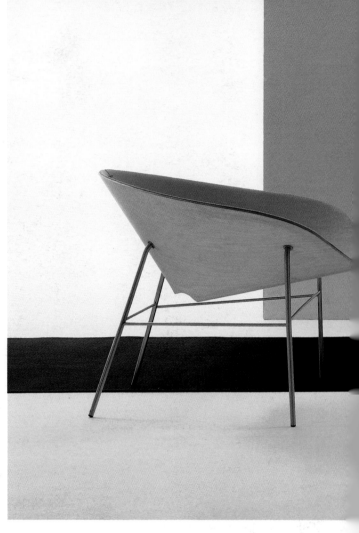

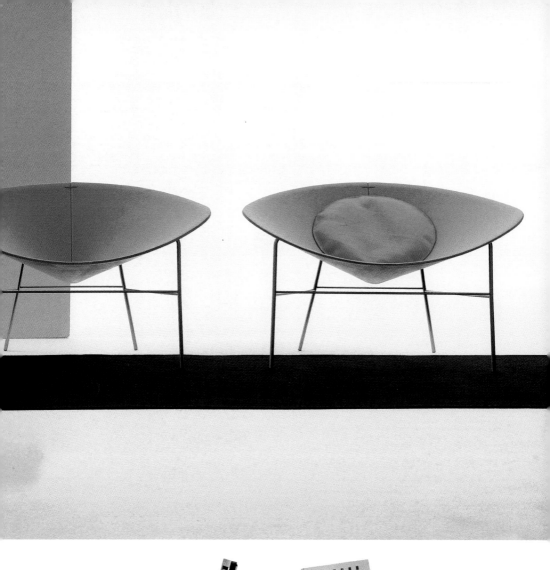

1. CHAIR "ZILLI", 2002. From Roberto Barbieri for Zanotta.
Structure in polished or painted aluminum, seat and backrest in polyester and PVC mesh or upholstered in fabric or leather. Stackable. Suitable for outdoor use.
⊟ 78 ⊟ 49 ⊟ 54 ⊟ 46 cm.

2. CHAIR "GAS", 2002. From Jesús Gasca for Stua.
Structure in polished aluminum. Seat and backrest upholstered or in synthetic mesh. IF Design Award. Red Dot Design Prize.
⊟ 78,5 ⊟ 50 ⊟ 48 ⊟ 44 cm.

3. CHAIR "COSMOS", 1999. From Gunilla Allard for Lammhults.
⊟ 80 ⊟ 44/50 ⊟ 51 ⊟ 46 cm.

4. CHAIR "LAGOA", from Enrico Franzolini for Accademia.
Structure in aluminum. Seat and backrest in polypropylene or oak.
⊟ 79 ⊟ 44 ⊟ 53 ⊟ 46 cm.

1. CHAIR "BOULEVARD", 1994–95.
From F. A. Porsche for Ycami∎
Made in aluminum. Stackable∎
⊢ 77 ⊟ 55 ⊦ 57 ⊟ 44 cm∎
2. CHAIR "ALU UNO", 2000. From
Kurt Thut for Indecasa∎
Structure in anodized aluminum.
Multiple combinations in backrest, in
polypropylene or aluminum and seat
in plywood or aluminum∎
⊢ 73 ⊟ 42.5 ⊦ 49.5 ⊟ 45 cm∎
3. CHAIR "ZEBRA". Produced by Sin-
tesi∎
Structure in steel tube. Seat and
backrest in water-resistant wood∎
⊢ 82 ⊟ 56 ⊦ 58 ⊟ 47 cm∎
4. CHAIR "TALLE", from P. King and
S. Miranda for Sellex∎
Structure in stainless steel. Seat
body in curved plywood∎
5. CHAIR "GINESTRA", 1994. From P.
Scarzella and P. Rasulo for Zanotta∎
Structure in aluminum. Seat and
backrest in natural fiber∎
⊢ 82 ⊟ 45 ⊦ 52 ⊟ 45 cm∎

1. CHAIR "GINGER", 1998. From Maurizio Peregalli for Zeus Noto∎ Structure in steel. Seat and backrest in metal∎

⊟ 81 ⊟ 49 ⊟ 54 ⊟ 46 cm∎

2. CHAIR "ZEBRA", from Johnny Sørensen for Magnus Olesen∎ Structure in tubular steel. Seat upholstered and backrest in beech or sycamore∎

3. CHAIR "FRAME", from Arco Meubel∎ Metallic structure finished in brilliant or matte chrome. Seat and backrest upholstered in fabric or leather∎

⊟ 83 ⊟ 50.5 ⊟ 57 ⊟ 45 cm∎

4. CHAIR "LILLY", from Sintesi∎ Structure in steel tube. Seat and backrest in plywood covered in aluminum∎

⊟ 85 ⊟ 40 ⊟ 50 ⊟ 46 cm∎

5. CHAIR "DONALD", from Studio Cerri & Associati for Poltrona Frau∎ Structure in aluminum. Seat and backrest upholstered in leather, with the Pelle Frau® color system. Folding∎

⊟ 76 ⊟ 46 ⊟ 49 ⊟ 45 cm∎

6. CHAIR "S60", from Glen Oliver Löw for Thonet∎ Cantilevered structure in steel. Seat body in wood, upholstered in fabric or leather. Reinterpretation of the Thonet chair from 1931 Designed by Mart Stam∎

⊟ 65 ⊟ 55 ⊟ 63 cm∎

7. CHAIR "ANTALYA". Created by Aldo Cibic for Bisazza∎ Structure in anodized aluminum with base covered in Vetricolor (20x20 mm) mosaic∎

1. Stool "Jim", from James Bruer and Scot Laughton for Pure Design. Base in chromed steel and seat in aluminum. Two heights: 76.2 and 61.

2. Stool "Copa", 1995. From Alfredo Arribas for Casas.
Support in cast aluminum. Seat in upholstered polyurethane. Three heights: 80, 65 and 45 cm.

3. Stool "Sputnik", from Vibiemme.
Base in steel. Swivel seat in plastic.
⊟ 93 ⊟ 59 ⊟ 82 ⊟ 59 cm.

4. Stool "Starla", from Pure Design.
Structure in steel. Seat upholstered in vinyl. Two heights: 76.2 and 61 cm.

5. Stool "Jacana", from Claudia e Mattia Frignani for Wunderkammer Studio.
Made in cast aluminum.
⊟ 78 ⊟ 40 ⊟ 40 cm.

6. Stool "Glow" from Rodolfo Dordoni for Fontana Arte.
The seat incorporates a light and thus also fulfills the function of a lamp.

7. Stool "Tantus", 2001. From Joan Casas Ortínez for Indecasa.
Structure and seat in aluminum. Swivel seat. Three heights: 80, 65 and 45 cm.

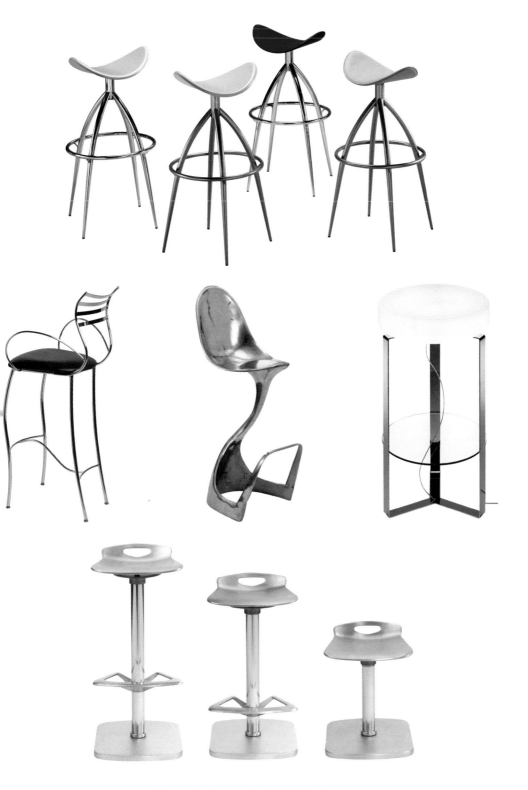

1. STOOL "TABLE-STOOL", from Richard Hutten for Pure Design▪ Fulfills the function of stool and auxiliary table. Structure in painted steel. Two heights: 76.2 and 61 cm▪
2. STOOL "JAMAICA" from Pepe Cortés for Amat 3 (Photo courtesy of Knoll)▪ Structure in chromed or painted steel tube. Swivel seat in cast aluminum or in solid beech. There is also a version with castors. Three heights: 77, 64 and 43 cm▪
3. STOOL "COCO", from Studio Kronos for Cattelan Italy▪ Structure in steel and seat in beech or upholstered in leather▪

⊢ 76/64 ⊣ 40 ⊢ 43 cm▪

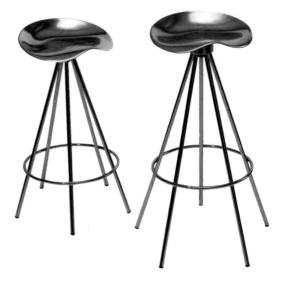

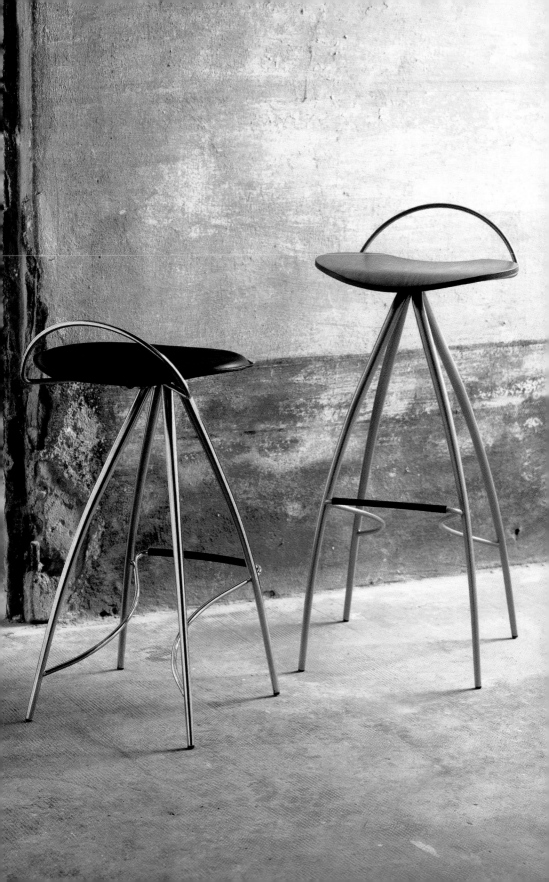

1. Chair and stool "Gaja" from Kazuhide Takahama. Produced by Ultramobile▪
Structure in chromed steel tube. Seat upholstered in rubber and synthetic wool. Chair:
⊟ 67 ⊟ 51 ⊟ 44 ⊟ 46 cm▪
stool:
⊟ 85 ⊟ 51 ⊟ 44 ⊟ 64 cm▪
2. Chair "Gin-Integra" 2002. Design from Mario Mazzer for Ycami▪
Structure in aluminum▪
⊟ 81 ⊟ 43 ⊟ 53 ⊟ 46 cm▪
3 and 4. Chair "Secondas" from Mario Botta for Alias▪
Structure in steel. Seat in perforated steel and backrest with cylindrical element in polyurethane▪
5. Chair Designed by Mario Botta. Produced by Alias▪
Sculptural forms with a structure of enameled steel▪

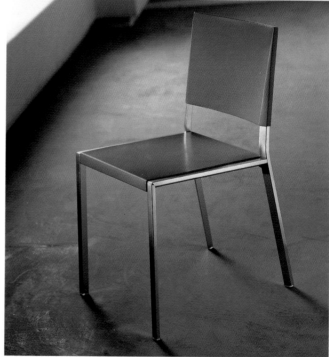

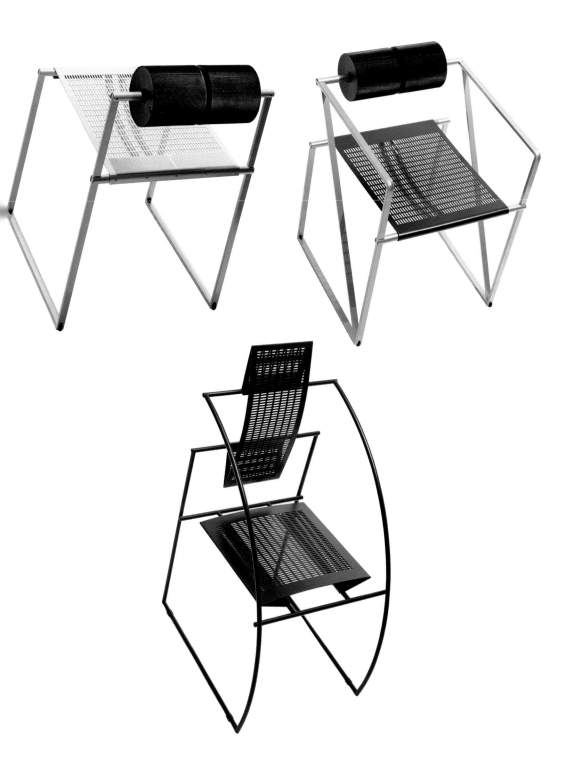

1. Easy chair "Centomila", 2001. From James Irvine for Magis▪ Structure in varnished steel tube. Seat and backrest in polypropylene. Stackable▪

🗌 70 🗌 66.5 🗌 57 🗌 39.5 cm▪

2. Chair "A900F", from Norman Foster for Thonet▪ Structure in anodized aluminum. Seat and backrest in transparent polypropylene. Stackable▪

🗌 80 🗌 55 🗌 53 cm▪

3. Chair "Tulu" from Kazuhide Takanama for Ultramobile▪ Structure in chromed steel tube. Seat and backrest upholstered in rubber and artificial wool. Stackable▪

🗌 73 🗌 48 🗌 51 🗌 43 cm▪

4. Easy chair "FTL Milana" from Jean Nouvel for Sawaya & Moroni▪

5. Chair "Vassili", from Sintesi▪ Reinterpretation of the classic model designed by Marcel Breuer. Structure in steel tube. Seat and backrest in PVC▪

🗌 78 🗌 78 🗌 79 cm▪

6. Easy chair "Spaguetti" from Giandomenico Belotti for Alias▪ Structure in steel. Seat and backrest in transparent PVC. Stackable▪

🗌 71 🗌 68 🗌 59 🗌 42 cm▪

7. Chair "Tempesta", Tanzi Design for Album▪ Structure in tubular steel. Seat and backrest in stainless steel. Stackable. Castors and arms optional▪

🗌 78 🗌 54 🗌 51 🗌 46 cm▪

8. Chair "Zilli", 2002. From Roberto Barbieri for Zanotta▪ Structure in polished or painted aluminum, seat and backrest in polyester and PVC mesh. Stackable. Suitable for outdoor use▪

🗌 78 🗌 49 🗌 54 🗌 46 cm▪

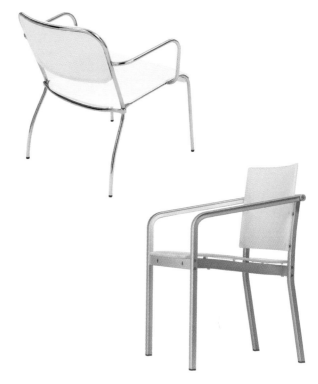

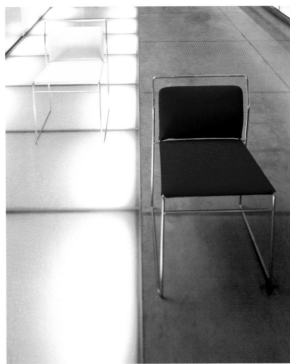

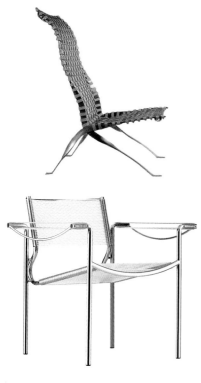

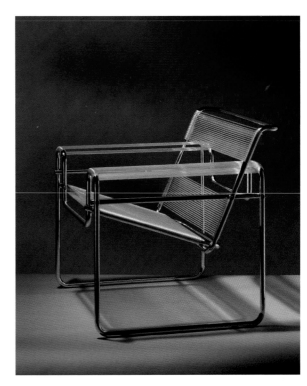

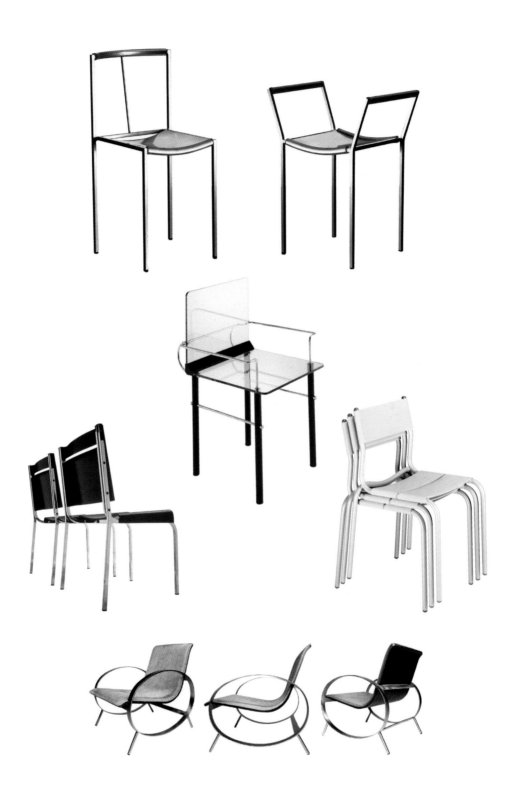

	1		6
2	3	4	
	5		7

1. COLLECTION "SEDIA", from Maurizio Peregalli for Zeus Noto▪
Structure in steel. Backrest in rubber. The seat is manufactured in various materials. Stackable. Chair dimensions:
▭ 81 ▭ 40 ▭ 44.5 ▭ 47 cm▪

2. CHAIR "UNISEX" from Raul Barbieri for Alivar (Gallery Collection)▪
Structure in chromed or painted steel. Backrest and seat in leather, walnut or lacquered in white▪
▭ 78/82 ▭ 48.5 ▭ 54 cm▪

3. CHAIR "3400" from the history file from Fontana Arte▪

4. CHAIR "MIES" from Natison Sedia▪
Structure in steel tube. Seat and backrest in polypropylene. Stackable▪
▭ 82 ▭ 52 ▭ 55 ▭ 43 cm▪

5. EASY CHAIR "CINQUANTA", 2000.
From William Sawaya for Sawaya & Moroni▪

6. CHAIR "MARGHERITA", 1997.
From Carlo Colombo for Ycami▪
Structure in aluminum. Seat and backrest in colored or transparent polycarbonate. Suitable for outdoor use▪
▭ 82 ▭ 42 ▭ 54 ▭ 45 cm▪

7. EASY CHAIR "LIPS", 2000. From Piergiorgio Cazzaniga for Dema▪
Structure in stainless steel. Body in laminated wood, upholstered interior▪
▭ 71 ▭ 95 ▭ 72 cm▪

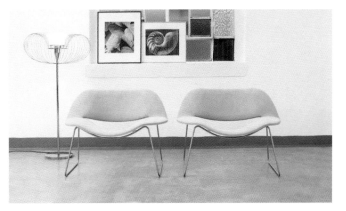

UPHOLSTERY

TEXTURE, COLOR AND COMFORT

1. CHAIR "OREA", from Gerard van den Berg for Label▪
⊟ 91 ⊟ 47 ⊟ 51 ⊟ 47 cm▪
2. MECEDORA "ROLY POLY", 2000. From Guido Rosati for Giovannetti▪ Structure in glass re-inforced resin. Upholstered in polyurethane that cannot be deformed and covered in protecting fabric▪
3. EASY CHAIR "SUNSET", 1997. From Cristophe Pillet for Cappellini▪ Structure in metal varnished in the color of aluminum. Swivel seat in plywood upholstered in fabric or leather▪
⊟ 75 ⊟ 82 ⊟ 45 ⊟ 41 cm▪
4. LOW EASY CHAIRS "TOKYO", 1997. From Nancy Robbins for Andreu World▪
Upholstered in a large variety of fabrics. The backrests are available in round or square formats▪

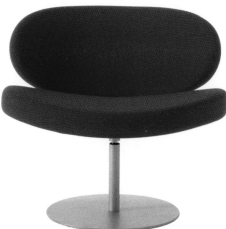

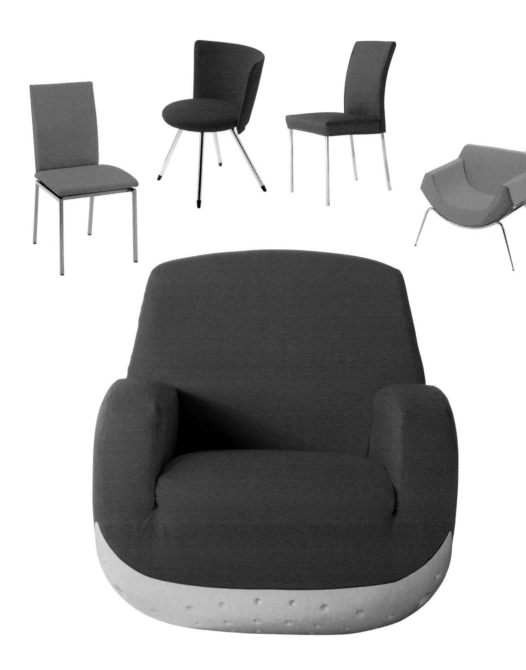

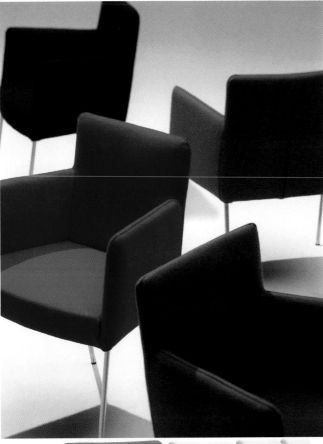

1. CHAIR "MAGAZINE" from Heitlinger Design for Calligaris▪
⊟ 90.5 ⊟ 45 ⊟ 55 ⊟ 4.,5 cm▪
2. CHAIR "DONNA" from Johannes Foersom and Peter Hiort-Lorenzen. Produced by Erik Jørgensen▪
3. CHAIR "ANNA" from J. Broente for Bonaldo▪
4. EASY CHAIR "MOSQUITO" from Fabrizio Gallinaro for Natison Sedia▪
Structure in chromed steel. Adjustable legs▪
5. ROCKING CHAIR "SWING", from Denis Santachiara for Domodinamica▪
Base in ABS. Rotation of 360°▪
⊟ 86 ⊟ 83 ⊟ 83 cm▪
6. CHAIR "TIBA" from Gerard van den Berg for Label▪
⊟ 81 ⊟ 61.5 ⊟ 53.5 ⊟ 46.5 cm▪
7. CHAIR "NEFER", 1999. From Diego Fortunato for CJC Concepta▪
Structure in beech. Seat and backrest upholstered in fabric or leather▪

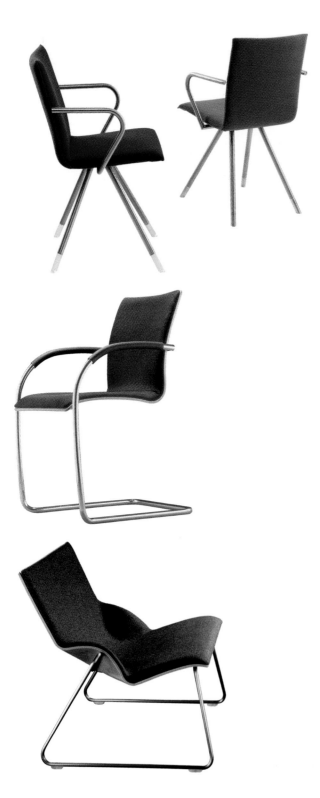

1. CHAIR "MIKADO", from Arco Meubel▪
Structure in stainless steel. Seat and
backrest upholstered in fabric or leather
or in lacquered wood. Transparent syn-
thetic legs or available in aluminum▪
⊟ 85 ⊟ 52 ⊟ 47 ⊟ 47 cm▪
2. CHAIR "S81", from Thonet▪
Structure in flexible tubular steel.
Upholstered seat and backrest▪
⊟ 84 ⊟ 54 ⊟ 56 cm▪
3. EASY CHAIR "S555", 2000. From
Jehs & Laub for Thonet▪
Structure in steel. Seat body in ply-
wood, upholstered interior▪
⊟ 79 ⊟ 75 ⊟ 69 cm▪
(Photo: M. Gerlach)▪
4. CHAIR "TRIENNALE", 1954/2002,
Design from Willem H. Gispen. Pro-
duced by Leolux▪
This model is a classic of German
design▪
⊟ 83 ⊟ 69 ⊟ 70 cm▪
5. CHAIR "ASIA", 2001. From Enrico
Franzolini for Crassevig▪
Structure in chromed steel. Seat and
backrest upholstered or in wood▪
⊟ 81 ⊟ 48 ⊟ 52 cm▪

1. STOOLS "CUBO", 2000. From Diego Fortunato for CJC Concepta∎ Structure in solid steel bar. Seat in upholstered wood∎
⊟ 80 ⊟ 28 ⊟ 28 cm∎

2 and 4. STOOLS "SOSHUN", 1990. From Masanori Umeda for Edra∎ Lacquered metallic structure. Seat upholstered in velvet and available in various colors. Two heights. Diameter: 56 cm∎

3. STOOL "TRAMPIE", 1996. From Paolo Golinelli for Zoltan∎ Structure in aluminum. Upholstered in leather or cotton. Four heights: 80, 70, 48 or 30 cm∎

5. STOOL "OTTO", 2002. From Design For Use for Zanotta∎ Structure in steel. Upholstered in fabrics or leather∎

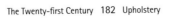

1	2
3	4
5	6

7

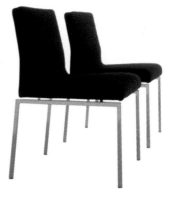

1. EASY CHAIR "SOLO" from Christian Steiner for Schmidingermodul■
Structure in beech■
⊟ 88 ⊟ 62 ⊟ 78 cm■

2. CHAIR "FIZZ" from Daniele Lo Scalzo Moscheri for Alivar (Gallery Collection)■
Structure in steel. Body in wood upholstered in fabric or leather■
⊟ 80 ⊟ 48.5 ⊟ 55.5 cm■

3. EASY CHAIR "WAITING" from CJC Concepta■

4. CHAIR "SMILLA", 2002. From Piergiorgio Cazzaniga for Acerbis International■

5. EASY CHAIR "GIGI" from Gerard van den Berg for Label■
Swivel seat■
⊟ 67 ⊟ 108 ⊟ 83 ⊟ 38 cm■

6. EASY CHAIR "POPI POP", Designed by Studio Ingenieria Modular for Domodinamica■
Reinterpretation of a classic form. Reclinable backrest■
⊟ 107 ⊟ 100 ⊟ 82 cm■

7. CHAIR "MEGGY", from Ca'Nova Design for Cattelan Italy■
Also manufactured without arms■
⊟ 85 ⊟ 43 ⊟ 52 ⊟ 46 cm■

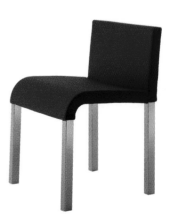

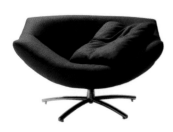

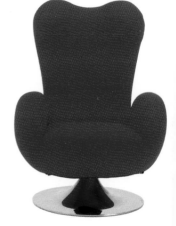

1. Easy chair "Saghi", from Kazuhide Takanama for Ultramobile∎
⊟ 67 ⊟ 64 ⊟ 76 ⊟ 40 cm∎
2. Easy chair "Bent", 2000. From Piergiorgio Cazzaniga for Dema∎
Structure in steel. Manufactured with or without armrests∎
⊟ 72 ⊟ 84 ⊟ 88 cm∎
3. Chair "Fun Bukko", from Natison Sedia∎
Structure in steel. Upholstered in leather or fabric∎
4. "Stafford Chair", 1998. From Andrew Stafford for SCP∎
Body in fiberglass. Interior completely upholstered. Legs in sycamore∎
⊟ 78 ⊟ 84 ⊟ 88 ⊟ 42 cm∎

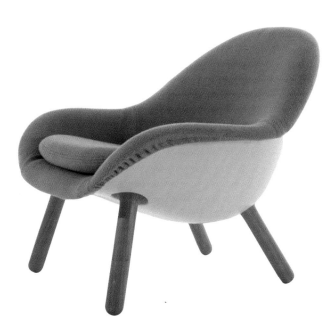

1. EASY CHAIR "DANDY" from Gijs Papavoine for Montis▪
Upholstered in fabric or leather▪
2. CHAIR "SHELLS", 2002. From Martin Ballendant for Tonon▪
Good Design Award 2002 from Chicago Athenaeum. Focus Gold Prize 2002, Germany▪
3. EASY CHAIR "SHELL" from Club 8 Company▪
4. CHAIR "GRETA" from Enrico Franzolini for Accademia▪
Structure in natural oak. Dimensions: chair,
☐ 78 ☐ 50 ☐ 57 ☐ 46 cm▪
easy chair,
☐ 79 ☐ 58 ☐ 59 ☐ 46 cm▪
5. EASY CHAIR "NIKITA" from Gerard van den Berg for Label▪
6. CHAIR "CIRCO" from Peter Maly for Cor▪
Swivel seat. Multiple options in upholstery▪
☐ 71 ☐ 61 ☐ 57 cm▪
7. EASY CHAIR "MALINDI" from O. Moon for Porada▪
Structure in cherry or walnut. Upholstered in fabric or leather webbing▪
☐ 75 ☐ 62 ☐ 81 cm▪

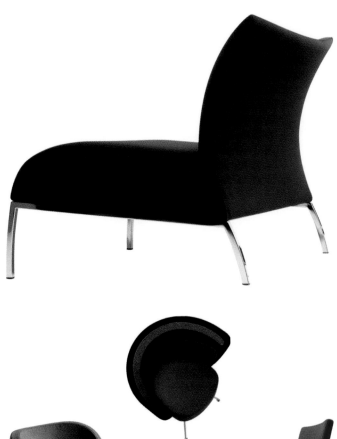

1. Easy chair "Pancras" from Borgensen & Voll for Iform.
Seat upholstered in fabric or leather. Body in compression molded wood.
2. Easy chair "Corona" from Poul M. Volther for Erik Jørgensen.
3. Chair "Pause-Café" Designed by Pascal Mourgue for Artelano.
4. Chair "Eleonoire" from Ca' Nova Design for Cattelan Italy.
⊟ 110 ⊟ 49 ⊟ 58 ⊟ 50 cm.

WOOD AND NATURAL FIBERS

A REINTERPRETATION OF TRADITIONAL MATERIALS

Previous page:
CHAIR "BALESTRA" from Enzo Berti
for Lago■
Structure in walnut. Seat uphol-
stered in leather■

1. CHAIR "ALIS", 2000. From
Palomba Serafini for Crassevig■
Structure in chromed steel. Seat in
laminated wood. Two sizes:
⊟ 81 ⊟ 52 ⊟ 54 cm■
⊟ 81 ⊟ 58 ⊟ 55 cm■
2. CHAIR "ECO", 2000. From Peter
Karf for Iform (Collection Voxia)■
Structure molded in one piece of lam-
inated beech. Stackable. IF Design
Prize■
⊟ 81 ⊟ 45 ⊟ 48 ⊟ 45 cm■
3. CHAIR "NXT", 2001. From Peter
Karf for Iform (Collection Voxia)■
Structure molded in one piece of
laminated wood. Red Dot Prize■
⊟ 75 ⊟ 51 ⊟ 46 ⊟ 45 cm■
4. CHAIR "GLOBUS", from Jesús Gas-
ca for Stua■
Structure in steel. Seat and backrest
in laminated wood lacquered in colors,
or finished in beech, cherry or wenge.
Stackable■
⊟ 85 ⊟ 47 ⊟ 55 cm■

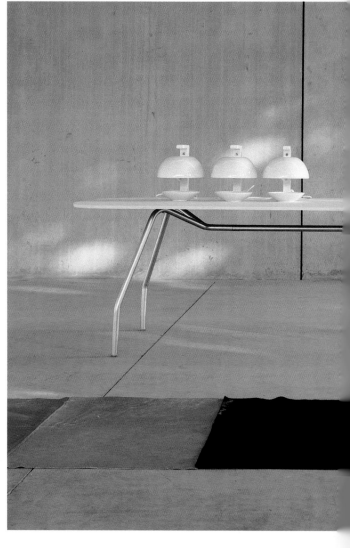

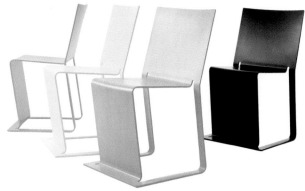

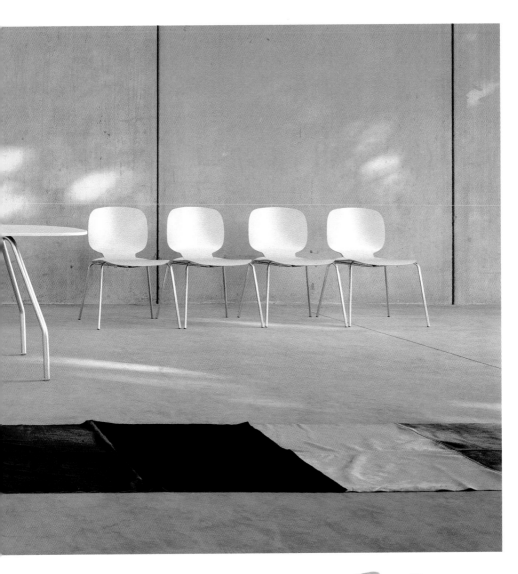

1. CHAIR "ANNA", 1998. From Palomba Serafini for Crassevig▪ Structure in beech. Seat in plywood or upholstered▪

⊟ 87 ⊟ 56 ⊟ 51 cm▪

2. CHAIR "OMU", from Oswald Matias Ungers for Sawaya & Moroni▪

3. CHAIR "DELTA" from Christian Steiner for Schmidinger▪ Structure in beech. Stackable▪

⊟ 81.5 ⊟ 49 ⊟ 51.5 ⊟ 45.5 cm▪

4. CHAIR "PRIMO" from Ruud Ekstrand for Iform▪ Structure in beech. Seat upholstered▪

⊟ 80 ⊟ 42 ⊟ 51.5 ⊟ 44 cm▪

5. CHAIR "SEAGRASS", from Karin Tyrefors for Iform▪ Structure in ash. Seat and backrest woven in natural cord▪

1. EASY CHAIR "ROOM 26", Design from Arne Quinze and Yves Milan for Quinze & Milan▪
⊟ 56 ⊟ 65 ⊟ 100/62 ⊟ 32 cm▪
2. STOOL "ROOM 26" Design from Arne Quinze and Yves Milan for Quinze & Milan▪
3. Chair "Laleggera" from Riccardo Blumer for Alias▪
Manufactured in cherry, sycamore or wenge. Stackable▪
⊟ 79 ⊟ 44 ⊟ 53 ⊟ 46 cm▪
4. CHAIR "TULI", from Marco Romanelli for Montina▪
Structure in oak. Seat and backrest upholstered in fabric or leather▪
⊟ 84 ⊟ 52.5 ⊟ 55.5 ⊟ 46.5 cm▪
5. CHAIR "VELA", from Driade▪
Structure in beech. Seat and backrest in industrial conglomerate▪
6. CHAIR "BALLERINA", 1991. From L. Bertoncini for Bernini▪
7. CHAIR "PAB", from Paul Baber for Pure Design▪
Structure in steel. Seat in molded laminated wood▪
⊟ 80 ⊟ 48.3 cm▪
8. CHAIR "ROUND" in Stefano Bianchi for Sintesi▪
Structure and armrests in steel tube. Seat and backrest in plywood▪
⊟ 82 ⊟ 59 ⊟ 59 ⊟ 46 cm▪

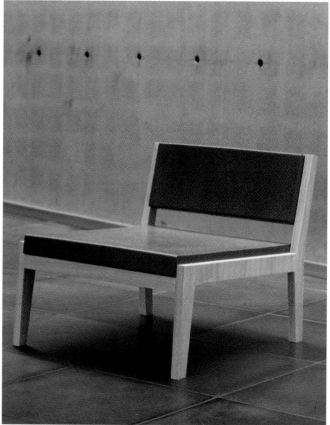

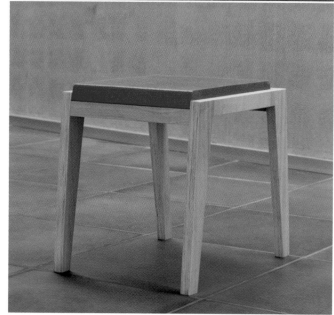

1. Chair from the series "8000" from Rud Thygesen and Johnny Sørensen for Magnus Olesen∎ Structure in laminated beech. Stackable∎

2. Stool "Hula", 2000. From Barber Osgerby for Cappellini∎

3. Stool "Origami", from Enrico D. Bona for Montina∎ Manufactured in oak∎

4. Chair "Hans", from Philipp Mainzer for e15∎ Structure in stainless steel. Seat and backrest in European walnut∎ ⊟ 80 ⊟ 43 ⊟ 50 cm∎

5. Chair "S664" from Eddie Harlis for Thonet∎ Structure in steel tube. Seat body in plywood∎ ⊟ 85 ⊟ 60 ⊟ 52 cm∎

6. Chair "Diva", 1987. From William Sawaya for Sawaya & Moroni∎ Structure in wood. Seat upholstered in leather∎ ⊟ 87 ⊟ 43 ⊟ 46 cm∎

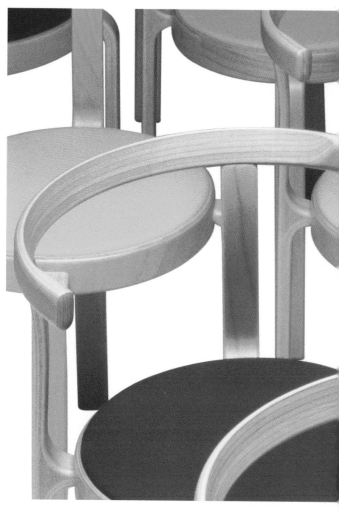

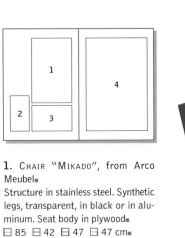

1. CHAIR "MIKADO", from Arco
Meubel▪
Structure in stainless steel. Synthetic
legs, transparent, in black or in alu-
minum. Seat body in plywood▪
⊟ 85 ⊟ 42 ⊟ 47 ⊟ 47 cm▪
2. CHAIR "JANET", from Sintesi▪
Structure in square steel tube. Seat
and backrest in varnished plywood
natural or stained in cherry▪
⊟ 86.5 ⊟ 41.5 ⊟ 50 cm▪
3. CHAIR "COLORI", from Natison
Sedia (Collection FUN Tasia)▪
Structure in steel tube. Seat body in
laminated wood. Stackable▪
⊟ 80 ⊟ 47 ⊟ 52 ⊟ 46 cm▪
4. CHAIR "CAMPUS", 1992. From Jo-
hannes Foersom and Peter Hiort-
Lorenzen for Lammhults▪
⊟ 76 ⊟ 47 ⊟ 49 ⊟ 45 cm▪

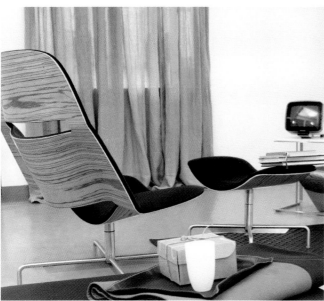

1. CHAIR "Ho" in Luca Meda for Molteni & C.
Structure in walnut, cherry, wenge or sycamore plywood. Joint that unifies legs, seat and backrest in metal.
⊟ 80 ⊟ 51 ⊟ 50 cm.

2. CHAIR "EGOA", 1988. From Josep Mora for Stua.
Structure in chromed steel. Seat in beech, ash, cherry or wenge. The backrest adapts to the back. Innovative Design Prize, Melbourne.
⊟ 82 ⊟ 50 ⊟ 54 ⊟ 41 cm.

3. CHAIR "ALL", 2000. From Laura Silvestrini for Giorgetti.
Structure in beech. Armrests and backrest in aluminum. Transformable from chair to easy chair. Dimensions:
chair,
⊟ 80 ⊟ 53 ⊟ 57 cm.
easy chair,
⊟ 83 ⊟ 53 ⊟ 51 cm.

4. CHAIR "PORTOGHESA 3200" from Helena Ladeiro for Sintesi.
Structure and armrests in steel tube. Seat in molded plywood.
⊟ 87 ⊟ 46 ⊟ 55 cm.

5. CHAIR "APTA", 1996. From Gabriel Teixidó for Andreu World.
Metallic structure and seat and backrest varnished in beech. Stackable.

6. CHAIR "KAZUHI" from Kazuhide Takahama for Ultramobile.
⊟ 107 ⊟ 46 ⊟ 47 ⊟ 43.5 cm.

7. EASY CHAIR "UPPER LIPS", 2000. From Piergiorgio Cazzaniga for Dema.
Structure in stainless steel. Body in laminated wood, upholstered interior.

1. CHAIR "ECO", 2000. From Peter Karf for Iform (Collection Voxia)■ Structure in laminated beech, molded in piece. Stackable. IF Design Prize■
⊟ 81 ⊟ 45 ⊟ 48 ⊟ 45 cm■

2. CHAIR "RUNNER", 1997. From Kasper Salto for Fritz Hansen■ Structure in steel tube. Seat and backrest in laminated wood. Stackable■
⊟ 83 ⊟ 46 ⊟ 42.5 ⊟ 45 cm■

3. CHAIR "THE KING OF SCHU", from Sirch and Bitzer for Schmidinger■ Manufactures in beech■
⊟ 87 ⊟ 38 ⊟ 52 cm■

4. CHAIR "SIXTA", 2000. From Miguel Milà for CJC Concepta■ Structure in steel tube. Seat, backrest and front legs in beech plywood. Seat upholstered. Stackable■
⊟ 86 ⊟ 56 ⊟ 58 cm■

5. CHAIR "PARADE" from Rud Thygesen and Johnny Sørensen for Magnus Olesen■ Legs in steel tube. Seat and backrest in laminated sycamore or beech. Stackable■

1. CHAIR "30 x 30", 1999. From Niall O'Flynn for CJC Concepta▪
Structure in beech. Seat and backrest in curved plywood▪
⊟ 73 ⊟ 42 ⊟ 54 ⊟ 45 cm▪
2. CHAIR "AMPOLLA", from Enzo Berti for Lago▪
Structure in walnut. Seat upholstered▪
3. CHAIR "TRI", from Peter Karf for Iform (Collection Voxia)▪
Structure is molded in one piece of laminated wood▪
⊟ 80 ⊟ 55 ⊟ 45 ⊟ 45 cm▪
4. CHAIR "LOLA", from Giacomo Passal for Andreu World▪
Structure in solid beech. Seat upholstered▪

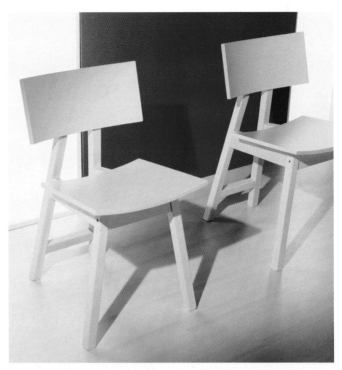

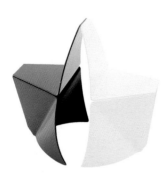

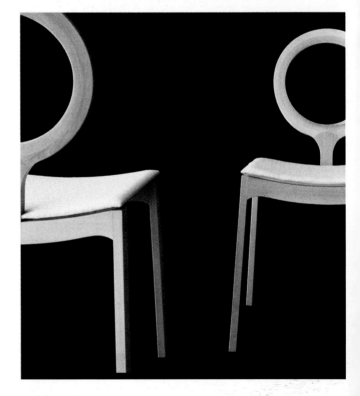

1. CHAIR "XUS" from Iform.
Cantilevered structure in one piece
of laminated beech.
2. CHAIR "OTO", 2001. From Peter
Karf for Iform (Collection Voxia).
Molded in one piece of beech plywood.
IF Design Prize.
⊟ 71 ⊟ 78 ⊟ 61 ⊟ 38 cm.
3. CHAIR "BOSSI" from Markus Pfyl
for Schmidinger.
Manufactured in laminated wood.
⊟ 78.5 ⊟ 51.5 ⊟ 53.5 ⊟ 43.5 cm.
4. CHAIR "AYU", 2002. From Roder-
ick Vos for Driade.
Structure in steel painted white.
Wickerwork covering. (Photo: T.
Vack).
5. CHAIR "RIGA", 1997. From M.
Marconato and T. Zappa for Bernini.
6. CHAIR "YOUNG LADY" from Paolo
Rizzatto for Alias.
Structure in aluminum. Seat frame
and backrest in cherry, wickerwork
covering. Swivel seat.
⊟ 80 ⊟ 59 ⊟ 59 ⊟ 48 cm.
7. CHAIR "HOP" from Lorenzo
Merani for Schmidinger.
Manufactured in varnished laminated
wood.
⊟ 72.5 ⊟ 68.5 ⊟ 72 cm.

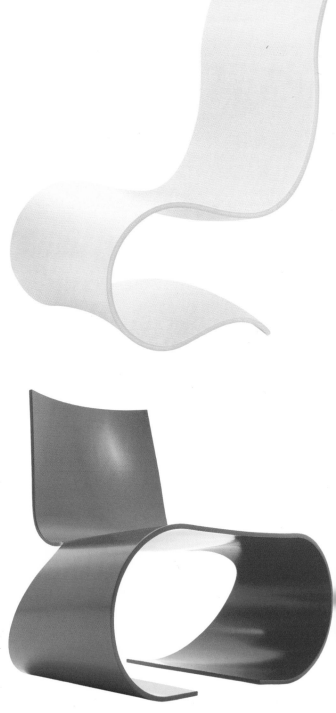

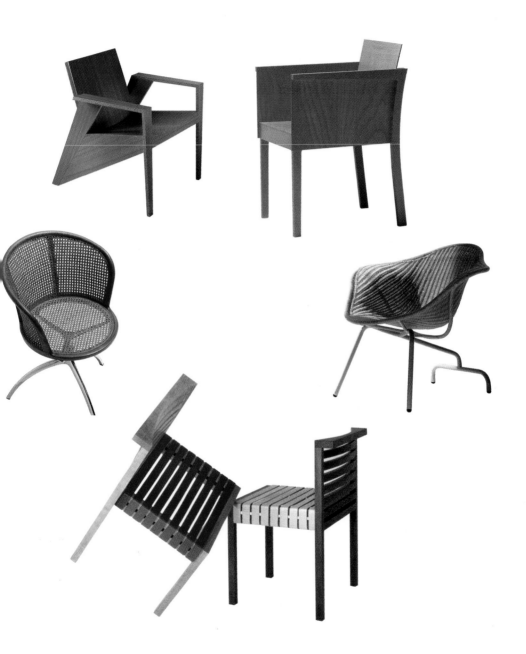

LEATHER BEYOND
THE PASSING OF TIME...

1. CHAIR "TECNA" from Edy and Paolo Ciani for Calligaris▪
⊟ 86 ⊟ 46.5 ⊟ 54.5 ⊟ 46 cm▪

2. CHAIR "ELBA" from Yoshiharu Hatano for Frag▪
Structure in steel. Seat and backrest upholstered in leather▪
⊟ 81 ⊟ 40 ⊟ 46 ⊟ 45 cm▪

3. EASY CHAIR "BANCOQUINE" from Yamakado▪
⊟ 72 ⊟ 77 ⊟ 77 cm▪

4. CHAIR "CIRCO" from Peter Maly for Cor▪
Swivel seat. Multiple options in upholstery. Backrest in woven leather strips▪
⊟ 71 ⊟ 61 ⊟ 57 cm▪

5. EASY CHAIR "3244", 1998. From Peter Mogensen for Fredericia Furniture▪
Structure in wood. Seat and backrest upholstered in leather or fabric▪

6. EASY CHAIR "DONNA" from Gerard van den Berg for Label▪
Structure in steel tube. Seat and backrest upholstered in fabric or leather▪
⊟ 98.5 ⊟ 62.5 ⊟ 62 ⊟ 49.5 cm▪

7. EASY CHAIR "DERBY", 2000. From Eoos for Matteograssi▪
Good Design Prize 2002, awarded by the Chicago Athenaeum Museum of Architecture and Design▪

8. EASY CHAIR "BRAVO" from Sergi and Oscar Devesa for Oken▪
Structure in steel tube and upholstered in hide. Technology based on the classics of the Bauhaus▪
⊟ 71 ⊟ 64.6 ⊟ 64 cm▪

9. EASY CHAIR "RIRÌ" from N. Gerosa and S. Vaio for Dema▪
Structure in metal covered in woven leather strips. Seat cushion upholstered in leather▪

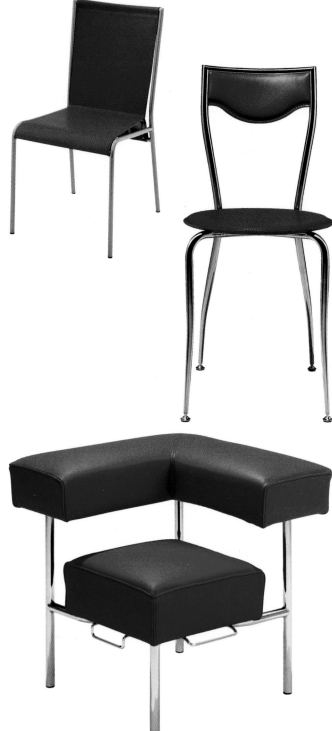

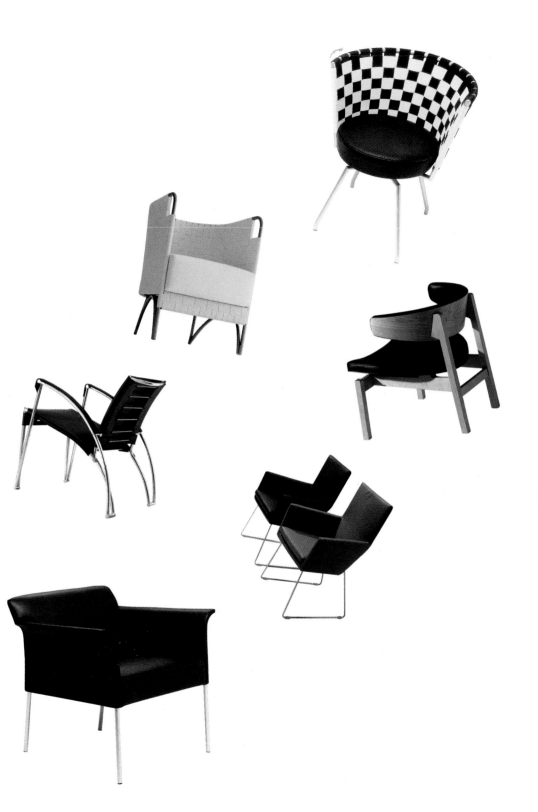

1. EASY CHAIR "BLOOM", 2000. From Giorgio Cazzaniga for Living Divani▪ Structure in stainless steel. Seat body made in molded laminated birch, covered in leather▪
2. EASY CHAIR "FUN BUKKO" from Natison Sedia▪
Pedestal-style base in steel. Seat upholstered in leather▪
3. EASY CHAIR "POPPEA" from Enrico Tonucci for Triangolo▪
Structure in stainless steel. Seat fabricated in leather, molded in the form of a cone▪
⊟ 66 ⊟ 80 ⊟ 80 ⊟ 42 cm▪

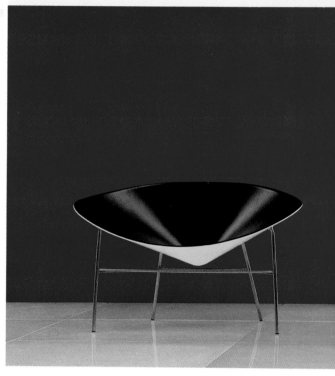

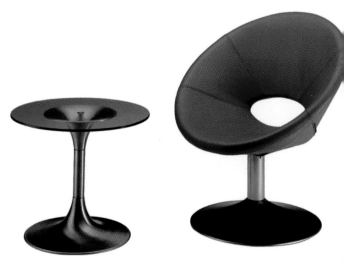

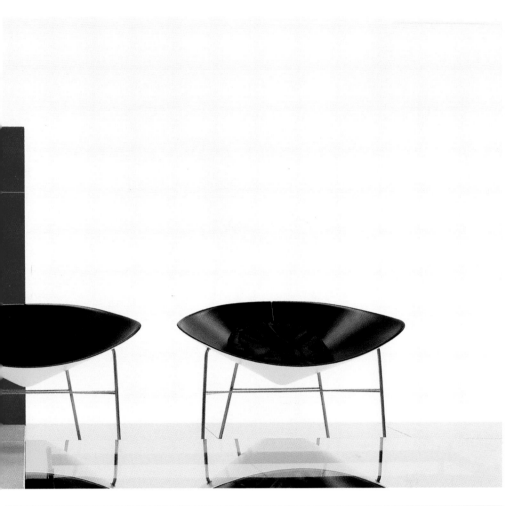

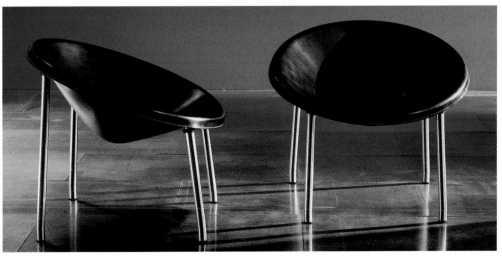

1. EASY CHAIR "CARMEN", 2000.
From Miguel Milà for CJC Concepta▪
Structure in beech. Seat and back-
rest upholstered in leather or fabric▪
⊟ 81 ⊟ 58 ⊟ 60 ⊟ 45 cm▪
2. CHAIR "APRIL" from Carlo Bartoli
for Matteograssi▪
Structure in steel and seat and back-
rest upholstered in leather▪
3. CHAIR "SAMOA" in Titta Paoloni
for Frag▪
Structure in steel tube. Backrest
upholstered in leather. Seat molded
in beech plywood, upholstered in
leather▪
⊟ 90 ⊟ 50 ⊟ 50 ⊟ 45 cm▪
4. CHAIR "KUMO", 1991. From
Toshiyuki Kita for Casas▪
Structure in painted aluminum. Seat
and backrest in leather▪
⊟ 80 ⊟ 56 ⊟ 55 ⊟ 46 cm▪
5. CHAIR "CENTOCINQUE" from Gal-
vano Tecnica▪
Structure in steel completely covered
in leather▪
⊟ 93 ⊟ 62 ⊟ 59 cm▪
6. Chair from Mario Botta for Alias▪
Structure in steel. Seat and backrest
upholstered in natural leather▪
7. EASY CHAIR "AGRA" from Enrico
Franzolini for Accademia▪
Structure in steel tube. Seat and
backrest upholstered in leather▪
⊟ 75.5 ⊟ 69.5 ⊟ 77.5 ⊟ 37 cm▪
8. EASY CHAIR "WIBBER", 1964/2002.
From Friedrich Hill and Scooter &
Partners for Leolux▪
⊟ 81 ⊟ 88 ⊟ 86 cm▪

1. Chair "St. Tropez", 2000. From Rossire and Salvi for Bernini▪

2. Easy chair "Saga" from Gioia Meller Marcovicz for Classicon▪
Base in steel. Seat body in cherry. Seat and backrest upholstered in leather▪

3. Chair "Vittoria" from Sviluppo Frau and Centro Investigación de Poltrona Frau▪
⊟ 90 ⊟ 53 ⊟ 61 ⊟ 46 cm▪

4. Chair "Evia" from Titta Paoloni for Frag▪
Structure in steel tube, totally upholstered in leather▪
⊟ 90 ⊟ 49 ⊟ 50 ⊟ 47 cm▪

5. Chair "Liz" from Sviluppo Frau and Centro Investigación de Poltrona Frau▪
⊟ 89 ⊟ 45 ⊟ 58 ⊟ 47 cm▪

6. Chair "Trama" from Umberto Bertoni for Calligaris▪
⊟ 83 ⊟ 46 ⊟ 49 ⊟ 45 cm▪

7. Chair "Sumbawa" from Paolo Valcic for Frag▪
Structure in elliptical steel tube. Seat and backrest upholstered in leather▪
⊟ 103 ⊟ 43 ⊟ 47 ⊟ 46 cm▪

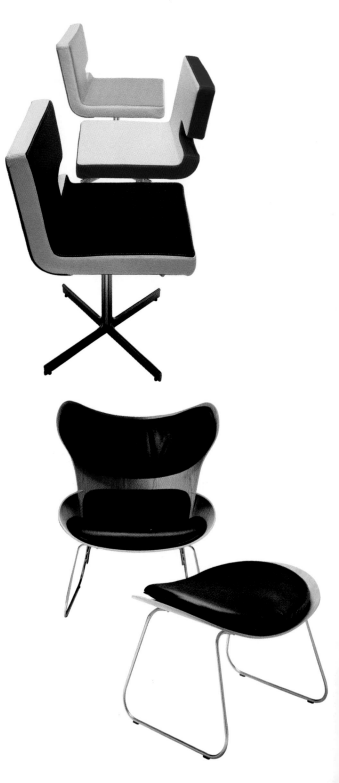

1. Stool "Way" from Francesco Ruffini and Margherita Quinto for Calligaris∎
⊟ 110　⊟ 48　⊟ 53.5　⊟ 75 cm∎
2. Stool "Golia", 1993/2002. From Maurizio Peregalli for Zeus Noto∎ Structure in steel. Seat in leather or Alcantara®∎
⊟ 80　⊟ 35　⊟ 35 cm∎
3. Stool "Manhattan", 2002. From Maurizio Peregalli for Zeus Noto∎ Structure in steel. Seat upholstered in leather or Alcantara®. Three heights: 49, 67 and 82 cm∎
4. Stool "Urbe" from Nancy Robbins for Andreu World∎
Structure in wood. Seat upholstered in leather and backrest in woven strips of leather∎

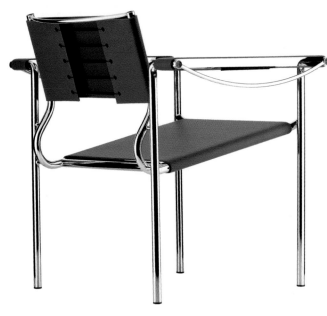

1. CHAIR "POLTRO" from Misura Emme.
Structure in steel. Seat and backrest upholstered in leather or fabric.

2. EASY CHAIR "SPAGUETTI" from Giandomenico Belotti for Alias.
Structure in steel tube. Seat, backrest and armrests in leather.
⊟ 71 ⊟ 68 ⊟ 59 ⊟ 42 cm.

3. CHAIR "GOA" from Paolo Valcic for Frag.
Structure in steel tube. Seat and backrest upholstered in leather.
⊟ 83 ⊟ 58 ⊟ 58 ⊟ 47 cm.

4. SEAT "MEDITATION POD", 2001. From Steven Blaess for Edra.
Structure of base in steel. Seat with forms evocative of the Pop movement.
⊟ 90 ⊟ 150 ⊟ 145 cm.

5. EASY CHAIR "AM", 2002. From William Sawaya for Swaya & Moroni.
Structure in chromed metal. Seat body in wood stained in the color of wenge. Seat and backrest upholstered in leather.
⊟ 80 ⊟ 60 ⊟ 59 ⊟ 45 cm.

6. CHAIR "EDITH", 1998. From Masafumi Katsukawa for Zoltan.
Legs in steel and seat upholstered in leather.
⊟ 85 ⊟ 30 ⊟ 49 cm.

7. CHAIR "HIMBA" from Gerard van den Berg for Label.
⊟ 89 ⊟ 46 ⊟ 62 ⊟ 44.5 cm.

8. CHAIR "VERONICA", from Afra and Tobia Scarpa for Casas.
Structure completely covered in leather.
⊟ 72 ⊟ 51 ⊟ 59 ⊟ 45 cm.

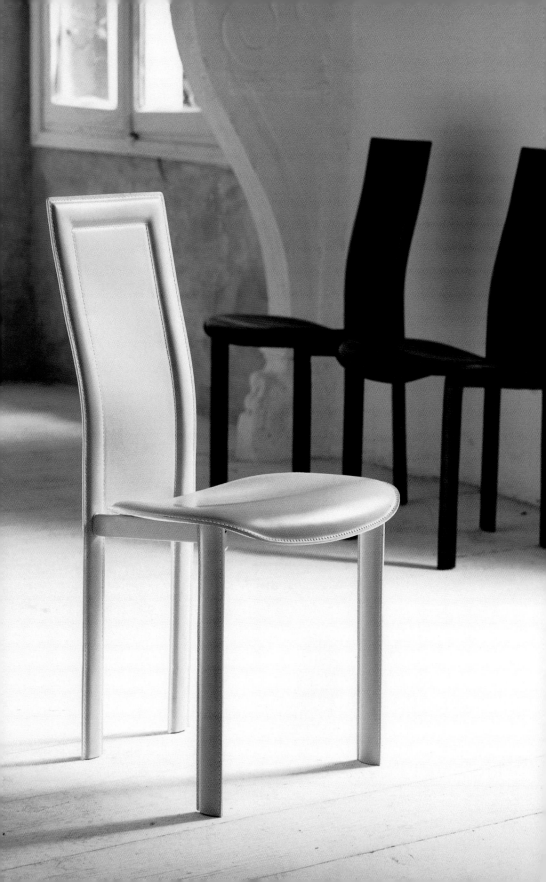

1. CHAIR "LARA" from Giorgio Cattelan for Cattelan Italy■
Structure totally upholstered in leather■
⊟ 92 ⊟ 49 ⊟ 52 ⊟ 48 cm■
2. CHAIR "GALLERY", from Carlo Bartoli for Segis■
Structure and armrests in aluminum. Seat and backrest upholstered in leather or fabric. Stackable■
⊟ 83.8 ⊟ 57 ⊟ 49 ⊟ 46 cm■
3. CHAIR "PANAREA" from Titta Paoloni for Frag■
Structure totally upholstered in leather. Available with steel legs■
⊟ 85 ⊟ 55 ⊟ 49 ⊟ 46 cm■
4. EASY CHAIR "ARTEMISIA" from Yoshiharu Hatano for Frag■
Structure in steel. Seat and backrest upholstered in leather■
⊟ 86 ⊟ 83 ⊟ 74 ⊟ 42 cm■
5. EASY CHAIR "NATRIX" from Claudia and Mattia Frignani for Wunderkammer Studio■
Structure in polished aluminum. Seat and backrest upholstered in leather, stained with vegetable dyes■

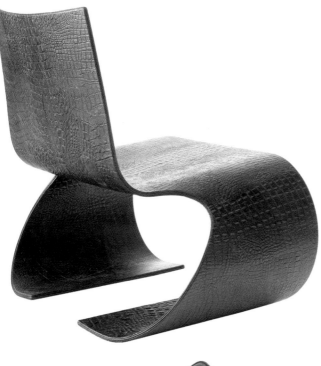

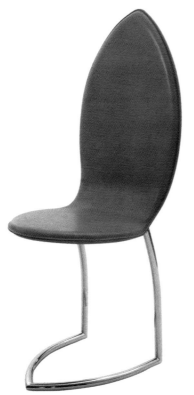

1. EASY CHAIR "DROP", 2001. From Emilio Nanni for Zanotta■
Structure in chromed steel. Seat and backrest upholstered in leather or fabric■
⊟ 67 ⊟ 60 ⊟ 73 ⊟ 38 cm■

2. EASY CHAIR "LUCCA", 2002. From Joan Casas Ortínez for Indecasa■
Two heights in seat: 37 cm, or 45 cm for the dinning room version■

3. EASY CHAIR "OTO CROCO", from Peter Karf for Iform (Collection Voxia)■
Structure in one piece of molded laminated wood, covered in leather■
⊟ 71 ⊟ 78 ⊟ 61 ⊟ 38 cm■

4. CHAIR "DAPHNE", from Claudia and Mattia Frignani for Wunderkammer Studio■
Structure in chromed steel. Seat and backrest upholstered in natural leather■
⊟ 117 ⊟ 42 cm■

ERGONOMICS AND WORK

FORMS THAT FACILITATE FUNCTION

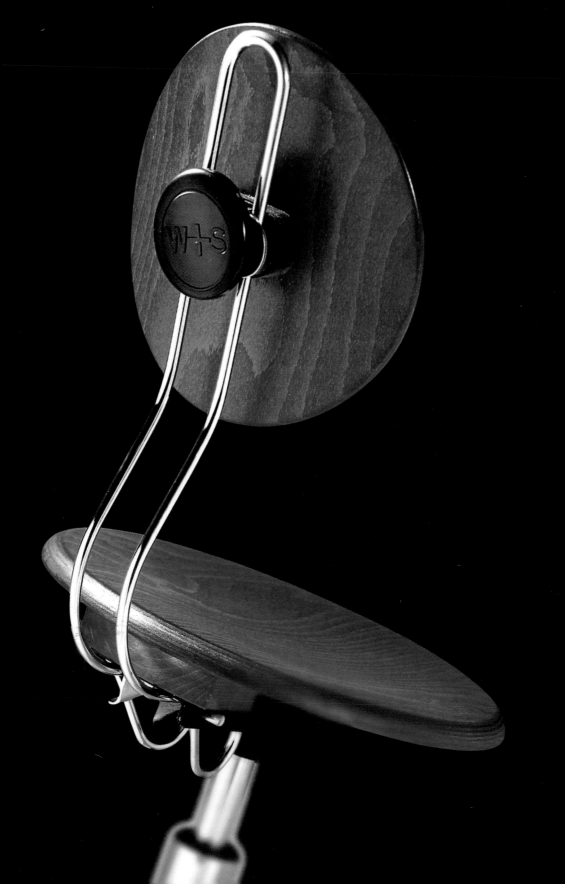

1. CHAIR "WEBB EXECUTIVE" from Burkhard Vogtherr for Davis Furniture▪
Structure in polished aluminum. Seat and headrest upholstered in leather. Backrest in woven strips manufactured in DuPont, which adapts to user's posture▪

2. CHAIR "VERSUS", 1999. From Miguel Ángel Ciganda for Casas▪
Base in injected aluminum. Made with recycled materials. Regulable in height▪
⊟ 97.5/108.5 ⊟ 69 cm▪
⊟ 64.5 ⊟ 44.5/55.5 cm▪

3. CHAIR "SOLIS", 2002. From Wiege for Wilkhahn▪
Swivel chairs with automatic synchro-adjustment systems. Structure in aluminum. Seat body in polypropylene, upholstered in various finishes. Version with low backrest▪

4. CHAIR "G15" from Offix Klass (Collection K&K Technogel®)▪
Seat developed with Technogel®, a polyurethane substance from the medical field, which adapts to body shape and distributes weight therefore reducing fatigue▪
⊟ 96/109 ⊟ 44 ⊟ 49 ⊟ 46/59 cm▪

5. CHAIR "MODUS", from Klaus Franck, Werner Sauer and Wiege for Wilkhahn▪
Swivel chair with automatic synchro-adjustment system. Structure in aluminum. Backrest in breathable semi-transparent elastic mesh. Armrests in glass reinforced polypropylene▪

6. CHAIR "X-88", from the design group ITO and design team Comforto for Haworth▪
Base available in steel or aluminum. Three possible types of armrests. Adapts to body movement. Lumbar zone and height adjustable. Backrest in woven mesh or upholstered▪

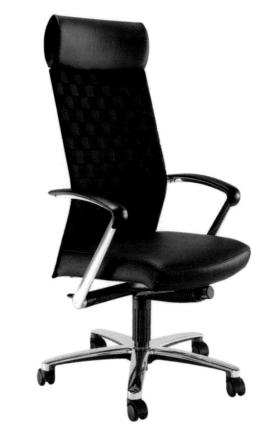

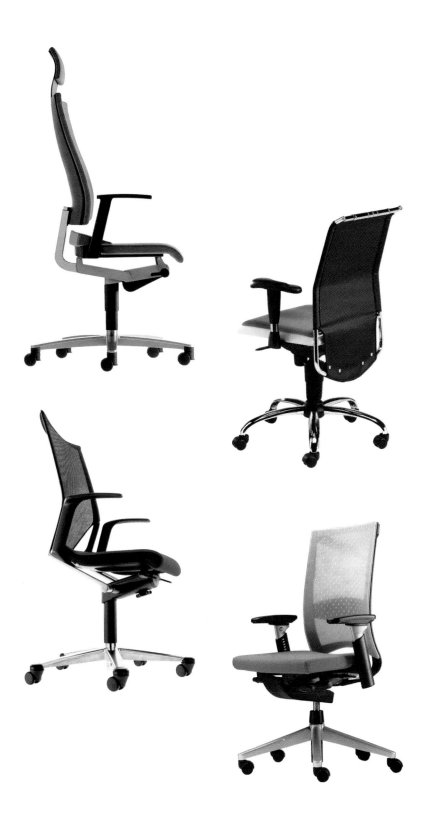

1. CHAIR "CLIA", 2002. From Bateman, Dillon and Grieves for Casas▪ Swivel chair with backrest made in Netware mesh. Lumbar zone and height adjustable▪
⊟ 92/103 ⊟ 68 ⊟ 69 ⊟ 44/55 cm▪

2. CHAIR "FS LINE", from Klaus Franck and Werner Sauer for Wilkhahn▪ Base in aluminum. Seat body and armrests in polypropylene. Highly flexible backrest that automatically adjusts to user's position▪

3. CHAIR "INGE GIREVOLE", from Enrico Franzolini for Sintesi▪ Structure in steel tube. Seat and backrest in polypropylene. Incorporates adjustment mechanism▪
⊟ 76 ⊟ 49 ⊟ 47 cm▪

4. CHAIR "VITTORIA" from Sviluppo Frau and Centro de Investigación de Poltrona Frau▪ Base in steel. Seat and backrest upholstered in leather. Adjustable in height▪

5. CHAIR "G12" from Offix Klass (Collection K&K Technogel®)▪ Seat developed with Technogel®, a polyurethane substance from the medical field, which adapts to body shape and distributes weight therefore reducing fatigue▪
⊟ 82/91 ⊟ 63 ⊟ 52 ⊟ 45/54 cm▪

6. CHAIR "YOUNG LADY" in Paolo Rizzatto for Alias▪ Structure in aluminum. Swivel seat cherry frame, covered in wickerwork▪
⊟ 80 ⊟ 59 ⊟ 59 ⊟ 48 cm▪

7. TASK STOOL "G20" from Offix Klass (Collection K&K Technogel®)▪ Stool developed with Technogel®, a polyurethane substance from the medical field, which adapts to body shape and distributes weight therefore reducing fatigue▪
⊟ 43/60 ⊟ 57 ⊟ 57 cm▪

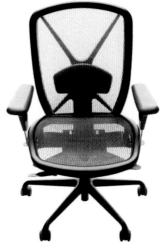

1. CHAIR "N7", 2000. From Marcello Ziliani for Zago▪
Synchro-adjustment mechanism. Adjustable seat, armrests, lumbar support and headrest▪
2. CHAIR "TALLE", from P. King and S. Miranda for Sellex▪
Base in cast aluminum. Seat body in curved beech plywood, totally upholstered in leather▪
⊟ 95.9 ⊟ 45.7 ⊟ 56.8 cm▪
3. CHAIR "FLUID", from Miles Keller for Allseating▪
Seat and backrest in breathable woven mesh that distributes body weight. Adjustable lumbar support and armrests. Good Design Prize 2001 from the Chicago Athenaeum▪
4. "THE SPIN CHAIR", 1996. From Burkhard Vogtherr for Fritz Hansen▪
Base in aluminum. Backrest body in upholstered beech plywood. Manufactured with four types of armrest and multiple combinations in heights and finishes available▪
5. CHAIR "MODUS", from Klaus Franck, Werner Sauer and Wiege for Wilkhahn▪
Swivel chair with automatic synchro-adjustment system. Structure in aluminum. Seat and backrest upholstered in leather. Armrests in glass reinforced polyamide, upholstered in leather▪

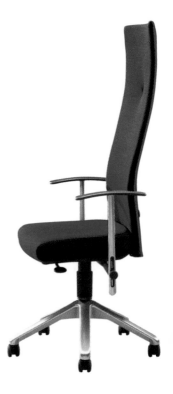

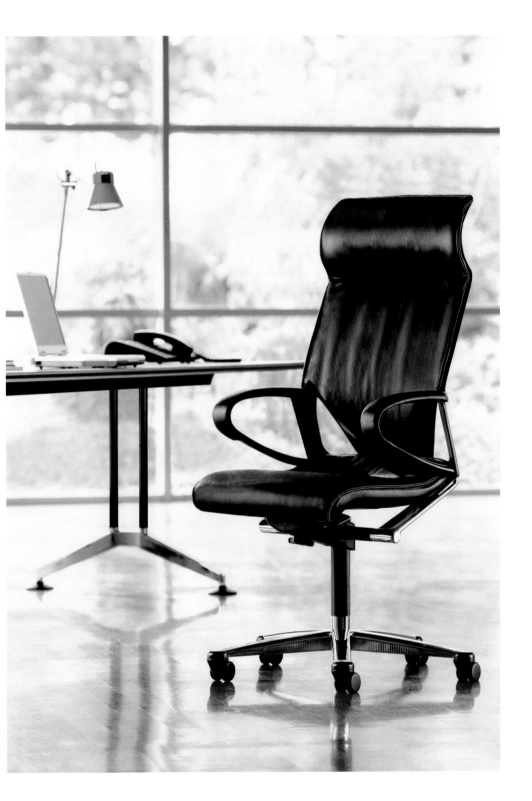

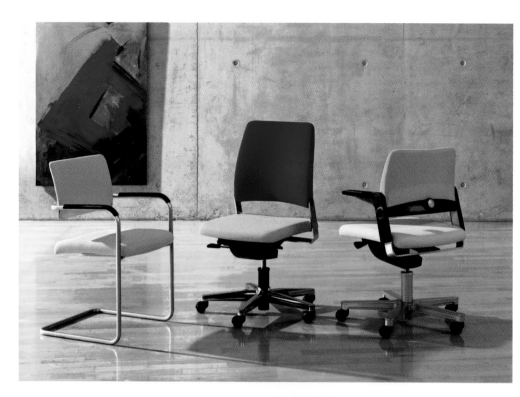

1. COLLECTION "ROOKIE" from the firm Röder for Haworth▪
Multiple combinations in fabrics and finishes▪
2. CHAIR "S-CON", 1998. From the firm Lepper, Schmidt, and Sommerlade for Haworth (Art Collection)▪
Metallic surfaces finished in matte aluminum. Backrest in woven mesh or finished in leather▪
3. CHAIR "SOLIS F", 2002. From Wiege for Wilkhahn▪
The construction of the seat and backrest is based on the use of highly elastic transparent covering stretched over an injected aluminum frame. Automatic synchro-adjustment system▪
4. CHAIR "GOGO" from Marcello Ziliani for Sintesi▪
Base in steel tube. Seat and backrest upholstered in leather▪
⊟ 84 ⊟ 59 ⊟ 59 cm▪
5. CHAIR "PILA", 1995. From Alfredo Arribas for Casas▪
Swivel base in steel tube. Armrests in cast aluminum▪
⊟ 109 ⊟ 65 ⊟ 65 ⊟ 44/57 cm▪

1. CHAIR "PARTNER", from Johannes Foersom and Peter Hiort-Lorenzin for Erik Jørgensen∎
Structure in matte chromed steel. Seat and backrest upholstered in fabric or leather∎
⊟ 91.5 ⊟ 69 ⊟ 76 ⊟ 43 cm∎
2. CHAIR "FLOW", 2000. From Burkhard Vogtherr for Fritz Hansen∎
Base in aluminum. Flexible backrest supported from a point on the aluminum rear rail. Available in a large number of sizes and finishes∎
3. CHAIR "BAHIA GIREVOLE", from Galvano Tecnica∎
Base in nylon or chromed steel. Seat structure in steel tube covered in leather∎
⊟ 90/104 ⊟ 56 ⊟ 60 cm∎
4. TASK STOOL "SBG 43", design inspired in the original created by Egon Eiermann in 1949/51. Produced by Wilde+Spieth∎
Incorporates legs in the Brussels style∎
5. CHAIR "SBG 41", originally designed in 1949, from Egon Eiermann. Produced by Wilde+Spieth∎
The model "SBG 41" incorporates legs in the Brussels style. Seat and backrest in stained wood∎
6. DESK-CHAIR "EASY RIDER". From Danny Venlet for Bulo∎
Structure in injection molded EPS (expanded polystyrene). Available with or without castors∎

1. CHAIR "LILLY LIFT", from Sintesi∎ Structure in steel tube. Seat in plywood covered in aluminum∎
⊟ 83/95 ⊟ 63 ⊟ 63 ⊟ 44/56 cm∎
2. SERIES "BULLDOG", from Dale Fahnstrom and Michael McCoy for Knoll∎
Multiple possibilities in adjustment. Seven different models∎
3. CHAIR "PUB & CLUB", from Bulo∎ These chairs combine the latest in ergonomics with rational contemporary aesthetics∎
4. CHAIR "D14", 1998. Produced by Tecta∎
Metallic base and seat body in natural wickerwork∎
⊟ 82/95 ⊟ 56 ⊟ 58 ⊟ 44/57 cm∎
5. CHAIR "D49", from Tecta∎
Base in aluminum. Seat body in molded acrylic∎
⊟ 88/101 ⊟ 72 ⊟ 62 ⊟ 48/61 cm∎
6. CHAIR "EGOA", 1988. From Josep Mora for Stua∎
Structure in chromed steel. Seat in beech, ash, cherry or wenge. Backrest adapts to back position. Innovative Design Prize, Melbourne∎
⊟ 80/93 ⊟ 59 ⊟ 59 ⊟ 40/53 cm∎

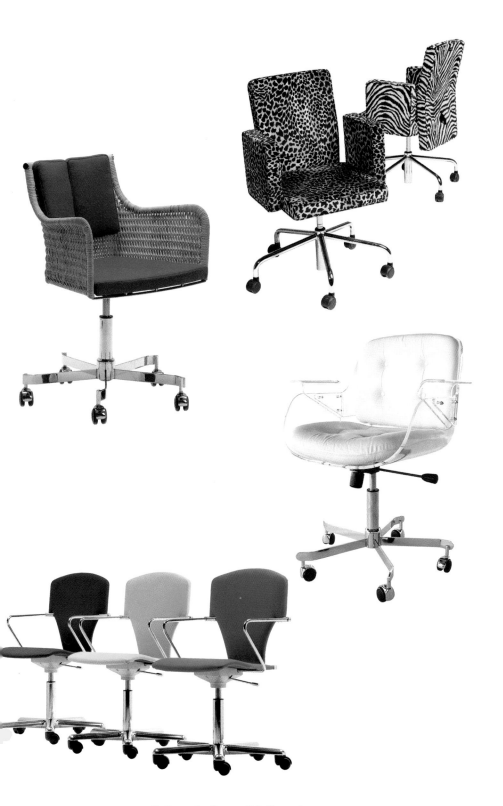

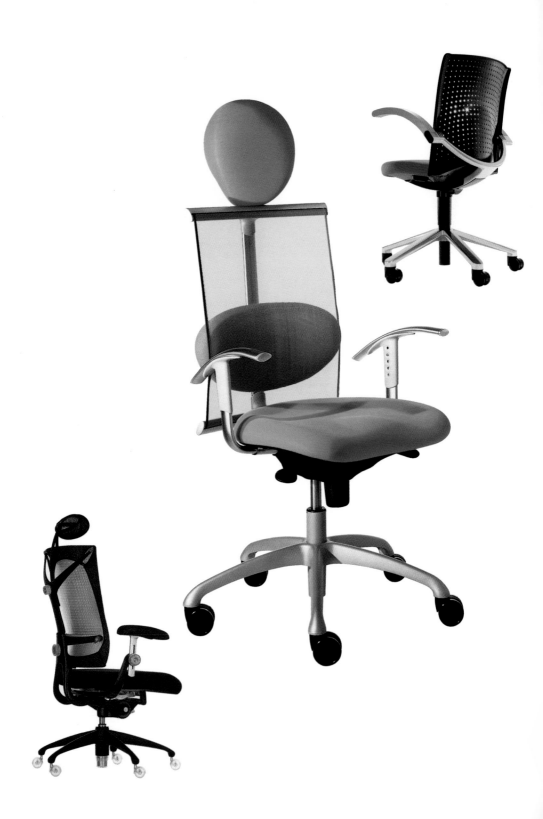

1. CHAIR "PICTO", from Roericht, Burkhard Schmitz and Franz Biggel for Wilkhahn■
Structure in aluminum. Seat and backrest in perforated polypropylene. Armrests in natural beech. Automatic synchro-adjustment■

2. CHAIR "N5", 2000. From Marcello Ziliani for Zago■
Synchro-adjustment mechanism. Seat, armrests, lumbar support and headrest adjustable■

3. CHAIR "YPSILON" from Mario and Claudio Bellini for Vitra■
Flexible unframed backrest which adapts to body in all possible positions and permits free air circulation. Upholstered in the fabric Mesh, or in leather. Many optional features available such as the termoactive seat Clima Seat®. (Photo: H. Hansen)■

4. COLLECTION "LIFE" developed by Knoll■
Flexible backrest and seat. Intuitive and synchro-adjustment movements. Lumbar support. Adjustable armrests. Many options in features and finishes■

5. COLLECTION "WEBB MEETING" from Burkhard Vogtherr and Jon Prestwich for Davis Furniture■
Structure in polished aluminum. Seat upholstered in leather. Backrest in woven strips manufactured in DuPont which adapts to user's posture■

6. WORK STATION "NETSURFER", 1995. From Teppo Asikainen and Ilkka Terho for Snowcrash■
Structure in steel. Seat upholstered in leather■
⊟ 98 ⊟ 78 ⊟ 161 cm■
(Photo: Urban Hedlund)■

PLASTIC AND NEW MATERIALS
TRIUMPH OF TECHNOLOGY

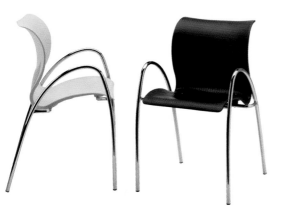

	1	
2	3	4

Page 247:
CHAIR "FREE", 2002. From Monica Graffeo for Kristalia∎
Structure in steel tube. Covered in polyester or polyurethane by created with technology devised to the sports shoe industry. Stackable∎

1. CHAIR "SPICE", 2002. From Jehs & Laub for Ycami∎
Structure in aluminum. Seat in lacquered fiberglass∎
⊟ 78 ⊟ 45 ⊟ 48 ⊟ 45 cm∎
2. CHAIR "EVA", 2002. From Marc Sadler for Kartell∎
Structure in chromed steel. Seat and backrest created from a new plastic compound that is soft and comfortable. Produced by injection techniques∎
3. EASY CHAIR WITH FOOTREST "MOLLY", 2001. From F. Bertero and A. Panto for Zanotta∎
Structure in aluminum alloy, outdoor version enameled in white. Cushions covered in polyurethane. Dimensions: easy chair,
⊟ 66 ⊟ 73 ⊟ 105 cm∎
footrest,
⊟ 35 ⊟ 73 ⊟ 41 cm∎
4. CHAIR "ZAIA", from Galvano Tecnica∎
Structure in steel. Seat body in polypropylene∎
⊟ 81 ⊟ 51 ⊟ 58 cm∎

1. CHAIR "MARIPOSA", 2001. From Afra and Tobia Scarpa for Casas▪
Structure in elliptical steel tube. Seat body in upholstered polyethylene terephtalate (PET)▪
⊟ 74 ⊟ 61 ⊟ 60 ⊟ 44 cm▪

2. EASY CHAIR "HYDRA", from Roberto Semprini for Sintesi▪
Structure in steel tube. Seat and backrest covered with PVC strips▪

3. CHAIR "NUVOLA", 1999. From Jutta and Herbert Ohl for Wilkhahn▪
Structure in polished steel. Seat and backrest in black polyester mesh. Stackable. Good Design Award, Chicago Athenaeum 1999▪
⊟ 75 ⊟ 56 ⊟ 57 ⊟ 40 cm▪

4. EASY CHAIR "GHOST", from Cini Boeri and Tomu Katatanagi for Fiam Italy▪
Made from one piece of curved 12mm crystal glass▪
⊟ 68 ⊟ 95 ⊟ 75 cm▪

5. CHAIR "BREEZE", 1997. From Carlo Bartoli for Segis▪
Structure in aluminum. Seat and backrest in recyclable polypropylene. Stackable. Suitable for outdoor use. ID Design Distinction 1997, USA. Red Dot for High Quality Design. IF Award for Excellent Design 1998▪
⊟ 80 ⊟ 58 ⊟ 49 ⊟ 46 cm▪

6. CHAIR "OUTLINE", 2001. From Jean Marie Massaud for Cappellini▪
Structure in steel. Seat body in fiberglass, interior upholstered in fabric or leather▪

7. MODULAR STOOL AND ROCKING CHAIR "SUTRA", from Kundalini▪
Manufactured in polyurethane. Dimensions: small,
⊟ 43 ⊟ 35 ⊟ 50 cm▪
large,
⊟ 43 ⊟ 67 ⊟ 90 cm▪

1. CHAIR "SONICA", from Arkiline for Calligaris∎
Structure in steel. Seat and backrest in technopolymer∎
⊟ 80.5 ⊟ 46.5 ⊟ 52 ⊟ 44 cm∎

2. SEAT MODULAR "Z-PLAY", 2002. From Zaha Hadid for Sawaya & Moroni∎
Pieces manufactured in high-density foam. The blocks are presented as if they form part of a puzzle and offer many possibilities for seating∎
⊟ 72 ⊟ 72 ⊟ 42 cm∎

3. PUFF "GLOBULO", 1999. From F. Bertero and A. Panto for Zanotta∎
Made in plastic in various colors. Suitable for outdoor use∎
⊟ 20 ⊟ 70 ⊟ 70 cm∎

4. TRANSFORMABLE SEAT "PISOLÓ", 1997. From Denis Santachiara for Campeggi∎
Plastic stool that contains an inflatable mattress and can be transformed into a bed∎
⊟ 82 ⊟ 67 cm∎

5. CHAIR "MAR", 2001. From Joan Casas Ortínez for Indecasa∎
Structure in aluminum. Seat and backrest in polypropylene. Stackable. Suitable for outdoor use∎

1. CHAIR "GALI", 1992. From Carlo Bartoli for Ycami▪
Structure in polished anodized aluminum. Seat and backrest in high-density foam▪
⊟ 80 ⊟ 49 ⊟ 46 ⊟ 45 cm▪

2. CHAIR "TEMPESTA", from Album International▪
Structure in tubular steel. Seat and backrest in transparent resin. Stackable▪
⊟ 78 ⊟ 54 ⊟ 51 ⊟ 46 cm▪

3. CHAIR "CAPSULE", from Innovation▪ Manufactured in plastic▪
⊟ 59 ⊟ 55 ⊟ 55 cm▪

4. CHAIR "AIDA", 2000. From Richard Sapper for Magis▪
Structure in chromed or stainless steel. Seat body in injection molded polypropylene▪
⊟ 85.5 ⊟ 57 ⊟ 54 ⊟ 44 cm▪

5. CHAIR "LILLY", from Sintesi▪
Structure in steel tube. Seat body in the high technology compound Hirek®▪
⊟ 86 ⊟ 49.5 ⊟ 50 ⊟ 47 cm▪

6. CHAIR "GIGI" from Marco Maran for Knoll▪
Structure in stainless steel. Body in polypropylene▪

7. CHAIR "BAHBAR" from G. Bardet for Liv' It (Grupo Fiam Italy)▪

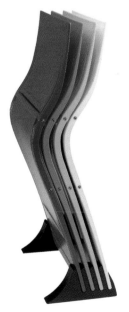

1. CHAIR "SAND", 2002. From Pocci Dondoli for Desalto■
Structure in aluminum, finished in Arctic gray or brilliant aluminum. Seat and backrest in glass reinforced polypropylene■
⊟ 82 ⊟ 47 ⊟ 54 ⊟ 45 cm■

2. CHAIR "BELLINI", 2001. From Mario Bellini for Heller■
First chair molded by gas injection. Compasso d'Oro Prize 2001. Prize for Good Design from the Chicago Athenaeum■

3. CHAIR "CARTA", 1998. From Shigeru Ban for Cappellini■
Structure in laminated birch. Seat and backrest made from small cardboard tubes■

4. CHAIR "INGE", from Enrico Franzolini for Sintesi■
Structure in steel tube. Seat and backrest in polypropylene■
⊟ 76 ⊟ 57 ⊟ 47 cm■

5. CHAIR "CALLA", 2002. From William Sawaya for Heller■
Structure in glass reinforced polypropylene. Flexible backrest. Suitable for outdoor use■

6. CHAIR "ISIS", 1997. From Olaf von Bohr for Sintesi■
Structure in steel tube. Seat and backrest in polypropylene. Prizes: "Top Ten" and "Chair of the year" 1997, Internacional Chair Exhibition (Promosedia)■
⊟ 77 ⊟ 42 ⊟ 50 cm■

7. CHAIR "WAVES", 2001. From Jens Ring Burshe for Natison Sedia■
Plastic. Folding. Suitable for exterior use. "Chair of the year" 2001, International Chair Exhibition (Promosedia)■
⊟ 80 ⊟ 48 ⊟ 57 ⊟ 45 cm■

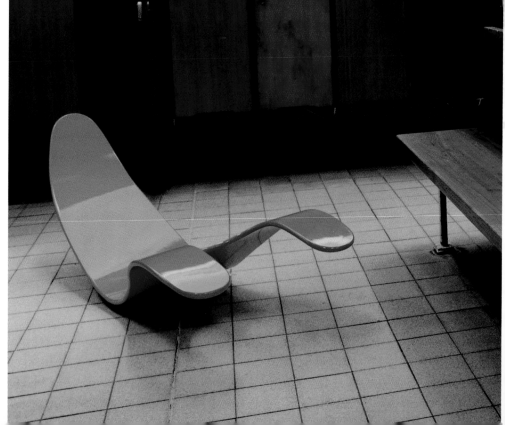

1. CHAIR "MARGHERITA", 1997.
From Carlo Colombo for Ycami.
Structure in anodized aluminum.
Seat and backrest in transparent or
colored polycarbonate. Suitable for
outdoor use.
⊟ 82 ⊟ 42 ⊟ 54 ⊟ 45 cm.
2. ROCKING CHAIR "CHIP", 1996.
From Teppo Asikainen and Ilkka Terho
for Snowcrash.
Structure in plywood with polyurethane
base.
⊟ 37 ⊟ 60 ⊟ 140 cm.
(Photo: Bobo Olsson).
3. SEAT "OM", from Maurizio Rusconi
and Swami Anand for Kundalini.
Structure in lacquered fiberglass.
The table is the model "Hari".
⊟ 80 ⊟ 60 ⊟ 50 cm.
4. CHAIR "GOGO", from Marcello
Ziliani for Sintesi.
Structure in lacquered steel tube.
Seat body in colored polypropylene.
⊟ 84 ⊟ 59 ⊟ 59 cm.

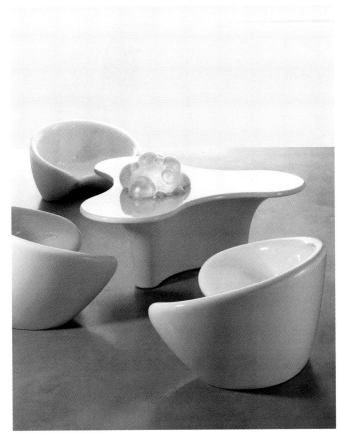

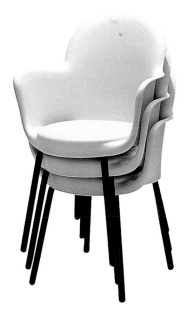

1. CHAIR "GAS", 2002. From Jesús Gasca for Stua■

Structure in polished aluminum. Seat and backrest in synthetic mesh. IF Silver Design Prize 2002. Red Dot Prize, Essen■

⊟ 78.5 ⊟ 50 ⊟ 48 ⊟ 44 cm■

2. CHAIR "S360F", from Delphin Design for Thonet■

Structure in chromed steel tube. Seat and backrest in plastic. Stackable. Can be linked to others for use in auditoriums■

⊟ 80 ⊟ 55 ⊟ 53 cm■

3. CHAIR "WING", 1998. From Sviluppo Frau and Centro de Investigación de Poltrona Frau■

Manufactured in carbon fiber, a construction material especially used in aeronautics and in Formula One racing■

⊟ 87 ⊟ 44 ⊟ 51.5 ⊟ 44.5 cm■

4. EASY CHAIR "GRAVITY", 2002. From William Sawaya for Sawaya & Moroni■

Produced in a numbered and signed limited edition■

⊟ 75 ⊟ 84 ⊟ 74 ⊟ 34.5 cm■

5. CHAIR "NET", from Daniele Molteni for Bontempi■

Structure in chromed steel. Seat and backrest in plastic. Stackable■

⊟ 81 ⊟ 48 ⊟ 59 ⊟ 46 cm■

1. CHAIR "MAXIMA", from William Sawaya for Sawaya & Moroni■ Structure in stainless steel. Seat body in compact high-density polyurethane■

⊟ 80 ⊟ 45.5 ⊟ 56 ⊟ 45 cm■

2. CHAIR "ORBIT", from Robby and Francesca Cantarutti for Sintesi■ Structure in steel and body in the high technology compound Hirek®■

⊟ 81 ⊟ 56 ⊟ 47.5 cm■

3. CHAIR "BOUM", 2002. From Monica Graffeo and Ruggero Magrini for Kristalia■ Structure in steel. Upholstered by the application of the same technology as used for the interior linings in cars■

4. CHAIR "AH CHAIR", from Tom Deacon for Umbra■ Structure in steel. Seat body in polypropylene■

5. EASY CHAIR "PRIMARY", from Quinze & Milan■

⊟ 47.5 ⊟ 44 ⊟ 44 cm■

6. CHAIR "CARRE", 2002. From Christophe Marchand for Ycami■ Structure in aluminum. Seat body completely in foam■

⊟ 76 ⊟ 52 ⊟ 54 ⊟ 46 cm■

7. CHAIR "DRESS", 1999. From Rane Vaskivuch and Timo Vierros for Snowcrash■ Structure in lacquered steel. Seat and backrest upholstered in nylon■

⊟ 82 ⊟ 63 ⊟ 75 cm■

(Photo: Bobo Olsson)■

1. Easy chair "Airbag", 1997. From Pasi Kolhonen and Ilkka Suppanen for Snowcrash▪

Seat upholstered in nylon, with polystyrene filling. Includes polyester straps to regulate the angle between seat and backrest. Converts into mattress. Dimensions: chair,

⊟ 80 ⊟ 85 ⊟ 90 cm▪

mattress,

⊟ 25 ⊟ 85 ⊟ 155 cm▪

(Photo: Bobo Olsson)▪

2. Chair "Flex", 2002. From Allseating▪

Seat flexible Flexion™ and reclinable backrest. Stackable. Good Design Prize, 2002, Chicago Athenaeum▪

3. Chair "Network", 2002. From Archirivolto Design for Segis▪

Structure in fiberglass reinforced with polyamide, molded by means of air injection techniques. Seat in steel or PVC mesh▪

4. Chair "K818", 2000. From Erik Magnussen for Thonet▪

Front legs, seat and backrest in polyamide. Back legs in steel. Stackable. Suitable for outdoor use▪

⊟ 78 ⊟ 51 ⊟ 56 cm▪

(Photo: Michael Gerlach)▪

5. Seat "LCP" (Low Chair Plastic), from Marteen Van Severen for Kartell▪

Structure made in one piece of molded plastic PMMA▪

⊟ 70 ⊟ 48.5 ⊟ 80 ⊟ 31 cm▪

6. Chair "Ice", from Kasper Salto for Fritz Hansen▪

Structure in aluminum. Seat and backrest in plastic▪

⊟ 79 ⊟ 50 ⊟ 48 ⊟ 45 cm▪

7. Chair "Casablanca" from Christophe Pillet for Artelano▪

1 and 3. "Pɪɴᴋ Bᴀʀʙɪᴇ Cʜᴀɪʀ" and "Tᴡᴇᴇᴛɪᴇ Bᴀʀʙɪᴇ Cʜᴀɪʀ". From Hannah Mae▪
Renewed version of this classic from the '60s originally designed by Burke Maurice for the firm Arkana. The structure is made in glass reinforced plastic (GRP) polished to a glossy finish. Available in seven colors. Suitable for outdoor use▪
⊟ 75 ⊟ 50 ⊟ 50 cm▪

2. Sᴇᴀᴛ "Sᴛᴀᴛᴜᴇᴛᴛᴇ", from 1995. From Lloyd Schwan for Cappellini▪
Varnished metallic base with aluminum appearance. Structure in fiberglass▪
⊟ 106 ⊟ 103 ⊟ 60 ⊟ 40 cm▪

4. Cʜᴀɪʀ "Eɴsᴇᴍʙʟᴇ", 1992. From Alfred Homman for Fritz Hansen▪
Structure in steel tube. Body in the synthetic material "Stapron N". Stackable▪
⊟ 81.5 ⊟ 59 ⊟ 45 ⊟ 43 cm▪

CHAIRS
AND ART

"Is a chair conceived as a work of art tragic or comic?"
James Joyce, *Portrait of the Artist as a Young Man*, New York, 1916.

Is a chair that nobody has ever sat in still a chair?

Does a chair that we find broken and abandoned on a wasteland sustain its original purpose?

What absence does a chair that appears in the foreground of a pictorial composition refer to?

Does a chair placed in the middle of an empty room symbolize something lost?

Can a chair with anthropomorphic forms tell a story?

Is a chair in offending aesthetics a political manifestation that expresses its anger toward the establishment?

Is a chair that contemplates the sea a poem?

In the hands of an artist, this domestic object that we are obliged to have around us loses its dictionary definition and becomes full of new significance that is as varied as the personality and state of mind of each of the creators found behind each of the works. In this way, chairs become a metaphor for life, for presence and for absence, for solitude and for company. As Henry David Thoreau wrote, "I had three chairs in my home. One for solitude, two for friendship and three for society."

It is not by chance that the chair enjoys a close relationship with art. It is an object with more than five thousand years of history. It is full of symbolism, tensions in power, able to reflect the personality, culture and economic status of its owner, capable, also, of reflecting the pulse of an age. It is an outstanding example of the aesthetic trends of any moment.

Page 269: Creation on paper by Sergio Massetti (Genoa, 1962). Image courtesy of Promosedia, from the exhibition "20 Artists Interpret the Chair". *Opposite:* Shannon Landis Hansin is the craetor of the work "The Chair and I", made in mosaic. From the collection of the Gallery of Functional Art, Santa Monica, California.

From the chair in Vincent Van Gogh's room in Arlés, tragic testimony to solitude and austerity, to the electric chair in the intensely colored screen print *Sing Sing* by Andy Warhol in 1971, with its implicit protest against violence and the death penalty, there have been many artists who have lent their thoughts to this piece of furniture that has become a valuable means of communicating emotions and that only retains a remote hint that it may be something that could be sat on.

The relationship between the chair and art can be viewed in three different ways: from its contemplative position, as an integral part of a work of art, or as functional art. As far as the "contemplative" type of relationship is concerned, there are many artists who believe that a chair is the best place to contemplate a work of art from. This is the spiritual side of the chair. It allows the body to relax and adopt a comfortable posture that encourages an intense concentration on the part of the viewer who then does not have to worry about other corporal necessities. We tend to identify sitting in this way with intellectual activity, as a posture halfway between standing and the total abandonment of the lying posture. Therefore, to take a seat in front of

Image from the show "Bestseller" that took place during the 26ª edition of the International Chair Exhibition, Promosedia. Companies such as Thonet and Poltrona Frau presented iconic pieces from the history of the chair.

a work of art implies adopting a contemplative attitude that is found between activity and passivity, between day and night.

As far as the chair in art is concerned, it is its range of metaphoric meanings that transforms it into an object of desire. Its very makeup is a fascinating metaphor of the human body: its arms, legs, back and head match our own silhouettes. Beyond this symbiosis, innumerable contradictions are expressed: an ironic criticism of the consumer society; a reflection of alienation and uniformity; a cry of liberty and licentiousness; a sign of strength or weakness; an explosion of joy or sadness; a symbol of poverty or wealth; or it can also, at the beginning or at the end, stand firm before one's eyes and undermine those deep-rooted convictions. It will depend on the place, the moment and the state of mind of he who exhibits and he who views.

Lastly, we have the chair as functional art, halfway between pure creativity and industrial conditioning. In this way, the chair embodies the duality present in works of

One of the stamps issued by the Italian postal service in September, 2001, from the series "Italian Design." Featured on the stamp is the chair "Free" from Monica Graffeo for Kristalia.

this nature: as a subject of admiration and as a utilitarian object. This is an example that accentuates the existent ambiguity in many cases of the division between art and merchandise. In fact, the prototypes of the grand maestros of the twentieth century (those marvelous creations by Breuer, van der Rohe, Le Corbusier or Eames, among others) and of those who continue working with their hands in the twenty-first century could all fall into this group. There must be a reason for the large museums and galleries exhibiting chairs as part of the cultural heritage of an era∎

In reality, they are chairs created as an excuse to build spaces, as architectonic representations on a small scale. Created to experiment with visions and representations, with form, with materials and techniques. Each and every one of them shows a capacity to see all of what we live with every day in a different way. When all is said and done, isn't this art?

As Joyce would say, welcome to the tragicomedy of the chair, to the contradictions of life∎

From left to right: "Lotus chair" from David Delthony; "The Cat Bird Seat" from Shannon Landis Hansen; chair from Gordon Chandler, and chair in the form of a flower from David Burry. All of these works are from the collection of the Gallery of Functional Art, Santa Monica, California∎ *Opposite:* Chair created by Alessandro Mendini (Milán, 1933) for the exhibition "20 Artists Interpret the Chair" organized by Promosedia∎

1985 - 1998

Previous pages: Image from the exhibition "100 Years-100 Chairs", organized by the Vitra Design Museum in Weil am Rhein, Germany■ *Above* Creation of Piero Gemelli (Rome, 1952), included in the exhibition "20 Artists Interpret the Chair" organized by Promosedia■

Chairs 278 Art

"Coveri" chair designed by the architect Raffaello Rossi for the Italian fashion firm founded by Enrico Coveri. Image courtesy of Promosedia, from the exhibition "20 Artists interpret the Chair".

Sculpture in wood by Urano Palma (Varese, 1936), for the exhibition "20 Artists Interpret the Chair", organized by Promosedia■

Sculpture in metal by Shlomo Harush (Jerusalem, 1961). Included in the exhibition "20 Artists Interpret the Chair", organized by Promosedia∎

Benches made by Gordon Chandler. From the collection of the Gallery of Functional Art, Santa Monica, California.

Photograph by Albano Guatti that brings out the ambience of the simple and authentic past of an old chair. The work was included in the exhibition "20 Artists Interpret the Chair," organized by Promosedia■

Creation by the artist and designer Cesare Sartori (Vicenza, 1930) for the exhibition "20 Artists Interpret the Chair", organized by Promosedia.

Chairs 284 Art

INFLATABLE EASY CHAIR, "LOUNGE CHAIR SIGNAL" created by Nick Crosbie in 1997 and included in the travelling exhibition "Blow Up-Shaped Air in Design, Architecture, Fashion and Art", organized by the Vitra Design Museum, Berlín. (Photo: Jason Tozer/Inflate)∎

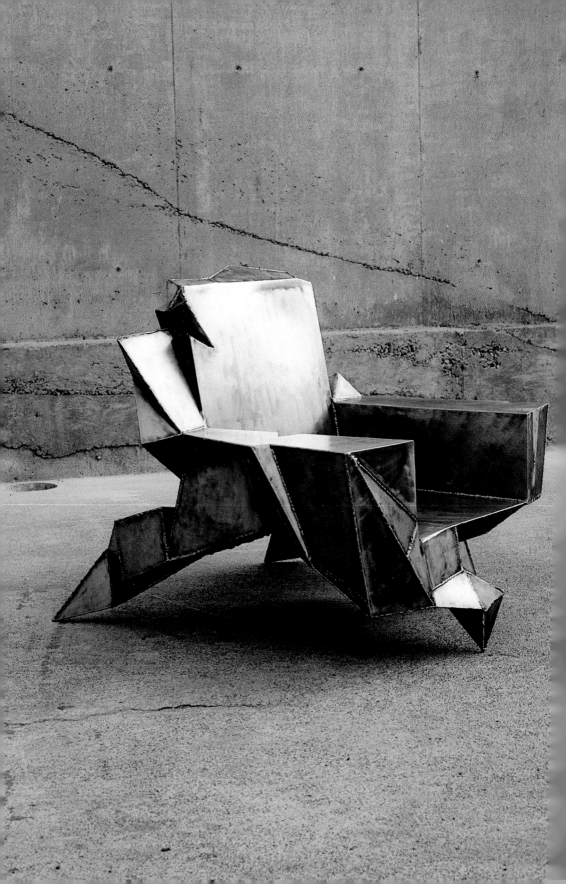

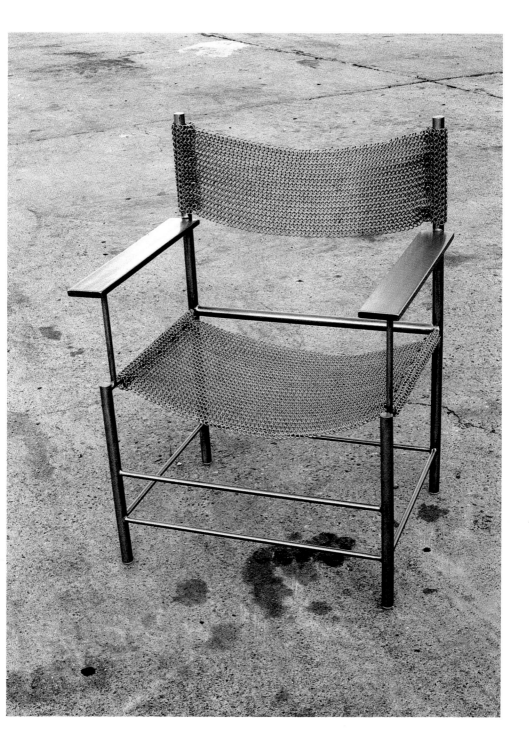

Opposite: "Meteor Chair", a piece of functional art made in steel■ *Above:* "Chain Mail Chair", stainless steel and chain mail. Both pieces are the work of the North American sculptor Bruce Gray■

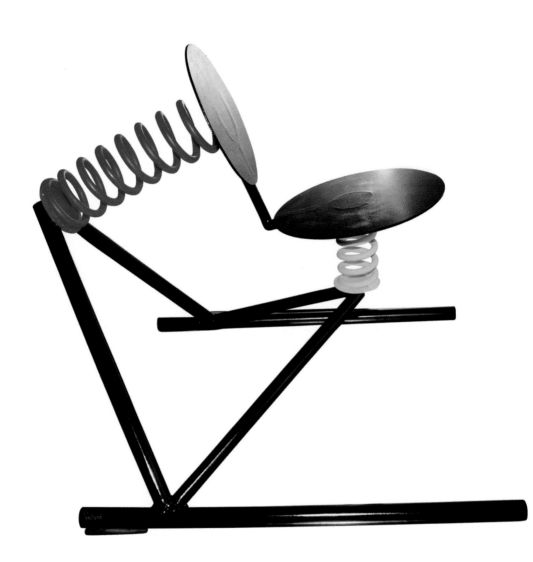

"CHOPPER", a piece of functional art by Bruce Gray, in painted steel.

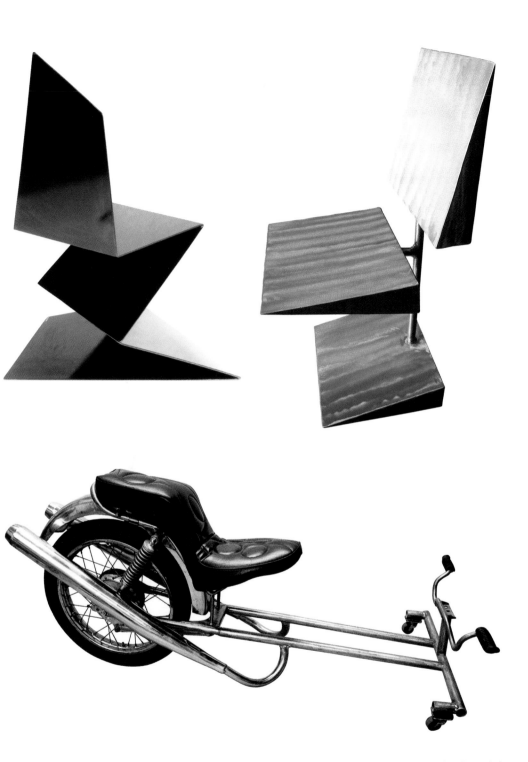

Top left: "Zig-zag" chair, steel■ *Top right:* "Wedges Chair", aluminum■ *Bottom:* "E2 Rider Chair", steel and recycled motorcycle parts. All by Bruce Gray■

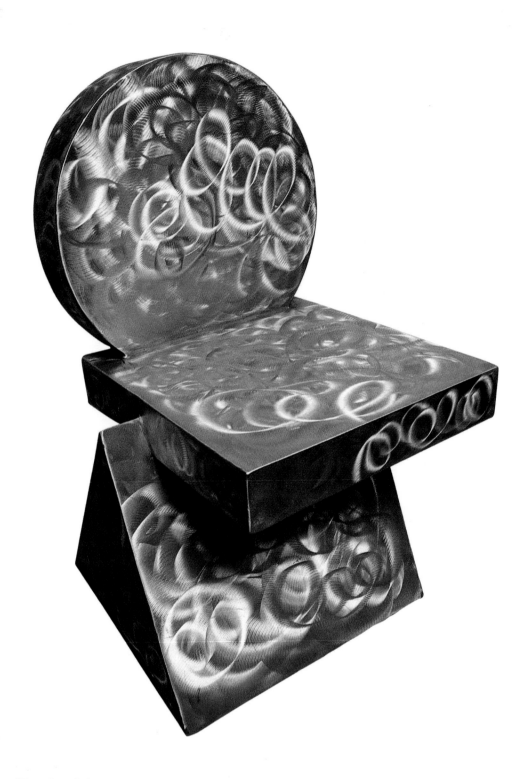

"Triad Chair", aluminum. *Opposite:* "Mehdown Chair", steel. Both pieces by Bruce Gray.

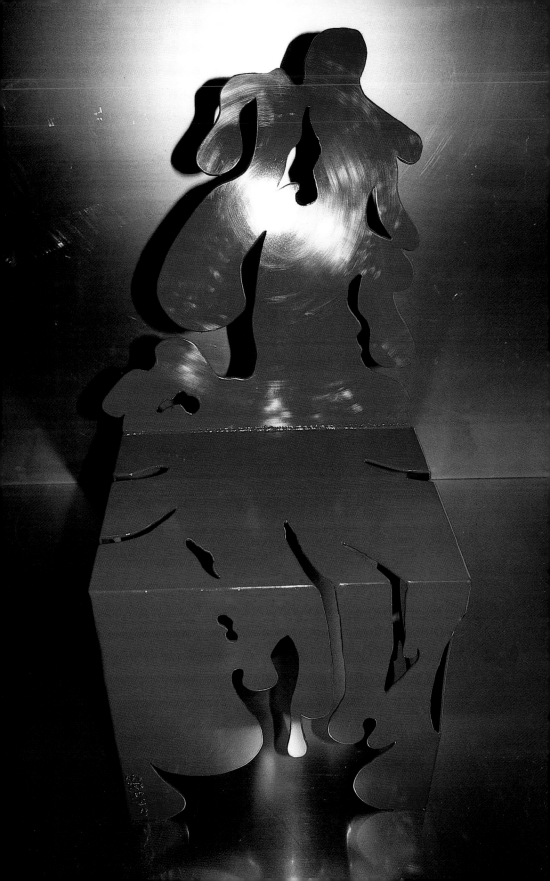

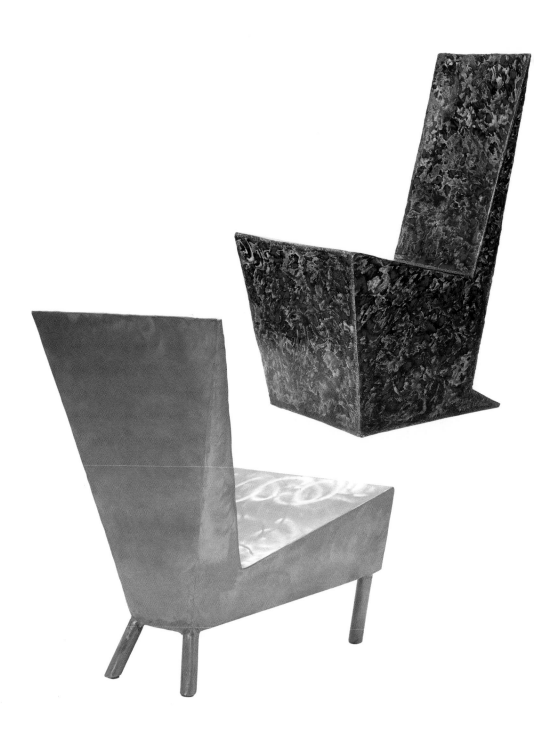

Top: "SCARLET" CHAIR, 2000, aluminum▪ *Bottom:* "LITTLE EASY", 2001, aluminum. Both pieces are works by the North American artist Christopher Poehlmann▪ (Photo: Ed Chappell)

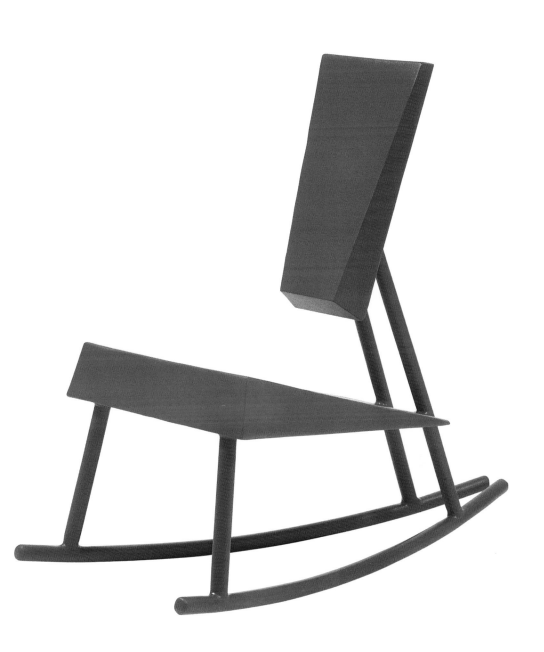

Rocking chair "Red Rocker", 2002, from Christopher Poehlmann. Aluminum■ (Photo: Ed Chappell)

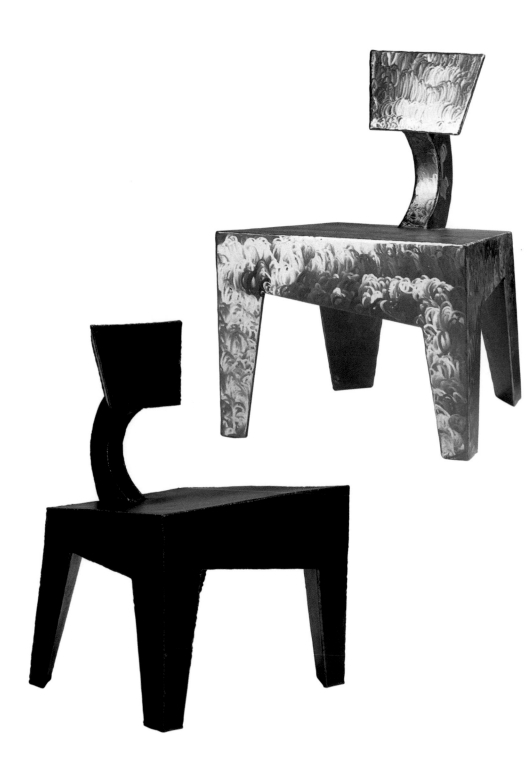

Two versions of the model "Chunky Chair" created by Christopher Poehlmann. Available in steel or aluminum and with various finishes.

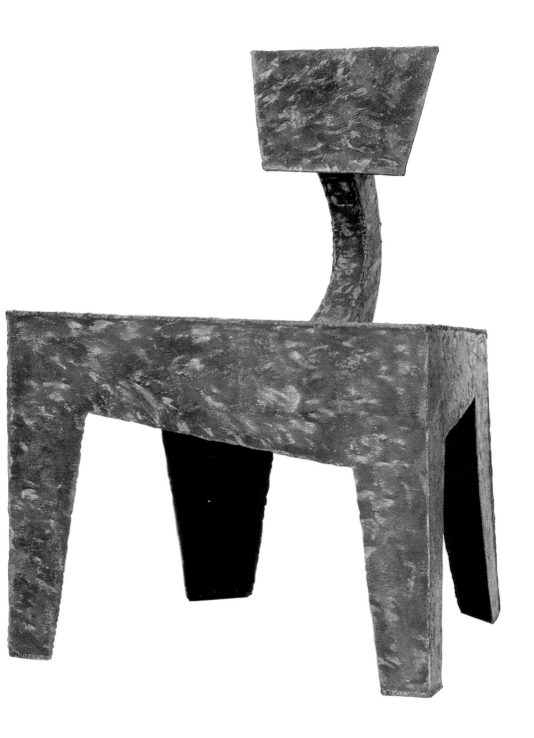

The "CHUNKY" chair in another finish. Designed and made by Christopher Poehlmann.

The artist Kathryn Semolic recovers old pieces of furniture and gives them a new life by painting and restoring them.■
Top: "Growth" chair, decorated with acrylic paint.■ *Bottom:* "Great Blue Herons" chair ■

HIGHCHAIR FOR CHILDREN, "APPLE OF MY EYE". hand painted in the colors of the rainbow. According to its creator, Kathryn Semolic, "each one of my pieces is created as if it were a sonnet to nature."

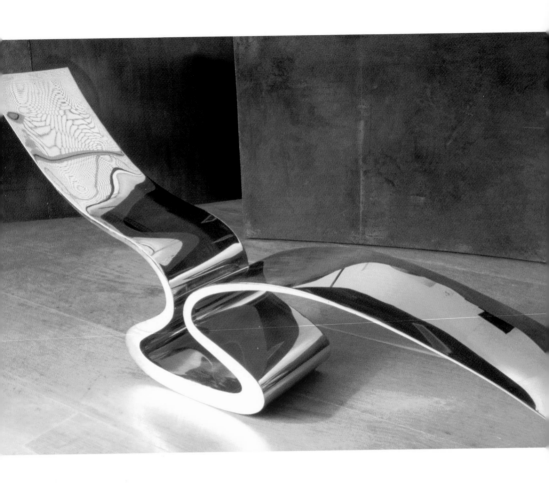

Ron Arad is the creator of "AFTER SPRING", from 1992. It is a chaise-longue that is also a rocking chair, in polished stainless steel■

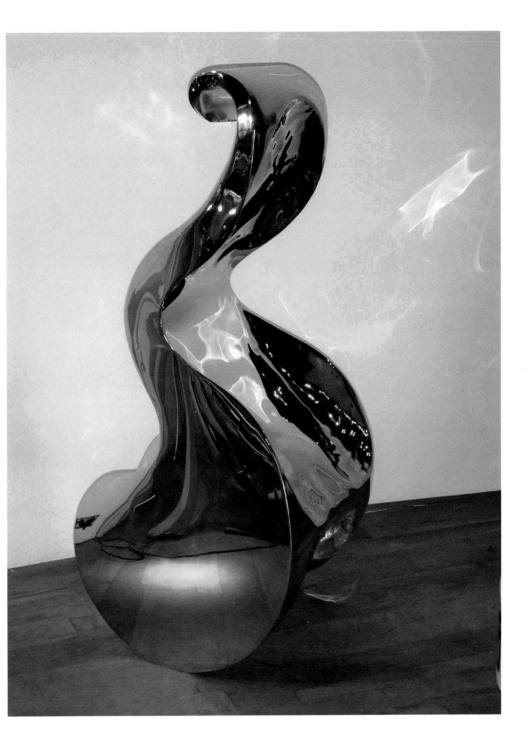

"A.Y.O.R.", 1990, created by Ron Arad for the Mourmans Gallery. When not in use, its rounded base leans forward and its chair appearance disappearsa▪

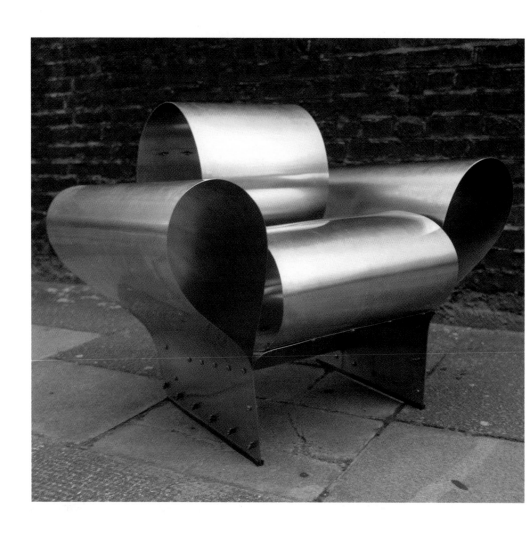

"WELL TEMPERED CHAIR" by Ron Arad. Originally designed in 1986, manufactured in tempered steel for the firm Vitra International.

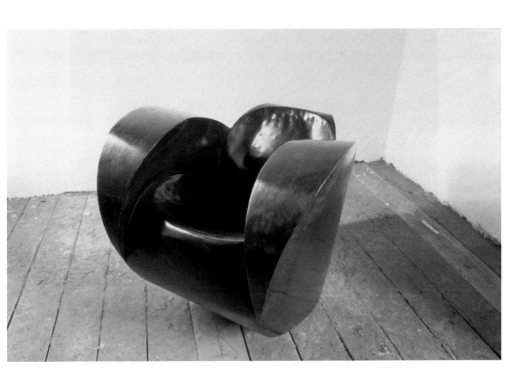

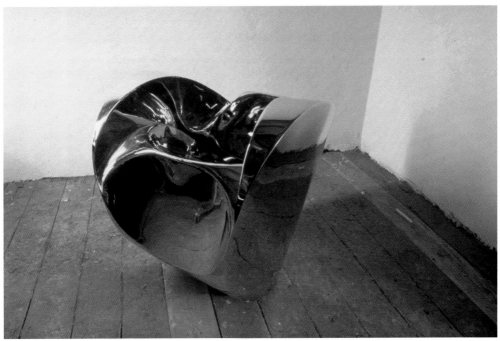

Two versions of the rocking chair, "ROLLING VOLUME", created in 1990 by Ron Arad. Made in brushed steel or in polished stainless steel, only twenty pieces in each finish exist▪

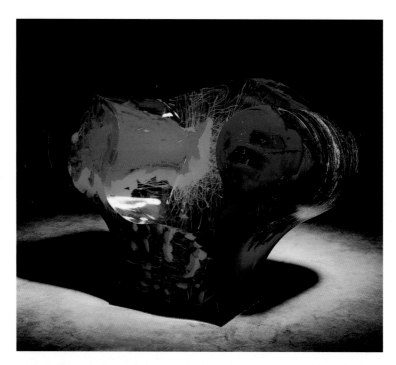

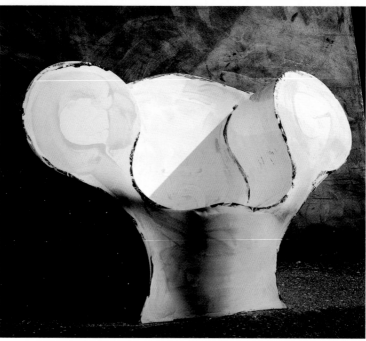

"NEW ORLEANS" easy chair in fiberglass and polyester, 1999. Created by Ron Arad for the Mourmans Gallery, in a limited edition of eighteen pieces, each different from the other.

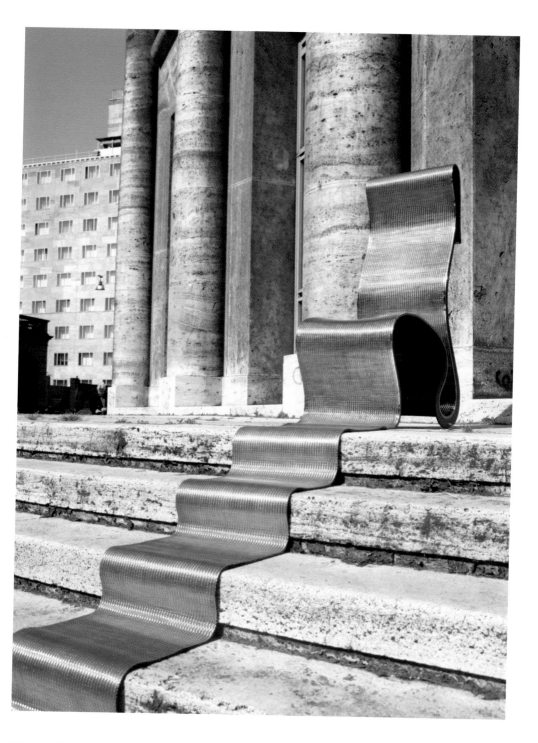

"NARROW PAPARDELLE", 1992, created by Ron Arad. Steel chair profile, welded to a polished stainless steel carpet. The carpet part of the piece may be rolled up to form a footrest.

Two views of the polished bronze stool "Fausto", created by Novello Finotti for Ultramobile.

Two views of the throne "MARGARITA", constructed from a recycled metallic barrel with bronze structure. Created by Sebastian Matta for Ultramobile▪